understanding hypermedia 2.000

Phaidon Press Limited
Regent's Wharf
All Saints Street, London N1 9PA

Understanding Hypermedia first published 1993
Second edition (revised, expanded and redesigned) published 1997
©1993, 1997 Phaidon Press Limited

ISBN 0 7148 36575 (hardback)
ISBN 0 7148 37407 (paperback)

A CIP catalogue record for this book is available from the British Library

Design director Malcolm Garrett, designer Cara Mannion, video images Peter Anderson
Special thanks to AMXdigital for computer facilities

Printed in Italy

For Benjamin George and Rozana Bucknill, and Benjamin Oliver

multimedia origins, internet futures

multimedia origins, internet futures
multimedia origins, internet futures
multimedia origins, internet futures
multimedia origins, internet futures

understanding
hypermedia 2.000

multimedia origins, internet futures

bob cotton & richard oliver

designed by malcolm garrett

multimedia origins, internet futures

multimedia origins, internet futures

multimedia origins, internet futures

multimedia origins, internet futures

multimedia origins, internet futures

x

understanding
hypermedia 2.000 contents

intro-duction

This book is an introduction to hypermedia, a radically new medium that is at the centre of a communications and media revolution. It is a digital medium, using many elements drawn from print, film and television to create exciting opportunities to communicate in entirely new ways.

When we wrote the first edition of this book, published in 1993, hypermedia was still in its infancy, and mainly the concern of a few enthusiasts. Since then it has grown up very rapidly and is now used by millions every day all over the globe.

We have taken the opportunity of producing a new edition: to re-think, revise, extend and update this general introduction to what we believe is a very exciting and important new medium. We hope that this book provides a broad picture of how hypermedia has developed, the new opportunities it presents, and its likely future development. We have tried to keep the language as non-technical as possible, focusing on the key principles that make hypermedia a significant new medium that has profound implications for the development of the design, media and communications industries and their impact on our everyday lives.

Hypermedia is an entirely new medium that has only very recently become a practical reality. While many of the ideas and concepts that underlie the medium have been developing over the past fifty years, it is only since the late 1980s that advances in computer and telecommunications technologies have enabled them to be realized. Hypermedia is now part of the everyday lives of millions of people all over the world. This unprecedented rate of technical and creative innovation shows no sign of slowing and is likely to remain as fast and as turbulent over the coming years as it has been in the recent past. Similarly the number of new uses and new users of the medium will continue to expand dramatically.

This book sets out to explain the significance and nature of the medium, and to provide a broad contextual framework so that its rapid development and the exciting new opportunities it presents can be understood and acted upon. Hypermedia is a genuinely new medium and while many of its elements are quite familiar, there are others which require us to think in different ways about the relationship between the users and creators of communications media. We hope that this book will provide the necessary resources and concepts to aid this process of re-thinking.

Hypermedia is a computer mediated medium that displays text, image, sound, animation and video in a variety of different combinations. It is a "random access" medium with no physical beginning, middle or end, enabling information to be linked in a network of connections that can be explored in many different ways. It is an interactive medium, where distinctions between users and creators can become blurred. It is a digital medium that can be distributed either on disc or over communication networks such as the Internet. It is also a medium that contains the potential to transform many aspects of how we live, work, learn and play.

To understand hypermedia has now become imperative for everyone professionally involved

in communication and media, since its impact on our lives promises to be as great as that other media revolution, the invention of print.

Only a small part of this book is about the technology that makes hypermedia possible. Far more intriguing and relevant to what most of us do is the potential of hypermedia as an expressive medium unlike any other we have experienced before: a ubiquitous medium giving sensory form and human meaning to the ever-growing, invisible world of digital electronics which increasingly permeates every aspect of our lives.

The first section of the book, "Media Fusion", looks at the origins of the medium: the convergence of technologies that have made hypermedia possible; the ideas of artists and designers that have laid the ground for some of the concepts and aesthetics that will find their full expression in hypermedia; and the work of the pioneers and visionaries of hypermedia and cyberspace.

The following section, "The Next Media Revolution", places the current stage of development of the medium in context, explains what makes it a radically new form of communications medium and examines some of the broader implications for how it can be used.

In the third section, "Media Matrix", we analyse the role and function of the individual media elements that combine to form hypermedia and the contribution that interface design, images, text, typography, audio, video, animation, virtual space and software engineering can make to the overall hypermedia experience.

The next section, "Design and Production", is concerned with the practical issues of designing and producing hypermedia programmes and Web sites and proposes a general model for this process, which is discussed in detail.

The fifth section, "Hypermedia Applications", draws on current examples from all over the world to show how hypermedia is being applied in a variety of different situations and to show the wide diversity of approaches and styles that have already developed.

The final section speculates on the future and suggests how the technologies that are moving out from research laboratories in universities and the research and development departments of computer, telecommunications and electronics companies will form the technical infrastructure for what we call "Millennial Media" and the context for the further development of hypermedia as the predominant communications medium of the next century.

InteractiveLand by Szadeczky & Steinfl and the Nofrontiere group

One of the best and most sophisticated of the purely experimental, non commercial interactive CD-ROMs produced in the early 90s.

Hypermedia is a hybrid medium that has grown out of a very wide range of parallel developments in fields as diverse as art, film, television, telecommunications and computer science. The major stepping stones in its technological development were the introduction of telegraph and telephone networks and cinematography in the 19th century, the invention of television in the 1930s, the digital computer in the 40s and 50s and the emergence of the personal computer and computer networks in the 70s. It was the convergence of these technologies in the late 70s and 80s that finally provided the framework that made hypermedia a practical possibility.

The conceptual and creative roots of the medium are equally diverse. The experiments in using multiple media and montage by 20th-century avant-garde artists combined with the ideas of a range of visionary thinkers, computer pioneers and science fiction writers have led to the creation of this new 21st-century multi-sensory, non-linear, digital medium.

1

media fusion

when technologies collide

media fusion

telegraph and telephone

The development of the electric telegraph in the 1830s signalled the very beginnings of a "cyberspace" infrastructure. Networks of telegraph wires, carrying their signals of dots and dashes, spread through Britain, Europe and the United States, and by the 1870s had spanned the Atlantic. Telegraphy initiated the era of electrical communications, and began a process that is now rapidly becoming a world-wide integrated digital network. But the telegraph was a form of "distance writing" not "distance speaking". The transmission of Morse code along telegraph wires required trained operators, and communications were only possible through special telegraph offices. It was the invention of the telephone that provided live voice communications that were available to everyone. By 1900 over two billion telephone conversations a year were being transmitted through the Bell telephone system alone.

cinematography

The first films encapsulated the theatrical experience and made it available to an audience massively wider than that of the theatre. Film was (in the terminology of the late 20th-century) the first audio-visual medium that involved "storage and delivery". It stored the theatrical experience while at the same time extending that experience beyond the physical boundary of the stage. The cinema could both encompass the real world and provide a vicarious experience of people and places distant in both space and time – all for the cost of a ticket. The early film-makers immediately realized that film could convey experiences that live theatre could not, allowing film stories to juxtapose incidents in time and space, take their audiences to the moon, or into the world of hand-drawn comics, or back in time to the American Civil War. And for little more expense than that of a theatrical performance, these experiences could be delivered to an audience that was millions of times larger.

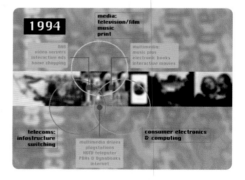

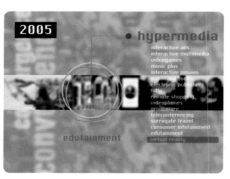

Convergence

Designed by Nicholas Negroponte in the mid-80s, the idea of representing the convergence of media, telecommunications and computing by means of successive Venn diagrams was one of the most successful means of explaining the enormity of the media revolution that was about to happen.

television

At about the same time, early experiments in television broadcasting signalled another major breakthrough, extending the possibilities of radio by incorporating pictures, and taking the power of the cinema right into the home. The audience could turn the television on and off at will, and select the kind of entertainment and information they wanted from an ever increasing number of channels. As a medium, television delivered most of what film could offer, but added the immediacy of radio news coverage, magazine programmes and chat and game shows, all of which it did electronically, invisibly, and with ever greater technological sophistication. After the interruption of World War Two, television rapidly overtook the cinema as the preferred entertainment medium. It integrated radio, film, theatre, dime novel, magazine, advertising hoarding, comic strip and newspaper, providing a multiple-media magazine of all these forms. Unlike film, which with its high-definition large-scale images required the audience to do no more than just sit back and watch, the low-definition, small-size television image demanded additional attention. The audience had to fill out the television image with their own imagination, interpreting the mosaic of phosphorescence that they were watching. Early television, with its dials, control buttons and low-resolution pictures, was an active medium that required participation.

computers

The final step towards the fusion of media technologies began with the development of digital computer technologies in the late 40s and 50s. During and immediately after the War the conceptual and technical framework for modern computers was put in place. The essential components – including Claude Shannon's Theory of Information, Norbert Weiner's work on cybernetics, John von Neumann's work in digital computing, the transistor, electromagnetic

memory and Grace Hopper's work in programming – were all in place by the mid-50s. The astonishingly rapid progress in micro-electronics, from transistor (1948) to integrated circuit (1959) to the microprocessor "computer on a chip" (1971), spanned only 23 years. The first personal computers appeared on the market in the early 70s, and commercially available software designed specially for hypermedia followed just ten years later.

media fusion

The invention of the microprocessor in 1971 was a key step in the process of media convergence. Its significance was that it created the possibility for all media to be created, stored, manipulated, reproduced and distributed digitally. Up until then all communications media, with the exception of computing itself and some specialized types of telecommunications, had been analog in form – that is, the information that was communicated was similar to its source. (For example, the grooves on a vinyl gramophone record correspond to the sound waves that created them and that they reproduce. The same music on a digital CD is described in a series of binary zeroes and ones.)

It was this movement from analog to digital that enabled media types that were different in physical form as well as aesthetically and functionally to start moving together. This was also the shift that made hypermedia a practical possibility, making text, images, sound, animation and video all capable of being organized and manipulated under computer control.

The digitization of media has led to the situation where, as Nicholas Negroponte, director of MIT's Media Lab, has often said we "need to be thinking bits not atoms". In other words, the value of intellectual and creative property lies in its content, not in its physical form.

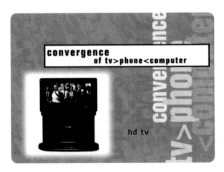

convergence
of tv>phone<computer

hd tv

portability
of consumer electronics

Mutability and portability

Stills from a presentation by Bob Cotton and Malcolm Garrett to the Monotype Conference in November 1994. The lecture covered both the causes and effects of the media revolution, and examined how it would effect graphic designers.

CD-ROM and the Internet

Two technologies have emerged from the process of media fusion that have been particularly important for defining the nature and direction of hypermedia. The first is CD-ROM, which was the first to engage the attention of many working in this new medium. The second is the Internet, the home of the World Wide Web, which has rapidly become the major focus of activity and innovation in this area. The two technologies have very distinct characteristics and encourage very different ways of thinking about the medium. CD-ROM stresses the use of hypermedia as a publishing medium, while the Internet emphasizes its use for communications. While these two approaches are not mutually exclusive they do encapsulate two contrasting models of how the medium will develop.

CD-ROM (Compact Disc Read Only Memory) is a digital optical storage medium jointly developed by Philips and Sony. The CD or compact disc was first launched in 1982 as a medium for carrying recorded music. By 1986 it had been adapted so that it could carry any form of digital data. Its attraction for hypermedia developers was that it offered up to 650 megabytes of storage. One of the obstacles to the development of hypermedia at that time was that storing data was comparatively expensive and components of hypermedia such as images, sound and video are memory intensive. With CD-ROM this problem

appeared to be resolved. Its storage capacity seemed more than adequate to carry sophisticated hypermedia programmes using text, sound, images, animation and video.

As well as its storage capacity, CD-ROM seemed at the time to have a number of other advantages, making it apparently the ideal storage and distribution medium for hypermedia. CD-ROMs comprise a polycarbonate disc that is covered in a series of pits and spaces which represent the "zeroes" and "ones" of digital information. This information is read by a laser and no physical contact is made with the disc. They can be mass-produced very cheaply by either injection or compression-moulding of heated polycarbonate.

The physical, read only, nature of the CD-ROM encouraged a view of hypermedia as a traditional publishing medium, where professionals produced a finished product that was used by consumers; a model that is very similar to book publishing or recorded music.

The Internet is very different, since from its inception it was conceived as a communications system, more like the postal service or the telephone system. It began as a US military-funded set of projects in the 60s and 70s. Essentially these projects first addressed two related problems. The first was how to produce a robust communications system that could continue to function even if substantial parts of it were destroyed in a nuclear war. The second was how to get different kinds of computers and computer networks to communicate with one another.

The solution lay in terms of thinking of the communications system as being like a fishnet. A message passing through the system is split into "packets" of equal length, each with the address of its destination and the address of where it has come from. Unlike the early telegraph or telephone systems where a direct line has to be established between sender and receiver, these packets of information can travel

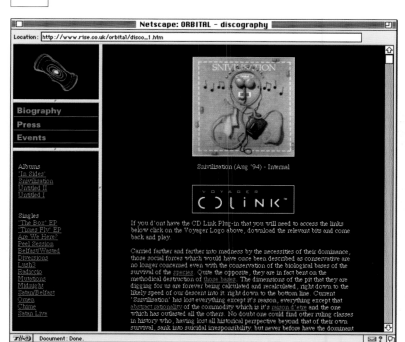

Voyager CD-Link

The pioneering electronic publishing company Voyager created CD-Link to provide instant links between text entries on Web pages and audio CDs in the user's computer CD-ROM drive. This enabled multimedia essays and critiques of music albums to be published on the Web and illustrated with sound clips or tracks from the CD.

independently through the network, coming together at their final destination. This means if any part of the network is not functioning or is destroyed the packets will route themselves around the damage, using those parts of the network that are still functioning.

By using a set of common software standards this system also means that any computer using those standards can be connected through the global telecommunications system to all the other computers using them. In a sense, the Internet is not so much a physical entity, more a translation language that enables communication and connection.

The Internet began life in the 70s as ARPANET. This was a network that linked defence-related projects sponsored by the Advance Research Projects Agency of the US Department of Defence. In the 80s it became the Internet and was mainly a network linking academic institutions and research centres throughout the world. It was following the invention of the World Wide Web at CERN (the European High Energy Physics Centre) that the Internet began to adopt the characteristics of a universal communications system that it has today. The World Wide Web builds on the software standards of the Internet to provide another set of standards, which enable it to be used for hypermedia.

In the long term, it seems certain that CD-ROM will be seen as a provisional technology along the route to fully networked hypermedia. Whether those networks will be based on Internet technology is still open to question, but looking at how technologies have developed in the past suggests that it probably will. In the meantime, despite the ever growing importance of the World Wide Web, CD-ROM is likely to continue to be an important medium for carrying hypermedia. The introduction of DVD (Digital Video Disc), which increases the capacity of CD-ROM several fold, will enable it to carry far more ambitious hypermedia projects than have been possible so far. A further interim technology is the hybrid CD-ROM which links to the Internet to offer the best of what both technologies can currently offer. This technology looks increasingly important and offers yet another example of the continuing convergence of media.

Mike Oldfield enhanced CD

Enhanced CDs carry both CD-audio and CD-ROM tracks, which music, video and multimedia, providing a new and exciting convergence of promotional media that were previously quite separate. By linking to the World Wide Web, fans can also browse a news channel, with the latest information of tour dates and concerts, as well as interviews with the stars.

media chronofile

1777 • Stanhope Logic Demonstrator
1793 • Mechanical Semaphore network
1793 • Stanhope Arithmetic Machine
1805 • Jacquard Programmable Loom

telecommunications & computers

television & video

This "chronofile" charts the development of the main forms of media over the last two hundred years or so. Entries have been colour-coded to show the changes from conventional "analog" forms to electronic analogs, and finally into the digital forms we have now. It is only in the last decade and a half of the 20th-century that the ingredients for hypermedia have entered the digital domain, sparking the beginnings of the next media revolution. (Note that this chronofile is a selective illustration, with entries chosen to show the principal events on the route to hypermedia, and is not meant to be an exhaustive history.)

Key: electronic
 digital

Caslon

Bodoni

1798 • Phantasmagoria projector

photography & film

1702 • *Daily Courant:* London's 1st daily newspaper
1704 • *The Boston News-Letter:* America's 1st regular weekly
1706 • *The Evening Post:* London's 1st afternoon daily
1710 • Le Blon:Three-colour engraving
1725 • Stereotypy

1764 • Fournier: point system
1768 • *Encyclopaedia Brittanica*
1770 • Didot typeface

1788 • Bodoni typeface

1796 • Senefelder: Lithography
1798 • Nicholas-Louis Robert: Papermaking machine
1814 • The London *Times* operates 1st Steam press

1734 • Caslon typeface

print & publishing

1750 • Baskerville typeface
1755 • Dr Johnson's *A Dictionary of the English Language*

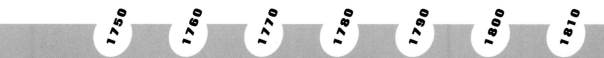

1700 1725 1750 1760 1770 1780 1790 1800 1810

1830 • De Colmar: calculating machine
1833 • Electronic Telegraphy
1833 • Babbage: Difference Engine
1835 • Babbage: Analytic Engine
1837 • Morse Code

1900 • Radio Telephone
1906 • Photo Telegraphy
1913 • Torres: Theory of Automata
1916 • Telex Machine

1866 • Trans-Atlantic Telegraph Cable
1876 • Bell: Telephone
1881 • Stereophony
1890 • Hollerith: Punch Card Counting Machine

1884 • Pual Nipkow: Nipkow Scanning Disc

1895 • Crookes: Cathode-Ray Tube (CRT)

1908 • Cambell-Swinton
"Distant Electrical Vision"

Edweard Muybridge *12 exposures of Sally Gardner galloping*

1877 • Edison: Phonograph & cylinders
1887 • Berliner: Gramophone & discs
1895 • Marconi: Wireless Telegraphy
1904 • Fleming: Diode
1910 • Crystal set
1917 • Variable frequency receiver

radio & records

1878 • Muybridge: Sequential photography
1882 • Marey: Chrono-photography 1903 • Lumiere: Autochrome colour photography
1884 • Eastman: Roll film
1888 • Kodak: Box camera
1889 • Edison: Sound cine camera
1891 • Anaglyph (red/green) stereo photos
1893 • Edison: Kinetiscope
1895 • Lumiere Bros: Cinematograph
1900 • X-ray photography

1828 • Plateau: Persistence of vision
1832 • Plateau: Phenatiskiscope
1833 • Stroboscope
1835 • Daguerre: Daguerrotype
1840 • Fox Talbot: Calotype
1849 • Stereoscope

Sholes & Glidden typewriter by Remington & Sons 1874

1822 • Photogravure printing
1822 • Church: 1st type-composing machine

1868 • Sholes: Typewriter
1880 • Hogan: Newspaper halftone
1885 • Mergenthaler: Linotype
1887 • Lanston: Monotype
1887 • Beardsley: Line block illustration
1892 • Kurtz & Ives: 3-colour process halftone printing

1904 • Offset lithography
1906 • Ludlow typecasting machine
1907 • Daily comic strips
1915 • Dada typography and collage
1916 • De Stijl asymmetric grids

print & publishing

1820 1830 1840 1850 1860 1870 1880 1890 1900 1910

media chronofile

telecommunications & computers

- 1927 • Trans-Atlantic Telephone Service
- 1930 • Vannevar Bush: Differential Analyser
- 1931 • Zuze: Z1 Computer
- 1936 • Turing: *On Computable Numbers*
- 1937 • Claude Shannon: *Information Theory*
- 1943 • ENIGMA computer
- 1943 • Colossus electro-mechanical computer
- 1944 • Aiken: ASCC general purpose digital calculator

- 1923 • Iconoscope/linescope television system
- 1926 • Baird: Electro-mechanical TV
- 1929 • Zworykin/Farnsworth: TV
- 1932 • BBC Television Broadcasting

Marconiphone popular TV

- 1940 • Radar
- 1941 • Regular TV broadcasts in USA

Lumiere Cabinet Grand Model c1924

- 1920s • Widespread radio broadcasting
- 1922 • Portable radio
- 1922 • Car radio
- 1926 • Pulse Code Modulation (PCM)
- 1928 • Magnetic recording tape
- 1933 • EMI: Stereo recording

radio & records

- 1926 • Sound movies (music only)
- 1927 • Sound movies ("Talkies")
- 1935 • Technicolor films
- 1935 • Kodachrome 35mm film
- 1937 • 3-d stereoscopic (anaglyph) movies

photography & film

ISOTYPE: International System Of TYpographic Picture Education

- 1920 • Bauhaus typography
- 1924 • Otto Neurath: Isotypes
- 1927 • Paul Renner: Futura typeface
- 1930 • Four-colour offset press
- 1933 • Henry Beck: Schematic London Underground map
- 1935 • Modern paperbacks

London Underground typeface by Edward Johnston

print & publishing

1920 1925 1930 1935 1940

Futura

1945 • ENIAC computer
1945 • Vannevar Bush: "As we may think" MEMEX article
1946 • Von Neumann: stored program computer
1946 • Stibetz: 1st electronic program-controlled digital computer
1947 • Bardeen, Brattain, Shockley: Transistor
1948 • Norbert Weiner: *Cybernetics*
1948 • Kilburn & Williams: Universal Machine – 1st working digital computer
1951 • UNIVAC 1st commercial mainframe computer
1951 • Computer flight simulation/air traffic control

1959 • Kilby/Noyce (independently): Integrated Circuit
1960 • Computer Aided Design
1960s • Cable TV networks
1962 • Telstar telecommunications satellite
1962 • Satellite TV
1962 • Ivan Sutherland: Sketchpad
1963 • Teletext
1965 • Engelbart: Mouse
1968 • Intel founded by Robert Noyce
1968 • Intel: RAM chips
1958 • 1st high level programming language: Fortran
1968 • Engelbart: "Augment" hypertext system

1949 • 1st cable TV narrowcasts
1951 • Mincom monochrome videotape recorder (VTR)
1953 • Colour TV broadcasting
1953 • Ampex VTR
1962 • Satellite TV broadcasting
1964 • Sony: Consumer VTR
1958 • Ampex hiband colour VTR
1959 • Closed Circuit TV (CCTV)

television & video

1947 • LP records
1947 • Modern electric guitar
1961 • Philips: Compact cassette
1965 • Moog: Synthesiser
1954 • Transistor radio
1967 • Dolby noise reduction system
1956 • Stockhausen: Electronic music
1958 • Consumer "hi-fi" stereo records
1958 • 45 rpm singles
1958 • Electric piano

1948 • Polaroid: Instant photography
1952 • 3-d stereo Polaroid movies
1963 • Colour Polaroid film
1955 • Blue screen optical matting
1966 • Kodak Carousel projector
Hasselblad Camera
1956 • Panavision Camera
1968 • Stanley Kubrick: 2001:A Space Odyssey
1956 • Cinerama
1958 • Heilig: Sensorama

photography & film

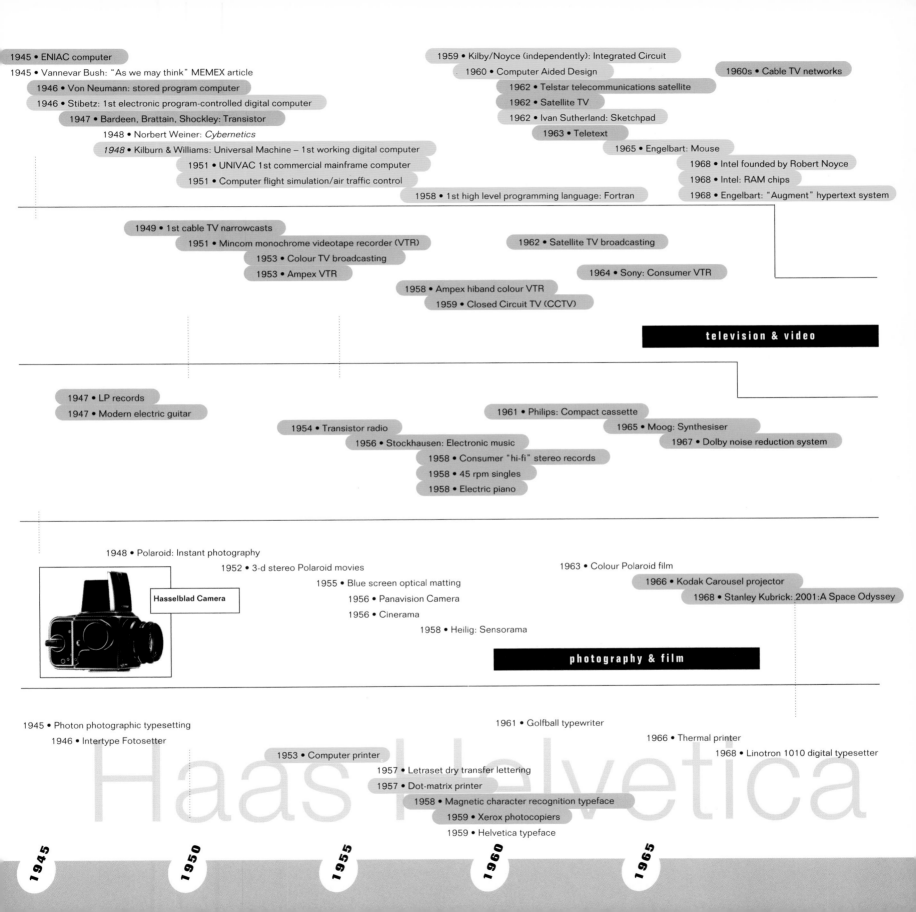

1945 • Photon photographic typesetting
1961 • Golfball typewriter
1946 • Intertype Fotosetter
1966 • Thermal printer
1953 • Computer printer
1968 • Linotron 1010 digital typesetter
1957 • Letraset dry transfer lettering
1957 • Dot-matrix printer
1958 • Magnetic character recognition typeface
1959 • Xerox photocopiers
1959 • Helvetica typeface

Haas Helvetica

1945 **1950** **1955** **1960** **1965**

1970 • Intel 1103: first widely available RAM chip (1kb capacity)
1971 • Intel 4004 microprocessor
1972 • Xerox Alto Personal Computer
1972 • Nolan Bushnell : 1st videogame
1973 • Modern Fax Machines
1973 • Sinclair Cambridge Pocket Calculator
1974 • Ted Nelson: *Computer Lib/Dream Machines*
1974 • Intel 8-bit 8080 microprocessor (5000 transistors)
1975 • Microsoft Corporation founded
1975 • Zilog z80 microprocessor
1975 • MITS Altair: first 8-bit personal computer construction kit
1975 • MOS Technology 6502 chip (AppleII, PET, BBCB)
1975 • Motorola 6800 chip
1976 • Cray 1 Supercomputer
1976 • 16 kbyte RAM chips
1976 • Apple Computer founded
1977 • Apple II Computer

1970s • first LAN networks (ETHERNET)
1970s • first WAN networks (ARPANET)
early 1970s • ATM banking machines and networks
late 1970s • Internet emerges
late 1970s • e-mail
early 1980s • networked multi-user games (MUDS)

1978 • 64 kbyte RAM chips
1978 • Intel 16-bit 8086 (29000 transistors/10 MHz)
1978 • Texas Instruments Speak & Spell toy with speech synthesis
1979 • Cell telephones
1979 • Visicalc: 1st spreadsheet software
1979 • Wordstar Word Processor
1979 • Motorola 68000 Microprocessor
1979 • Intel 8088 (low-cost version of 8086)
1980 • Dbase II database management software
1980 • Motorola 8MHz 32-bit 68000
1980 • Sinclair ZX80 100 computer kit
1980 • SystemX digital telephone exchanges in UK
1980 • Atari Pac-Man videogame slot machines
1981 • IBM PC running 4.77 MHz Intel 8088
1982 • Sinclair Spectrum
1982 • Intel 16-bit 80286
1983 • Inmos: Transputer

telecommunications & computers

1971 • Sony U-Matic VTR
1972 • Philips: 1st consumer video cassette recorder (VCR)
1974 • Sony: Mavica still-video camera
1975 • Sony: Betamax VCR
1976 • JVC: VHS VCR
1978 • Philips: Laserdisc

1979 • MIT: Interactive Video (IV)
1982 • Sony: Betamovie camcorder

television & video

1979 • Sony: Walkman
1979 • Philips announce Compact Disc Audio
1980 • Digital sampling

radio & records

1981 • MIDI interface
1983 • Compact Disc Audio launched

1970 • Steadycam mount
1970s • Satellite remote-sensing digital photography
1971 • Omnimax Cinema
1973 Michael Crichton: *Westworld*

1977 • George Lucas: *Star Wars*

photography & film

1980 • Digital film effects
1980s • Space probe digital photography
1981 • Sony: Mavica electromagnetic camera
1982 • Kodak: Disc film
1982 • Steven Lisberger: *Tron*
1982 • David Cronenberg: *Videodrome*

1983 • Motion Control
1983 • Showscan process

1973 • Canon colour photocopier
1977 • Laser typesetting
1978 • Daisywheel printer

print & publishing

Apple Laserprinter

1980 • Laserprinter
1980 • Hypertext systems

1970

1975

1980

1984 • Apple Macintosh (68000)
1984 • IBM PCAT (6MHz 80286)

1985 • Intel 32-bit 20 MHz 80386 (275,000 transistors)
1985 • Philips/Sony: CDROM
1985 • Adobe: PostScript page description language (PDL)
1985 • Commodore Amiga (68000)
1985 • NeXT Computer founded
1985 • Atari ST (68000)

1986 • Apple Desktop Publishing (DTP) system
1986 • OWL: Guide hypertext software
1986 • Compaq DeskPro IBM compatible
1986 • Amstrad PC1512

1990 • Microsoft launch Windows 3.0

1987 • Apple Macintosh II range of computers
1987 • Acorn Arch\imedes first mass market RISC-based computer
1988 • VPL: Dataglove
1988 • NextCube and NextStation computers launched
1989 • Intel 25 MHz 80486 (1.2 million transistors)
1989 • Nintendo: Gameboy

1985 • Sony: Video 8
1985 • Sony: Digital Video Recorder
1985 • Philips: LVROM
1985 • Teleshopping

1987 • Philips: Compact Disc Video (CDV)
1987 • Philips: Compact Disc Interactive (CDI) prototypes
1988 • GEC announces Digital Video Interactive (DVI) multimedia system

1990 • HDTV broadcasts in Japan
1990 • Desktop Video (DTV)

1987 • Digital Audio Tape (DAT) recorders

1989 • Sony: CD Walkman
1989 • CD-MIDI

Sony CD Walkman

NCC WORM 1:Hypercard:BANDWIDTH:Bandwidth Panic

Apple HyperCard

1984 • Kodak DX coding
1984 • James Cameron: *The Terminator*
1985 • Holographic film
1985 • Digital film editing suites

1987 • Paul Verhoevan: *RoboCop*

1989 • Adobe Photoshop: professional digital image processing
1990 • Paul Verhoevan: *Total Recall*

"the neuron either...
Theatre of Memory...
"Hardcore systems"
There's a direct relationship between the non-linear, allusive, interconnected...

Authori

1985 • Adobe: Postscript page description language (PDL)
1985 • Aldus: Pagemaker software
1986 • Apple Desktop Publishing (DTP)
1986 • Canon colour laser photocopier
1987 • Apple: HyperCard
late 80s books on demand

1988 • Colour laserprinter

1989 • Voyager: expanded book format for floppydisk
1989 • Desktop Reprographics
1990 • Voyager: expanded books on CD-Rom

1985

1990

media chronofile

1991 • Sony: Data Discman
1991 • "Multimedia" PC
1991 • Virtuality: Arcade Virtual Reality
1991 • Empruve: Cornucopia multimedia DVI/CD-ROM computer
1991 • Apple / Motorola PowerPC consortium founded
1991-2 • World Wide Web

1992 • Microsoft: Multimedia Windows
1992 • Rediffusion: Personal entertainment simulators
1992 • Apple: Personal Digital Assistant announced
1992-96 • WWW browsers

1993 • Intel Pentium processor (60-66 MHz, 3.1m transistors)
1993 • digital mobile phones

1994 • (January 94: 1 million Web users)
1994 • Webvertising
1994 • Intel/Hewlett Packard agree to codevelop the 786 Merced chip
1994 • World Wide Web search engines

1995 • Pentium Pro
 (5.5m transistors/150-200 MHz)
1995 • Microsoft launch Windows 95
1995 • NeXT launch Web Objects
1995 • Webcasting
1995 • Sun Microsystems launch Java

telecommunications & computers

1991 • Commodore CDTV multimedia system launched
1991 • Philips CDI multimedia system launched in US
1992 • Philips CDI launched in UK
1993 • MPEG digital video standard

1994 • Digital satellite broadcasting
1994 • Sony DSP camcorders
1995 • Digital video camcorders
1995 • PC-TVs

television & video

1994 • Multimedia enhanced CDs
1994 • Web sites for bands and record labels
1994 • Floppydisk promotional mailers
1994 • Livecam: video on the Web

1991 • Sony: Minidisc
1992 • Philips Digital Compact Cassette (DCC)

radio & records

1995 • Digital audio broadcasting
1995 • Concerts on the Web

1991 • James Cameron: *Terminator2*
1992 • Kodak: Photo CD

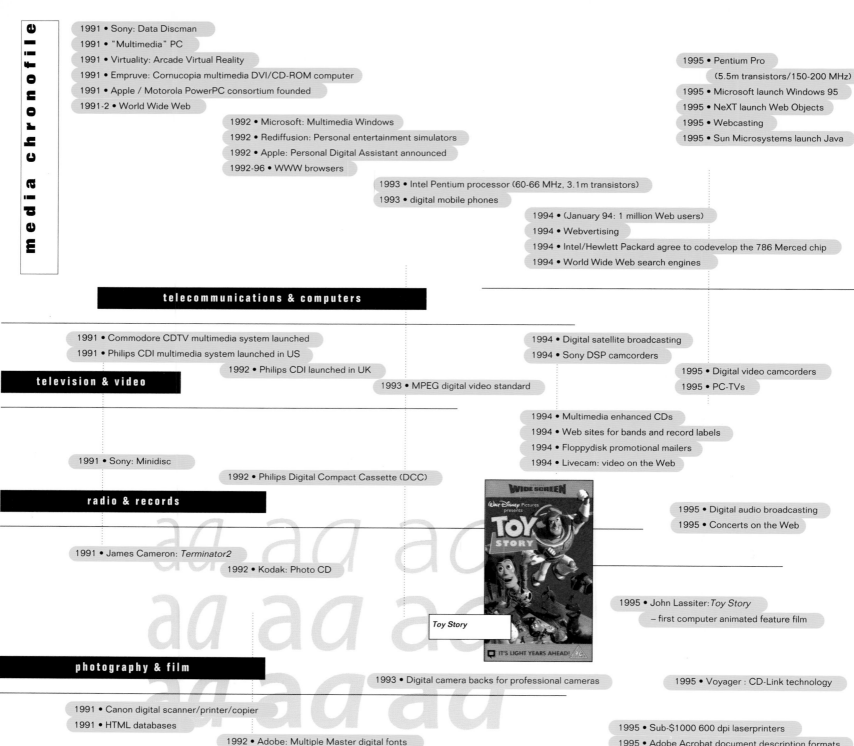

Toy Story

1995 • John Lassiter: *Toy Story*
 – first computer animated feature film

photography & film

1993 • Digital camera backs for professional cameras

1995 • Voyager : CD-Link technology

1991 • Canon digital scanner/printer/copier
1991 • HTML databases
1992 • Adobe: Multiple Master digital fonts
1993 • Sub-$500 300dpi colour inkjet printers
1993 • Web publishing: great texts on the Web

1995 • Sub-$1000 600 dpi laserprinters
1995 • Adobe Acrobat document description formats

print & publishing

1991

1993

1995

2000 • microprocessors expected to have 50million transistors and run at 500 MHz

1996 • Nintendo 64 – first 64-bit games console

1996-97 • DVD and DVD-ROM

1996 • Exponential Technology announce X704: a PowerPC-compatible chip capable of speeds of 533MHz costing $1000

1996 • PDAs with built-in phones

1996 • Apple buy NeXT and plan to implement NeXT Openstep OS for the Mac (instead of the planned system 8 Copland OS)

telecommunications & computers

1996 • Satellite VBI digital data transmission

1996 • Set-top boxes

1996 • TV/Web modems

1996-97 • DVD MPEG 2 digital video disk

1997 • DVD & DVDROM: digital video disc standards

radio & records

1998 • British Interactive Broadcasting launch

television & video

photography & film

1996 • DVC: Panasonic prosumer digital video standards for camcorders

1996 • DV-CAM: Sony digital video standard for camcorders

1996 • Low-cost consumer digital cameras

print & publishing

1996 • 30 million Web users

1996 • Dye diffusion thermal transfer (photo-printer)

1997 • 120 million Web users, 1 million Web sites

As the technologies for creating, distributing and experiencing media of all kinds move increasingly into the digital realm, our traditional media categories begin to blur and break down as distinctive entities. At the same time new media forms, such as hypermedia, begin to emerge and develop a distinct identity of their own.

media chronofile

Artists have been crucial to the exploration of the language of the new media technologies since the American painter Samuel Morse devised the electric telegraph and the code named after him. Throughout the 19th century, science and technology forced the pace of change in art, with photography, optical theory, electric light, X-ray photography, the cinematograph, colour photography, line block, halftone; as soon as new media technologies emerged, artists and designers seized upon the opportunities they afforded to experiment with ever more adventurous art forms.

At any time of rapid technological and social change, the nature of the *Zeitgeist* is apprehended most readily by artists, who often succeed in inventing a new form, or combination of forms, with which to express their insight. The most famous example of this "parallelism" between science and art (cited by John Berger in *The Success and Failure of Picasso*) is Cubism. For several years (between 1907 and 1914), Picasso, Braque and the other Cubist painters

explored a new kind of painting that broke with vanishing point perspective and the singular view of the world that this implied. Their new vision was multifaceted. Berger, Bronowski and others have noted the similarities between Cubism and the "phase shift" in physics signalled by Plank and Einstein between 1900 and 1905: a shift away from the Newtonian single, universal frame of reference towards a new conception of space–time as relative to the observer.

Berger does not suggest that the Cubists understood, or even knew about, the new physics. But they did develop a response to the spirit of the age as they perceived it, a response that was an expressive counterpoint to these revolutionary shifts of thinking in the sciences.

Although it has taken some time to emerge, it seems that a similar parallelism is developing in the last decade of the twentieth century. In hypermedia artists and designers are creating a new art and communications medium that perfectly expresses the non-linear "field" nature of electronic technology. As Marshall McLuhan pointed out in 1963 in *Understanding Media*, the instant communication offered by electronic media leads to fragmentation. Sequence is replaced by montage. As it emerged from the convergence of the two

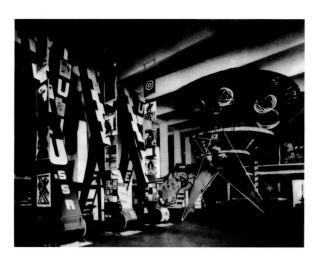

El Lissitsky: exhibition design for *Pressa*, 1928

One of the most influential Modernist designers, Lissitsky understood the transformations in media heralded by electricity. In the 20s he described the possibility of electronic books, and his exhibition designs demonstrate the multimedia approach to problem solving that is a recurring theme in 20th-century design.

Laurie Anderson

Performance artist Laurie Anderson is remarkable for her enthusiastic engagement with themes of science and technology, and her exploration of the multimedia possibilities of the new media technologies. The Voyager Web site lists her current projects: http://www.voyagerco.com.

Dada Typography

In their typographic experiments, the Dadaists and Futurists explored the presentation of information in "non-linear" formats, using montage and the juxtaposition of type and image.

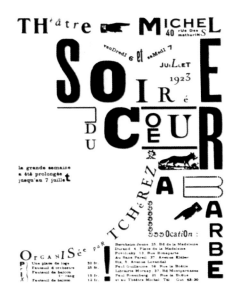

vertical text: multimedia arts

24

Peter Phillips: *Select-o-mat Variation no.13*

In his Selectomat series, Peter Phillips provided a collection of imagery and encouraged his clients to choose the images they wanted for their own customized painting. This method, derived from the technique of customizing cars popular in the US in the 50s, prefigures an important aspect of hypermedia programmes.

dominant electronic technologies, television and computing, hypermedia is indeed designed to be fragmented. Blake's poetic vision of perceiving the universe in a grain of sand is given concrete expression in hypermedia. Whatever the starting point, it is possible to end up exploring the universe.

Fragmentation and synaesthesia have been two recurrent themes in Modernism. From Wagner's Gesamptkunstwerk, Whistler's *Nocturnes* and Kandinsky's correspondences between colour and music, to the Futurists' Art of Noise, to Dadaist Anti-Lectures and Cabaret, to the layering of media in Bolshevik Agitprop propaganda, to *Finnegans Wake*, to Vertov's *Man with a Movie Camera*, to the explorations of Oscar Schlemmer and László Moholy-Nagy at the Bauhaus, and on through the work of John Cage, through the

light/sound shows of USCO, Warhol and Expo 67, through the work of Nam June Paik, Stan Van der Beek, the Whitney brothers and the other artists featured in Jascia Reichardt's seminal Cybernetic Serendipity exhibition at London's Institute of Contemporary Art in 1968, through "happenings", and the performance art of Laurie Anderson, artists have given expression to the "invisible revolution" that is occurring as our senses reorientate to accommodate media that are instant, global and multi-sensory.

Sergei Eisenstein: diagram from *The Film Sense*

Eisenstein's meticulous working diagrams show the correlation between image, camera movement, music and script, and anticipate many of the issues faced by the hypermedia programme director. *The Film Sense* includes Eisenstein's theory of montage.

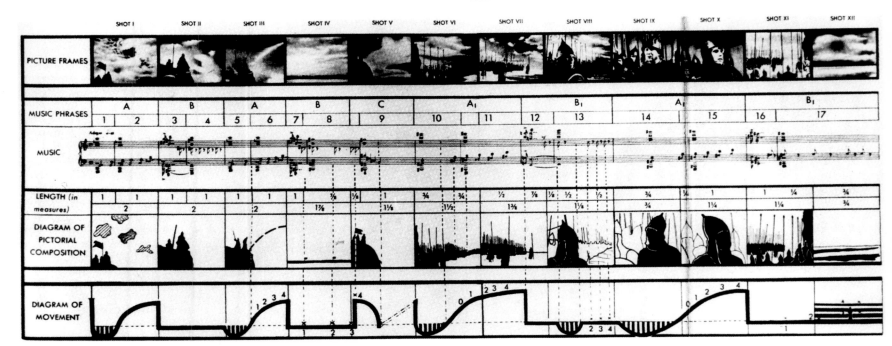

Greenfield & Rollestone: Urban Feedback

Sophie Greenfield and Giles Rollestone's recreation of the urban experience – fusing together fragments of media, ranging from scanned radio to Super8 film – forms a digital collage. Using sound, image and text, they construct a set of free-form, dreamlike, exploratory "spaces" based on London and Amsterdam.

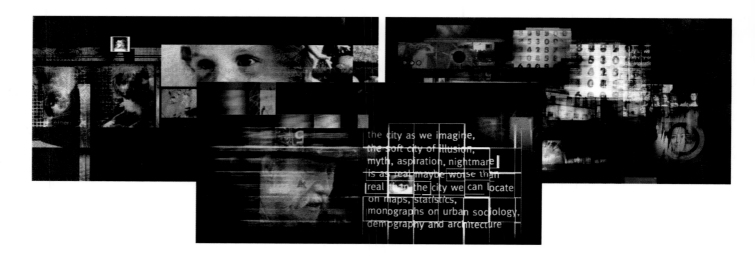

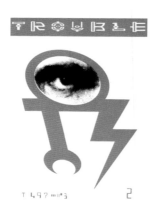

David Crow: Trouble

David Crow's "magazine" takes a variety of forms, from a T-shirt to scratchcards, which explore and subvert a range of cultural, political and commercial issues. A quotation from Trouble illuminates aspects of Crow's working method: "Displacement of everyday objects undermines their accepted meanings and enlarges our experience of them."

Maxine Gregson & Rory Hamilton: Cognitive Overhead

A collage of video and elements from a Macintosh desktop.

Tom Phillips: page from A Humument

In his method of superimposing alternative readings within an established text, Tom Phillips suggests the linking mechanisms of hypertext, and the different perspectives available to the users of hypermedia systems.

Jake Tilson: The Cooker

Jake Tilson's Web site features work created specifically for the medium, and also information about his other multimedia work in video, sound, print and exhibitions.

http://www.ruskin–sch.ox.ac .uk/~jake/thecooker/

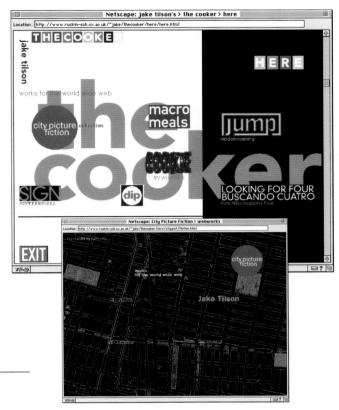

Peter Gabriel: Eve
Real World Studios

This is an elegant display of how well the current technologies of multimedia and software engineering can be combined into a technically and artistically seamless experience for the user. Delightful interactive sequences work alongside a brilliant use of still and motion images.

The Guerrilla Girls

This group of women artists and arts professionals produces posters, printed works and performance actions, using humour to expose and provoke discussion about sexism and racism in culture and the arts.

http://www.voyagerco.com/gg

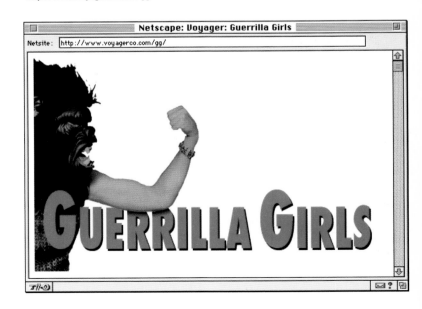

a brief history of hypermedia

"Media Chronofile" (pages 16 to 23) illustrated the convergence of media that has made hypermedia possible. This short overview takes up the story to describe some of the key events in the history of hypermedia itself. It is followed by a more detailed discussion of the contributions of some of the leading hypermedia innovators – from Vannevar Bush to Marc Andreeson.

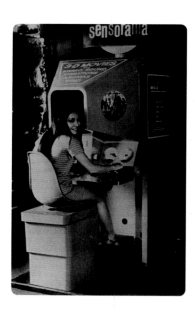

Morton Heilig: Sensorama

The first multi-sensory "virtual reality" engine invented back in the 50s, used film loops, stereo sound, smells, wind and other effects to create the illusion of motorbiking through downtown Brooklyn.

thirties

1938

Vannevar Bush and John H.Howard build and patent the Rapid Selector, a system for searching and retrieving documents stored on microfilm. Bush's practical work on this system were to lead to his more visionary ideas about how such a technology could be further developed.

forties

1945

Vannevar Bush publishes the article "As we may think", first in the *Atlantic Monthly*, later in an edited form in *Life* magazine. Among a number of visionary ideas, he proposes a hypothetical personal hypermedia workstation, based on microfilm technology, that he calls the Memex.

sixties

1960

Ted Nelson first develops the ideas that form the basis of his Xanadu project, a hypothetical, networked database linking the total sum of published human knowledge.

1962

Ivan Sutherland demonstrates Sketchpad, a drawing program that is the first real example of interactive computing using graphics, a window, icons and a GUI (Graphical User Interface).

Douglas Engelbart publishes *A Conceptual Framework for the Augmentation of Man's Intellect*, outlining his ideas about how the computer could amplify collective human intelligence.

1964

Douglas Engelbart and William English invent the mouse at Stanford Research Institute.

1965

Ted Nelson coins the words "hypertext" and "hypermedia".

1967

Andries van Dam, Ted Nelson and others at Brown University, Rhode Island, build the Hypertext Editing System. The first working hypertext system, it is later used to produce documentation for the Apollo space program at Houston Manned Spacecraft Center.

Alan Kay and Ed Cheadle at the University of Utah develop the FLEX "personal computer", a graphically orientated computer designed to be used by non-technical people.

1968

Engelbart demonstrates his NLS (oN Line System) system to several thousand people in San Francisco, showing the mouse, hypertext, screen regions, and interactive cooperative work with video, voice and shared screen.

Alan Kay develops the idea for the Dynabook, a networked, hypermedia portable computer, which will become the inspiration for his work at Xerox PARC.

1970

Xerox PARC, the Xerox Corporation's research and development centre, is founded in Palo Alto, California. Xerox PARC will become a centre where many of the technical innovations that form the basis of hypermedia are created.

1972

Ben Laws and Alan Kay develop the first font editor at Xerox PARC.

Alan Kay and Steve Purcell develop the first bitmap painting at Xerox PARC.

Alan Kay designs and Dan Ingalls implements the first Smalltalk interpreter at Xerox PARC.

1973

Chuck Thacker develops the ALTO workstation, at Xerox PARC, running Smalltalk as its operating system with a mouse and black-and-white bitmapped screen. This system became the inspiration for the GUIs (such as the Apple Mac interface or Microsoft Windows) that most us use today.

1974

Ted Nelson publishes his seminal book *Computer Lib/Dream Machines.*

1978

The Aspen Movie Map is demonstrated at the Massachusetts Institute of Technology (MIT). This is the first interactive hypermedia programme, using video, text and sound.

The original Apple Macintosh computer.

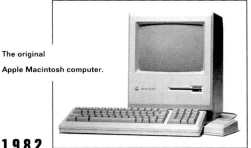

1982

Janet Walker begins work on the Symbolics Document Examiner, the first commercial system for reading hypertext documents. The system is created in an authoring package called Concordia, developed by the same team.

1984

Apple Macintosh, the first affordable multimedia personal computer, is launched.

Telos introduces Filevision, a hypermedia database for the Macintosh.

William Gibson coins the term "cyberspace" in his novel *Neuromancer.*

1985

The Symbolics Document Examiner hypertext system is released. An 8,000 page document, presented as a 10,000 node hyperdocument containing 23,000 links, it acts as an on-line manual for users of Symbolics Workstations.

Norman Meyrowitz and others at Brown University develop Intermedia, a hypermedia system running on A/UX (a Macintosh version of Unix).

1986

OWL introduces GUIDE, a hypermedia document browser for the Macintosh and later Windows, originally developed by Peter Brown of the University of Kent, UK.

1987

Apple Computer introduces Bill Atkinson's HyperCard, the first widely available personal hypermedia authoring system.

1989

Tim Berners-Lee proposes the World Wide Web project at CERN.

1991

Tim Berners-Lee's "WWW Program" released on to the Internet, launching the World Wide Web revolution.

1993

Marc Andreesen's graphical World Wide Web browser, Mosaic 1.0 for X Windows, is released in March by the National Center for Supercomputing Applications. Versions for the Macintosh and Microsoft Windows released in August.

1994

Netscape Communications Corporation is founded by Marc Andreesen and Jim Clark.

Netscape's Web browser Netscape Navigator is released, with Beta copies downloadable free on the Internet.

1995

Netscape Communications Corporation shares offered to the public in one of the most successful launches of a new company in the history of the stockmarket.

The hypermedia revolution begins.

Vannevar Bush

Associative links

The vision that brought about the genesis of hypermedia was elaborated by Vannevar Bush in an article entitled "As we may think", first published in the *Atlantic Monthly* in July 1945. (It was republished in an edited form later in the same year in *Life* magazine.) Bush was a remarkable man whose range of achievements and influence as an inventor, engineer, entrepreneur, businessman, administrator, academic, mentor, public servant and visionary still waits to be fully acknowledged today. During World War II Bush was scientific advisor to both presidents Roosevelt and Truman and coordinated the work of many thousands of scientists involved in defence-related research.

Bush's great insight, which arose, in part, from his work during the War, was that the rigid ways in which published knowledge were classified were becoming an obstacle to human progress. The sheer volume of material that was being generated by researchers, combined with an ever increasing specialization, meant that valuable knowledge was becoming concealed within the systems that held it. Bush contrasted the rigid, hierarchical systems for storing and retrieving information with the way human beings seem to think.

"The human mind does not work that way", claimed Bush in his article. "It operates by association. With one item in its grasp, it snaps instantly to the next that is suggested by the association of thoughts, in accordance with some intricate Web of trails carried by the cells of the brain ... trails that are not frequently followed are prone to fade, items are not fully permanent, memory is transitory. Yet the speed of action, the intricacy of trails, the detail of mental pictures, is awe-inspiring beyond all else in nature."

In "As we may think" Bush described a vision of a personal "memory extension" system, the "Memex", that would allow its user to build up and retrieve trails of association. These trails would link documents and the user's own notes and comments in a similar way to how he saw the human mind working, but in a more permanent form. The system would allow the operator to input text, drawings and notes through an early form of dry photocopier or through head-mounted stereo camera spectacles; to store this information in a microfiche filing system; to display several such microfilm files simultaneously, and to link related files together with a simple code. Bush envisaged a photographic (microfilm) data compression system; a method of exchanging information with other Memex users; the use of voice-transcription by means of voice recognition technologies; automatic character recognition, and much else that still has to be fully implemented in desktop hypermedia systems.

Vannevar Bush Bush was the first to realize the potential of storing items of information with built-in associative links to other data. He never actually built a real Memex, but the idea of such a system was a driving force in the development of hypermedia.

Bush envisaged Memex ("Memory Extension") in 1945 (three years before the transistor was invented, and 30 years before personal computers), and thought of it in terms of extrapolations from 1940s technology. Some 40 years later Apple launched HyperCard for the Mac; with a scanner, laserprinter and modem, a hypermedia system like Memex was finally created.

The Memex System: desktop hypermedia in 1945

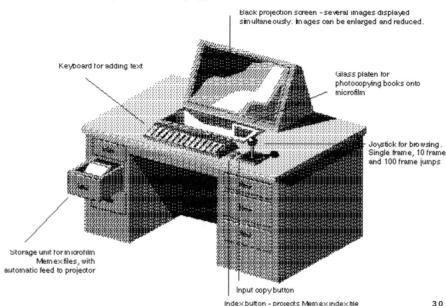

Back projection screen - several images displayed simultaneously. Images can be enlarged and reduced.

Keyboard for adding text

Glass platen for photocopying books onto microfilm

Joystick for browsing. Single frame, 10 frame and 100 frame jumps

Storage unit for microfilm Memex files, with automatic feed to projector

Input copy button

Index button - projects Memex index file

Bush defined the Memex system in terms of the photo-mechanical technologies available in the mid-40s, with his informed guess as to how these technologies could be extended and optimized. He also mentioned the possibilities of electromagnetic memory cards, and hinted at the potential of using television to provide network links between several Memex users.

In Memex, microfilm "files" are retrievable in three distinct ways: they can be called to the screen by means of a conventional index (which is itself a microfilm file that can be projected on demand); they can be displayed sequentially (using a "joystick" to control the frame rate), slowly for browsing, and fast for speedy location of an item; and most importantly they can be viewed by following the "trails of association" that the user or author has established by linking together one card with another. The resulting trails can be followed by other users and they too can make annotations, or create further links. With the Memex, Bush claimed, "Wholly new forms of encyclopedias will appear, ready-made with a mesh of associative trails running through them, ready to be dropped into the Memex and there amplified."

Bush continued to work on the idea of the Memex system for the next two decades. In some of his later thinking he incorporated the power of the digital computer into his concept, but in doing so lost the idea of the Memex as a multimedia system. His original concept of an interactive, desktop "hypermedia" system, while never fully implemented, in the end proved the most powerful. It continues to resonate to this day, inspiring, along the way, many of the individuals who were to make important contributions to the hypermedia revolution of the 90s.

Douglas Engelbart

Douglas Engelbart read Bush's article "As we may think" in *Life* magazine towards the end of the War, while he was still an army radar technician. Within 20 years or so, at his laboratory at the Stanford Institute, he had developed his own contributions to hypermedia: the mouse and windows, electronic mail and teleconferencing. All these components formed part of Engelbart's "Augmentation" project – a project that provided much of the framework for the development both of the personal computer and hypermedia. Engelbart conceived the idea of a computer-based system for the "augmentation of man's intellect" in the early 60s:

"Augmentation of the Human Intellect"

Douglas Engelbart Engelbart was a pioneer in office automation. During the 50s and 60s he invented the mouse, multiple-window screens and many other of the now familiar components of desktop computing and hypermedia.

When I first heard about computers, I understood from my radar experience during the War that if these machines can show you information on printouts, they could show that information on a screen. When I saw the connection between a television-like screen, an information processor, and a medium for representing symbols to a person it all tumbled together in about half an hour. I went home and sketched a system in which computers would draw symbols on the screen and I could steer through different information spaces with knobs and levers and look at words and data and graphics in different ways. I imagined ways you could expand it to a theatre-like environment where you could sit with colleagues and exchange information on many levels simultaneously. God! Think of how that would let you cut loose in solving problems!

By 1968 Engelbart had produced the NLS (oN Line System), which embodied features that were to become prototypes for all the hypermedia systems we have now. These features, ranging from the mouse, windows and electronic mail to word processing and hypertext, were all steps on the road towards an "Augmentation" system that would marry contributions from a human user (the ability to organize; a knowledge of procedures, customs, methods and language; and skills, knowledge and training) with a "tool system". This would include capabilities for communicating with other users,

or "travelling" through an information space, for viewing information in a variety of ways, and for the retrieval and processing of information in a number of different media.

Now in his seventies, Engelbart continues to promote his ideas for amplifying human intelligence through his Bootstrap Institute. Still a visionary, he is collaborating with Sun Microsystems and Netscape Communications to create an alliance of business, government and civic organizations that will act as a prototype for many of his ideas. The collaborators are using Netscape's Web technology and Sun's Java programming language to build a system that will enable its members to exchange ideas and knowledge over the Internet to augment their collective intelligence. After years of struggle, Engelbart's vision may, at last, become a practical reality.

Ted Nelson

Hypermedia

Ted Nelson coined the term "hypermedia" in 1965 in order to describe a new media form that utilized the power of the computer to store, retrieve and display information in the form of pictures, text, animations and sound. He had already used the prefix "hyper" to describe a system of non-sequential writing: "text that branches and allows choices to the reader". In "hypertext", textual material could be interlinked, providing a system which would break down traditional subject classifications and allow non-computer-literate users to follow their own lines of enquiry across the whole field of knowledge.

Echoing Vannevar Bush's comments on the Memex system, Nelson points out that the value of hypertext is that it more closely models the way

we think, allowing us to explore a subject area from many different perspectives until we find an approach that is useful for us. Using hypertext, authors would no longer have to write for a specific "average" reader. They could include any level of detail, and allow the reader to decide how deep into the subject matter they wanted to go.

In a series of seminal articles and books, including *Computer Lib/Dream Machines*, Nelson develops the idea of "fantics" (the "showmanship of ideas"), "thinkertoys" (computer systems for helping to visualize "complex alternatives"), and "super virtualities" (the conceptual space of hypermedia). These ideas encapsulate his vision of hypertext and hypermedia, and explore the nature of how these media could be used for both education and entertainment. Nelson has mapped out much of the theoretical territory that is now being explored by practising hypermedia designers, and has stressed the point that "learning to program has no more to do with designing interactive software than learning to touch-type has to do with writing poetry". Creating successful hypermedia, like making feature movies, depends on applying the arts of communication design to both the content and the structure of the programme.

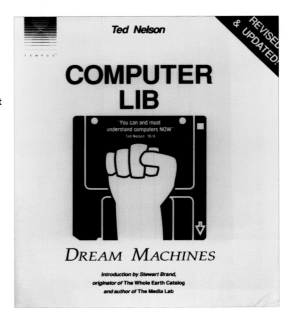

Ted Nelson: *Computer Lib/Dream Machines*, 1987

This is Nelson's "manifesto", mapping out the future of hypermedia in a collage of articles, features and sketches. Nelson thought it all through in the 60s and 70s, and this book is the best evidence of his vision.

Ted Nelson Nelson invented the term "hypermedia" and developed many innovative ideas for the application of hypertext (linked text). He has always championed the idea of hypermedia as two-way, read/write media, available to everyone.

Ted Nelson is now based in Japan, at the Sapporo HyperLab, a new design centre for electronic media for the Internet. There he works with Professor Yuzuru Tanaka, the inventor of the IntelligentPad software system, which has been described as "HyperCard on steroids". Together they plan to develop many of the ideas derived Nelson's Xanadu project, which he has been working on for more than half his life. A more complex system than the World Wide Web, the Xanadu system is intended to link together the sum total of the world's knowledge in text, pictures, video and sound, any element of which could be accessed, combined and recombined in a variety of ways by anyone, anywhere.

Often dismissed as a maverick and an eccentric, Nelson has undoubtedly made a major contribution to the development of hypermedia and may still make further important contributions in the future.

Alan Kay

the Dynabook In 1968 Alan Kay built a cardboard model of a portable hypermedia system which he called the "Dynabook". This prototype was designed to have a flat screen display, a graphical interface, and would be capable of handling large quantities of text. It would be a read/write medium for children, with an easy to use "development environment" called "Paintbrush" that children could use to create and animate pictures. Kay proposed that the Dynabook would link, by phone line and wireless, to other Dynabooks and to library resources. He wanted it to be produced for under $500, so that it could be made available to every schoolchild. Much of Kay's subsequent work at the Xerox Palo Alto Research Centre (PARC) was driven by the Dynabook vision. There his team developed

hypermedia innovators

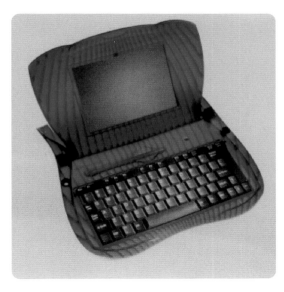

Apple eMate

This portable computer, designed specifically for school children is yet another step closer to Alan Kay's vision of the Dynabook.

software that allowed users to control a computer by means of a "graphical user interface" that included features such as windows, bitmapped screens, menus, icons and the mouse. These innovations were adapted by Apple for their Lisa and Macintosh computers and later adopted by Microsoft for their Windows graphical interface. There they also developed a new kind of object oriented programming language, Smalltalk, the precursor of many popular hypermedia authoring packages such as HyperCard, SuperCard and Macromedia Director.

Kay foresees the development of Dynabook-like computers as a culmination of the process that began with Gutenberg's invention of printing, progressed with the idea of the portable, printed book and went on to give us the modern paperback. Just as books went from desktop-sized with Gothic typefaces to pocket-sized and Roman (modern) faces, so the computer would become a personal and individualized information resource, as easy to use as reading a book. And just as the availability of mass-produced books helped create the individualism and personal perspective that spurred the Renaissance, so the "intimate computer" will – according to Kay – initiate profound social changes that will make a serious impact on the next century.

In an interview with *Byte* magazine in 1991 Kay expanded on this view:

If you tie interest in simulations together with pervasive networking and ask what impact that is going to have on a culture as a whole, I would say that it creates sceptical man. When you have something on your person at all times that is as innocuous as pencil and paper, that is continuously connected to the information utilities of our culture, and that you can use to

Alan Kay Kay's idea of the "Dynabook" (a portable, personal hypermedia computer) is a continual inspiration for the developers of portable, easy-to-use notepad computers that incorporate telecoms with hypermedia access to information sources.

play what-if games based on the information, there's going to be far less you have to take on faith. The retrieval systems of the future are not going to retrieve facts but points of view. The weakness of databases is that they let you retrieve facts, while the strength of our culture over the past several hundred years has been our ability to take on multiple points of view.

Alan Kay is now a Disney Fellow and the Vice President of Research and Development working within Walt Disney Imagineering. He is also continuing with his long-standing interest in using computer technology to create better learning environments for children and adults.

Kay is a key figure in the development of modern computing and the technologies that make hypermedia possible. More than that, the profound questions he continues to ask, and his insistence that computers should be used to improve the human capacity for learning, make him the focus of much of the continuing, thoughtful debate about the future development and direction of the medium.

Bill Atkinson

HyperCard

Bill Atkinson can be seen as the man who made computing a "right brain" activity. People who had claimed to be totally uninterested in computers fell under the spell of the Macintosh when they played with MacPaint. Being able to create pictures on a computer shifted the whole idea of what computers were for. Suddenly the secret that computers were creative, playful tools became visible to people whose background, education and assumptions about the world had concealed this from them.

MacPaint was not the first computer paint program. However, combined with an interface

hypermedia innovators

HyperCard
Many of today's leading hypermedia designers and developers learned their craft using HyperCard.

that appeared to have been designed by humans for humans and the cute little box that was the first Macintosh, it was almost certainly the first one to touch thousands of people's lives.

Bill Atkinson's influence on the Macintosh lay far deeper than MacPaint, however. Atkinson had worked on the Lisa, Apple's first (commercially unsuccessful) attempt to apply the ideas they had seen at Xerox PARC to a personal computer. His contribution to the Lisa was to invent the software that manages the arbitrary updating of regions of the screen. This enables the computer to handle overlapping windows, while allowing each window to be updated independently (a problem that the team at Xerox PARC had never been able to solve).

This software combined with some drawing routines became the basis of LisaDraw, the Lisa's drawing package. When Atkinson moved on to work on the Macintosh project this code became the basis of QuickDraw, the system software that lies at the heart of the Macintosh's success as a multimedia computer.

Bill Atkinson's work on QuickDraw and MacPaint would have ensured him a minor place in any history of hypermedia, but his next big project put him right up with the key figures in the development of the medium. The introduction of HyperCard in 1986 was a major step in the hypermedia revolution. Again, HyperCard was not the first hypermedia authoring packaging, but because it was bundled with every Macintosh, it was the first one that became easily available to a mass market and rapidly became an invaluable tool for every multimedia developer worldwide. Like many significant innovations, HyperCard was poorly understood when it first appeared. Many reviews dwelt on its apparent shortcomings in

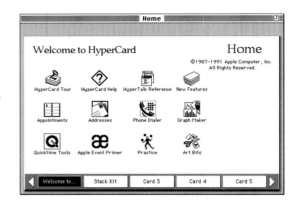

comparison with other computer programs. It was said that it was not a very good database, programming language, paint program and so on. This set of criticisms totally missed the point. What HyperCard did was to act as an easy-to-use hypermedia construction kit. One of the great strengths of HyperCard was that it allowed people

Bill Atkinson The brilliant software designer who developed the "oh-so-easy-to-use" MacPaint for the first Macintosh computer (1984), and followed up in 1987 with Apple's HyperCard, the first popularly accessible hypermedia toolkit.

with very little knowledge of programming to create their own applications by copying and pasting elements from other applications. With HyperCard, everything from images, text and sounds, to the programming code that makes things happen, can be re-used or modified to create new applications.

But despite this ease of use, HyperCard never had the democratizing effect of encouraging ordinary computer-users to create their own hypermedia applications as Atkinson and others had hoped. Perhaps this was because of the domination of the IBM-compatible PC that made Macintosh ownership a relatively expensive minority occupation. Perhaps it was the way that Apple handled its marketing and promotion. Or perhaps it was simply too far ahead of its time. Whatever the reason, HyperCard remains a landmark in the history of hypermedia and the launchpad for the careers of many of the early hypermedia designers.

Bill Atkinson is now with General Magic, a company he founded with a number of colleagues from Apple. General Magic was set up in 1990 to develop the software that would be the basis for "personal intelligent communicators". These are intended to be small, easy-to-use devices that combine many of the features of personal organizers, telephones and computers. His work at General Magic can be seen as a natural extension of his earlier achievements of moving the computer away from being a technical tool for specialists into being a general purpose communications medium designed to be used by everyone.

<div style="writing-mode: vertical">hypermedia innovators</div>

the World Wide Web

In the summer of 1991 Tim Berners-Lee made the historic decision to make his "WWW Program", the basis for the World Wide Web, freely available for others to use. He began by placing it on the Internet so that it could be downloaded by members of the three Internet communities he thought would be interested. The first was the high energy physics community, because the software had originally been developed for them to access and exchange information. The second was the hypertext community, because it was a hypertext system. The third was the NeXT community, because he had originally developed the software on a NeXT computer. From those three starting points the World Wide Web began to grow, at first barely noticed, but building in momentum until some four years later it was recognized as a communications revolution.

The explosion of interest in the World Wide Web would have been very hard to predict when Berners-Lee was first working on the project at CERN (the European High Energy Physics Centre). It began as an endeavour to help people at CERN access and exchange information. Berners-Lee explains:

> I was trying to coordinate many people in many different labs, all working together on distributed processing projects. CERN is a fairly anarchic environment – a bunch of physicists, all working for different institutes. And I found that a lot of the management was communication, just sharing knowledge, keeping up-to-date your common view of what's going on. So the idea was that it should be interactive, and it had to be hypertext, because when you're working in the real world, you find connections all over the place.

Tim Berners-Lee and his colleague Robert Cailliau first put forward a proposal to develop this idea for internal use at CERN in November 1990. Their proposal was for a client/server hypertext system. A server is a computer that has

Tim Berners-Lee It was Berners-Lee's World Wide Web that formed the catalyst for the hypermedia revolution and led to an astonishingly rapid international adoption of hypermedia.

been set up to store software and documents that can be accessed by other computers, called clients. The significance of their idea was that by basing their system on Internet technology and defining standards for data – not hardware or software – different kinds of computers could communicate with one another.

The key to their innovation can be expressed in three acronyms: URL, HTTP and HTML. An URL (Uniform Resource Locator) is the means of giving any document on the Web a unique address that can be accessed from anywhere in the world. HTTP (HyperText Transfer Protocol) is the set of communications software standards that enable different kinds of computer to communicate with one another over the Web. HTML (HyperText Markup Language) is the programming language that specifies how a document will appear when it is viewed on a browser running on a client computer.

Berners-Lee is now working at the Massachusetts Institute of Technology (MIT) for the World Wide Web Consortium, an independent body set up to coordinate the development of software and software standards on the World Wide Web. His vision for the World Wide Web is true to its origins:

> I had (and still have) a dream that the Web could be less of a television channel and more of an interactive sea of shared knowledge. I imagine it immersing us as a warm, friendly environment made of the things we and our friends have seen, heard, believe or have figured out. I would like it to bring our friends and colleagues closer, in that by working on this knowledge together we can come to better understandings. If misunderstandings are the cause of many of the world's woes, then can we not work them out in cyberspace. And, having worked them out, we leave for those who follow a trail of our reasoning and assumptions for them to adopt, or correct.

While it is dangerous to ascribe any revolution to the work of one person, the fact remains that it was Tim Berners-Lee who conceived the World Wide Web and it was his decision to make it available for anyone to use. Just as we now call the print revolution that helped transform our world the Guttenberg revolution, future generations may call our current one the Berners-Lee revolution.

Marc Andreesen Andreesen's graphical World Wide Web browser, Mosaic, was the application that launched the hypermedia revolution by making the medium cheaply accessible to millions worldwide. He subsequently founded the Netscape Corporation, whose range of Internet software has helped to establish hypermedia as a medium with radical implications for all aspects of life into the new millennium.

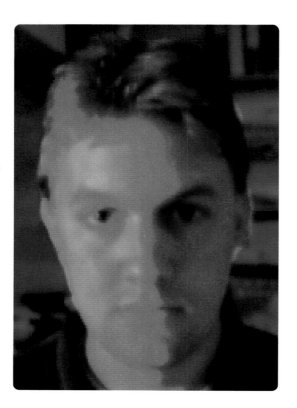

Marc Andreesen

Mosaic If Tim Berners-Lee created the spark that exploded into the hypermedia revolution, it was Marc Andreesen who fanned the flames. It was the browser NCSA Mosaic he developed with colleagues at the National Center for Supercomputing Applications at the University of Illinois that gave the World Wide Web the popularity it enjoys today. What made Mosaic unique was that it was a graphical browser that could display both text and pictures in a visually appealing way. Its other immediate attractions are that it enables users to move easily around the Web by a mouse click on signalled links in documents, and lets them save the URLs of interesting sites or documents in a "hotlist".

Marc Andreesen and a colleague, Eric Bina, conceived the idea of developing a graphic browser for the Web in November 1992. They began by working on a browser for Unix workstations that used a front end called X Windows. Andreesen dealt with the networking aspects of the browser and Bina handled implementing it to run under X Windows. Both thought the other had the more difficult task. They began coding in December 1992, and by 23 January 1993 they had released their first demonstration version, which was welcomed enthusiastically by Tim Berners-Lee. In March they released version Beta 1.0 for X Windows. Versions of Mosaic for the Apple Macintosh and Microsoft Windows were released in August of the same year. Their colleagues assisted: Aleks Totic did the work for the Macintosh and Jon Mittelhauser and Chris Wilson for Microsoft Windows on the PC.

At the end of 1994 Andreesen left NCSA, intending to do no further work on Mosaic. But some months later he was approached by Jim Clark, one of the founders of Silicon Graphics, who had been very impressed by Mosaic and its potential. They agreed to start a company to develop his ideas commercially. They recruited some of the key members of the Mosaic team from NCSA and set up the Mosaic Communications Company, later renamed the Netscape Communications Corporation.

The team very quickly brought out Netscape Navigator which, like Mosaic, they freely distributed over the Internet. Netscape Navigator was a completely redesigned version of Mosaic and much faster than its predecessor, so it rapidly became the preferred browser of most users.

On 9 August 1995 Netscape placed some of its shares on the stockmarket at $20 each. The price rose rapidly to $87 a share, valuing the company as a whole at some $7 billion. Subsequently the share price dropped, but in 1997 the company was still valued at several billion dollars.

Marc Andreesen may not be as much of a visionary as the other hypermedia innovators, but his importance in the development of hypermedia should not be underestimated. The success of Mosaic in attracting both users and providers of information to the Web would have been sufficient to guarantee him an important role in its history. In the long term, his role in founding Netscape may be even more significant. Its rapid appearance as a multi-billion dollar corporation marks a point where hypermedia moved from being an interesting curiosity to a medium whose implications were being taken very seriously by decision makers at the highest level in government, industry and business.

Web browsers

Andreesen's Mosaic has been further developed at the NSCA, University of Illinois, where it is still available for downloading over the Internet. However, later Web browsers, such as Netscape Navigator and its rival Microsoft's Internet Explorer, rapidly overtook it in popularity.

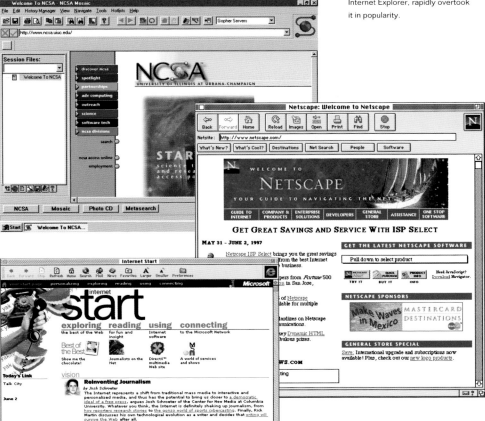

The Marshall McLuhan Center on Global Communications

A valuable source of information on McLuhan's thinking and work.

The development of hypermedia and its rapid emergence at this time can be seen as part of a much wider phenomenon. As we move into the 21st-century an ever-increasing number of human activities are migrating from a world of tangible physical objects into a world of messages and symbols. One reading of the "Media Chronofile" (pp 16–23) is as a description of this process, beginning with the very abstract dots and dashes of telegraphy in the early 19th century and moving forward to the hypermedia-mediated environments we see developing today.

Although this new world is entirely a human creation, it is also a mysterious place we do not fully comprehend. It is a space where many of the obstacles of time and distance have been abolished and which, while it directly affects our more familiar material world, seems to operate with a different set of rules. This is the place where hypermedia is most rapidly evolving, and where it is likely to have the greatest impact on our everyday lives.

Many thinkers and visionaries have begun the process of mapping out the implications and potential of this new sphere of human action and perception, which even in its most primitive form

has only existed for about three generations. It has been called by different names at different times. Pierre Teilhard de Chardin, the Jesuit priest and palaeontologist, described it as the final phase of evolution, the "noosphere", a membrane of thought encircling the world. Marshall McLuhan, the Canadian literary critic and 60s media guru, called it "the global village", in which he said in his *Gutenberg Galaxy*, "thanks to the prodigious biological event represented by the discovery

Marshall McLuhan: *Understanding Media*, 1964

McLuhan was the first to realise that electronic media would create a "global village", simultaneously shrinking the world down to village size while extending our central nervous system to give us electronic "eyes" and "ears" wherever the TV camera, radio microphone or satellite imager is used.

of electromagnetic waves, each individual finds himself henceforth (actively and passively) simultaneously present, over land and sea, in every corner of the earth".

The name for this space which finally seems to have stuck is "cyberspace", a word coined by William Gibson in his novel *Neuromancer*, first published in 1984. Using the device of the soundtrack of a children's television programme overheard by one of his characters, he described cyberspace in this key passage in the following terms:

'The matrix has its roots in primitive arcade games', said the voice over, 'in early graphic programs and military experimentation with cranial jacks.' On the Sony, a two-dimensional space war faded behind a forest of mathematically generated ferns, demonstrating the spacial possibilities of logarithmic spirals; cold blue military footage burned through, lab animals wired into test systems, helmets feeding into fire control circuits of tanks and war planes. Cyberspace. A consensual hallucination experienced daily by billions of legitimate operators, in every nation, by children being taught mathematical concepts … A graphic representation of data abstracted from the banks of every computer in the human system. Unthinkable complexity. Lines of light ranged in the nonspace of the mind, clusters and constellations of data. Like city lights, receding…

idoru, a novel by William Gibson.
Completed February 5th, 1996.
Publication Dates: US-September
1996 - Putnam Berkley, UK -
October 1996 - Viking Penguin

William Gibson: *Idoru* **Web site**

Gibson continues his exploration
of the implications of cyberspace
technology in his later novels such
as *Idoru*. His picture of an
underclass struggling to survive in
a hi-tech world dominated by big
corporations is also reflected in
other cyberpunk work, such as the
Manga movie, *Akira*. His strong
women characters may even have
influenced characters in computer
games, such as Lara Croft in Core
Design's Tomb Raider, for the Sony
Playstation (featured on the cover
of the magazine *The Face*).

Gibson's seminal trilogy, *Neuromancer, Count Zero* and *Mona Lisa Overdrive* were all set in the far distant future, but as he remarked in a recent interview, "My writing allows readers to see how weird the present is. We need to be insulated from the terrifying surreality of contemporary life just to get by. A science fiction book makes our hair stand on end because we see that it describes the way things already are."

Douglas Rushkoff in his book *Children of Chaos: Surviving the End of the World as We Know it,* echoes this sentiment. "Well, welcome to the twenty-first century. We are all immigrants to a new territory. Our world is changing so rapidly that we can hardly track the differences, much less cope with them. Whether it's call-waiting,

William Gibson: *Neuromancer*, 1984

In this seminal "cyberpunk" novel, Gibson elaborates his idea of "cyberspace" as a global media/telecommunications network.

Richard Buckminster Fuller: *I Seem to Be a Verb*, 1970

Fuller was an architect, engineer, poet and philosopher with engaging insights into the condition of the arts and sciences in the late 20th century. This book is designed in a very "multimedia" style, with graphics, typography, quotes, new articles, images and content acting together to present a montage of his ideas. Like many hypermedia programmes, this book has no beginning or end – it can be read back to front and upside down, since the page layouts work in both orientations.

MTV, digital cash, or fuzzy logic, we are bombarded every day with an increasing number of words, devices, ideas and events we do not understand … Without having migrated an inch, we have, nonetheless, travelled further than any generation in history."

Rushkoff's strategy for dealing with the strange new world we have created is to look to our children and to learn from them. As he points out it is invariably the children of immigrants who first learn the language, customs and culture of a new country.

The voice of a very young Web site designer describing her feelings about what the Internet means to her, gives us some sense of how people experience this new human space:

… this space we live in online is to me a whole other planet than the physical and physically flawed world we live on, with its artificial boundaries and distance b/w souls. w/o the net would I ever have found my place? I think the struggle would have been longer and harder.

The freedom I find here, to express myself in a thousand ways, to gain knowledge that would

be difficult to find, to ask questions and be answered by kindred and non-kindred spirits alike, this freedom I value is unmatched in the physical world. There is no nation on this planet that wouldn't fear and take action against something or other they find threatening to their status quo.

I prefer to live here.

John Perry Barlow, Grateful Dead lyricist, rancher, and founder member of the Electronic Frontier Foundation, responded to one such perceived threat by issuing his "A Cyberspace

Independence Declaration". He had been so incensed by President Clinton signing in to law the Telecom Reform Act, which among other things sought to control what could be said on the Internet, that on Friday 9 February 1996, the day after the signing, he sent an e-mail message to a number of his friends and colleagues that began:

> Governments of the Industrial World, you weary giants of flesh and steel, I come from Cyberspace, the new home of Mind. On behalf of the future, I ask you of the past to leave us alone. You are not welcome among us. You have no sovereignty where we gather. We have no elected government, nor are we likely to have one, so I address you with no greater authority than that with which liberty

Children of Chaos

Douglas Rushkoff holds the optimistic view that the adoption of new media is creating a new generation of "screenagers", who are more open-minded and flexible than their more "programmable" parents.

But Barlow's, and our very young web site designer's, vision of cyberspace, while romantically attractive, is only one among a number of others. There is Vice President Al Gore's vision of the Information Superhighway. There is the vision of some commercial interests of cyberspace becoming one gigantic, digital

itself always speaks. I declare the global social space we are building to be naturally independent of the tyrannies you seek to impose on us.

Within hours of him sending this message thousands of people all over the world had received it, the message being passed on friend to friend, included in mailing list after mailing list. If nothing else Barlow's Declaration of Independence was a demonstration of the power of the Internet to disseminate ideas very widely and very quickly.

shopping mall. There are those who see it becoming a vast conduit for thousands of entertainment channels, supported by subscription and advertising. There are some, like Michael Benedikt, who see it as a place where businesses will become more real than they are in the material world:

> In cyberspace, information-intensive institutions and businesses have a form, identity, and working reality – in a word and quite literally, an architecture – that is a counterpart and different to the form, identity, and working reality they have in the physical world. The ordinary physical

reality of these institutions, businesses, etc, are seen as surface phenomena, as husks, their true energy coursing in architectures unseen except in cyberspace.

Others, such as William Gibson, remind us that cyberspace is not quite as new and wild as some of us may think:

> Cyberspace is a metaphor that allows us to grasp this place where since about the time of the Second World War we've increasingly done so many of the things that we think of as civilization. Cyberspace is where we do

our banking, it's actually where the bank keeps your money these days because it's all direct electronic transfer. It's where the stock market actually takes place, it doesn't occur so much any more on the floor of the exchange but in the electronic communication between the world's stock exchanges.

Up until very recently, cyberspace was largely comprised of streams of data, voices on the telephone, and the unadorned text of the e-mail and computer conference, where imagination had to supply the sensual elements of the material world that made such stuff meaningful. The coming of hypermedia clothes this world of pure information with a richer sensory mix. This will undoubtably accelerate the process of creating a virtual world, where we will spend increasing amounts of time working, playing and conducting many of the other human exchanges and interactions that currently take place in the material world. The shape and texture of this virtual world of cyberspace is still being determined and no single vision of how it will be is likely to be correct. What does seem certain is that it will be experientally richer and more diverse than than its earlier forms, and hypermedia will play a major role in making it so.

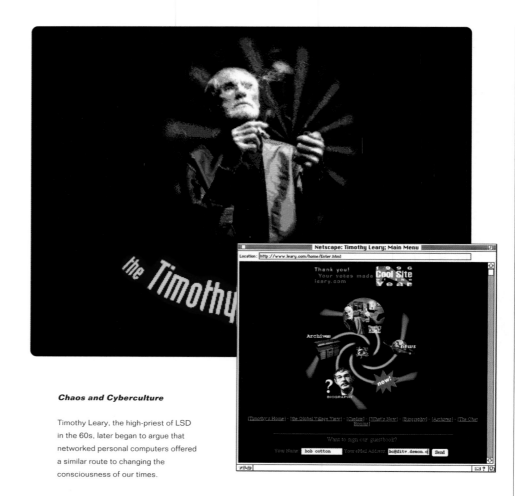

Chaos and Cyberculture

Timothy Leary, the high-priest of LSD in the 60s, later began to argue that networked personal computers offered a similar route to changing the consciousness of our times.

Silicon Snake Oil

Clifford Stoll provides a critique of all those people, including the authors, who believe that the new communication technologies and hypermedia offer a real opportunity to improve the human condition.

Secker & Warburg

The
VIRTUAL
COMMUNITY

Howard Rheingold
Author of *Virtual Reality*

Virtual Communities

Howard Rheingold's thorough exploration of the wide variety of "virtual communities" that have been established in cyberspace.

Out of Control

Kevin Kelly, editor of the influential *Wired* magazine, argues that we have entered a period when our machines are becoming more like self-organizing biological organisms rather than controllable mechanical devices. The anarchic Internet is one of the best examples of his thesis.

OUT OF CONTROL
THE NEW BIOLOGY OF MACHINES
'Shatters more paradigms per page than any other text this decade' BRUCE STERLING

For further ideas about cyberspace, see these Web sites:

William Gibson
http://www.idoru.com/

The Noosphere and Teilhard de Chardin
http://www.sun-angel.com/noosphere/info.html

Mark Weiser
http://www.ubiq.com/weiser.html

Richard Seltzer
http://www.samizdat.com/

Douglas Rushkoff's Stuff
http://www.levity.com/rushkoff/index10.html

The Marshall McLuhan Center on Global Communications http://www.mcluhanmedia.com

Buckminster Fuller Institute (BFI)
http://www.bfi.org/

Hakim Bey
http://www.hermetic.com/bey/

Gilles Deleuze and Felix Guattari
http://www.uta.edu/english/apt/d&g/d&gweb.html

Kevin Kelly
http://www.absolutvodka.com/kelly/8-0.html

Mark Pesce
http://www.hyperreal.com/~mpesce/

John Perry Barlow
http://www.eff.org/~barlow/barlow/library.html

Manuel De Landa
http://www.t0.or.at/delanda/

George Gilder
http://www.gildertech.com/

Kevin Kelly
http://www.absolutvodka.com/kelly/8-0.html

David Lochhead
http://www.interchg.ubc.ca/dml/tdws.html

Timothy Leary Home Page
http://www.leary.com/

Jaron Lanier's Homepage
http://www.well.com/user/jaron/index.html

Today's Readings for Cyberspace Society and Culture
http://umbc7.umbc.edu/~curnoles/readtoda.html

Cyberspace, Virtuality Reality, and Critical Theory
http://twine.stg.brown.edu/projects/hypertext/landow/cpace/theory/theoryov.html

The Hypermedia Research Centre
http://www.wmin.ac.uk/media/HRC/manifesto/hmm.1.html

CTheory
http://english-server.hss.cmu.edu/ctheory/ctheory.html

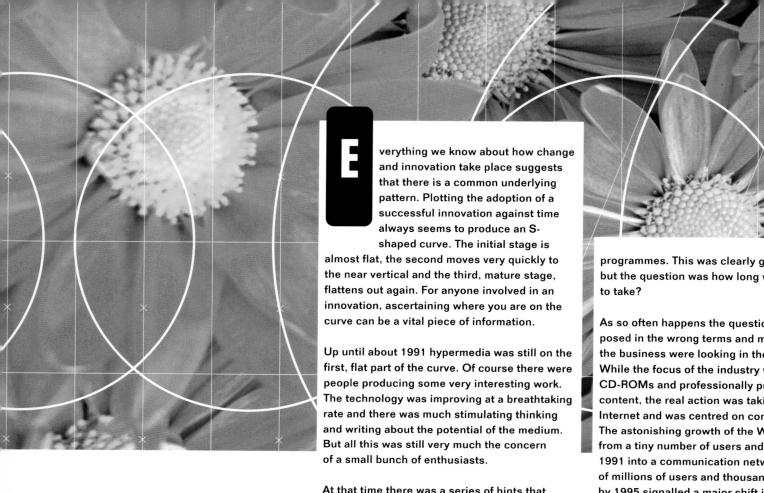

Everything we know about how change and innovation take place suggests that there is a common underlying pattern. Plotting the adoption of a successful innovation against time always seems to produce an S-shaped curve. The initial stage is almost flat, the second moves very quickly to the near vertical and the third, mature stage, flattens out again. For anyone involved in an innovation, ascertaining where you are on the curve can be a vital piece of information.

Up until about 1991 hypermedia was still on the first, flat part of the curve. Of course there were people producing some very interesting work. The technology was improving at a breathtaking rate and there was much stimulating thinking and writing about the potential of the medium. But all this was still very much the concern of a small bunch of enthusiasts.

At that time there was a series of hints that the curve was moving upwards, but most of us working in this area saw its development in terms of professionally produced and published disc-based hypermedia. While many of the tools and skills for producing interesting hypermedia programmes were there, the markets for those programmes were very small and the distribution channels virtually non-existent. The central problem was that there simply were not enough people who owned computers capable of playing and displaying disc-based hypermedia

programmes. This was clearly going to change, but the question was how long was it going to take?

As so often happens the question was being posed in the wrong terms and most people in the business were looking in the wrong place. While the focus of the industry was on CD-ROMs and professionally published content, the real action was taking place on the Internet and was centred on communication. The astonishing growth of the World Wide Web from a tiny number of users and Web sites in 1991 into a communication network consisting of millions of users and thousands of Web sites by 1995 signalled a major shift in the position of the medium.

Looking back we can now see that 1995 marked the point when hypermedia moved from the slow, flat part of the S curve of innovation and into the second phase of very rapid growth and development. While much of the focus of activity and interest has centred on the World Wide Web, 1995 was also significant for disc-based hypermedia. In that year, CD-ROM drives became a standard component in the majority

h y p e r m e d i a o n t h e S c u r v e

of new computers and games consoles. The large number of users of the World Wide Web and the growing number of computers with the capacity to store and play hypermedia programmes had removed one of the major obstacles holding back the growth of the medium.

We can now look forward to a period, of at least a decade, more probably two, when the number of users of hypermedia and the number of uses for it continues to expand at a heady rate. This period of expansion is likely to be even more turbulent and confusing than the earlier development. Technical, creative and business innovations will proliferate as an expanding market generates new opportunities for their adoption. But, equally, the possibilities of failure will multiply as competition intensifies and the pace of change accelerates.

As we enter this second, revolutionary, stage of the S curve, the likely pattern of development of the medium becomes much clearer. The details, of course, will be unpredictable and surprising, but much of the broad sketch outline has been drawn. In this section of the book we try to map out a general picture of where the medium is at now and how it is likely to develop in the immediate future. We begin by describing what makes hypermedia a radically new communications medium and then go on to examine what we see as its three main areas of activity: publishing, communicating and thinking.

2

hypermedia

the next media revolution

the next media revolution

The development of all major innovations follow the patterns of an S curve, and hypermedia is no exception to the general rule. Mapped against time, the first stage is always slow, the second period one of very rapid and frantic growth, and the third – mature – stage slows down again, with only incremental changes. No one can predict with certainty the precise timing of particular details of innovation of this kind, and the examples shown are "best guesses". What does seem certain is that hypermedia will follow the general pattern of the S curve, and that we entered the period of very rapid growth some time around 1995.

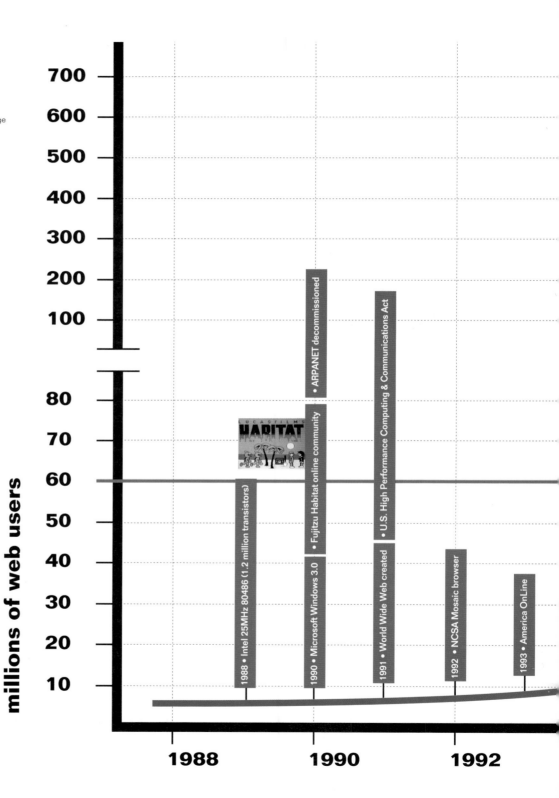

millions of web users

700

600

500

400

300

200

100

80

70

60

50

40

30

20

10

1988 • Intel 25MHz 80486 (1.2 million transistors)

1990 • Microsoft Windows 3.0

• Fujitzu Habitat online community

• ARPANET decommissioned

1991 • World Wide Web created

• U.S. High Performance Computing & Communications Act

1992 • NCSA Mosaic browser

1993 • America OnLine

1988 **1990** **1992**

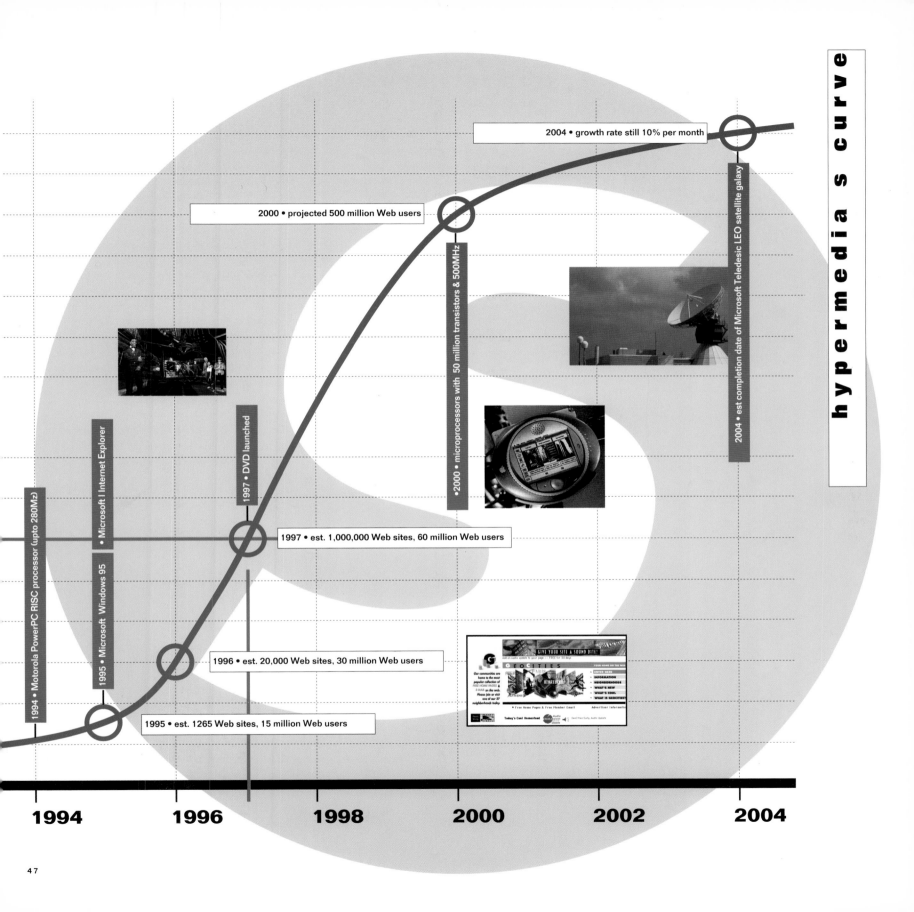

hypermedia s curve

2004 • growth rate still 10% per month

2000 • projected 500 million Web users

2004 • est completion date of Microsoft Teledesic LEO satellite galaxy

•2000 • microprocessors with 50 million transistors & 500MHz

1994 • Motorola PowerPC RISC processor (upto 280Mz)

• Microsoft I Internet Explorer

1997 • DVD launched

1995 • Microsoft Windows 95

1997 • est. 1,000,000 Web sites, 60 million Web users

1996 • est. 20,000 Web sites, 30 million Web users

1995 • est. 1265 Web sites, 15 million Web users

1994 1996 1998 2000 2002 2004

what makes hypermedia new ?

Shoshana Zuboff: *In the Age of the Smart Machine*, **1988**

A key text for anyone who wants to understand the impact of information technology on the world of work, Zuboff's book is, by implication, an argument for the development of hypermedia as the "human face" of IT.

There are five main reasons why hypermedia is a radically new communications medium. Firstly, it is a digital medium that can exploit all the opportunities offered by the powerful combination of computers and telecommunication technologies. Secondly, it is interactive, requiring active contributions from its users in order to function. Thirdly, it is non-linear with no beginning, middle or end. Fourthly, it employs multiple media that can be brought together in a variety of different combinations. And finally, the same technology that is used to experience the medium can be used to create it.

It is this combination of features that makes hypermedia a new medium unlike any other. Of course there are aspects of the medium that are similar to previous media. Many commentators have pointed out that books are often used in a random access, non-linear manner. Film,

television and video can use combinations of multiple media in different ways. And, as we have discussed in an earlier section, many of the ideas and concepts underlying hypermedia as a creative medium can be seen as extensions of the experiments of twentieth-century avant-garde arts. Nevertheless, while there are clearly links with earlier media, hypermedia is also moving out into uncharted territory where there are no obvious precedents or landmarks to guide us.

The explosive and surprising development of the World Wide Web served as more than a signal that hypermedia was moving into a period of very rapid development and innovation; it also marked a significant shift in the way people were thinking about the medium.

In the late 80s and early 90s the predominant model of the medium and its future was based on publishing. This was partially due to the influence of commercial interests. Many publishers saw the

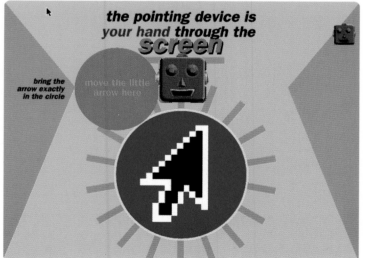

medium as an opportunity to repackage material that they already owned. Many computer and electronics companies saw the medium as an opportunity to sell new equipment which could play this repackaged product. However, commercial interests are only part of the explanation. Equally significant is what Marshall McLuhan called "looking at the future as though through a rear-view mirror". Most people involved in working in the medium were, as McLuhan would have predicted, seeing it in similar terms to "the horseless carriage" – only their version was "the electronic book" or "the interactive movie".

The advent of the World Wide Web was a powerful reminder and demonstration of an older and, curiously, more forward-looking tradition. While the idea of publishing did feature within that tradition, the idea of using hypermedia as a means of communication between people, rather than simply communicating to people, was much stronger. The coming of the Web reaffirmed the concept of hypermedia as a communication medium more like writing or the telephone rather than just a publishing medium like the book, or film or television.

The idea of the intranet (a private internal network within an organization or company, using Internet and Web technology), which grew out of the success of the World Wide Web, revived another part of that older tradition. Some organizations have been developing their intranets to promote the exchange of ideas and knowledge, or as Douglas Engelbart put it, "to augment the human intellect". In other words, they are attempting to use hypermedia to improve their collective thinking.

So as we enter the more dynamic and expansive phase of hypermedia development, we can see three main focuses of activity: publishing, communication and thinking. In the following pages we will discuss each of these in more

detail. But before we do so, it is worth reflecting on one further point.

Hypermedia is a product of information technology (IT) – which can crudely be defined as computers plus telecommunications. This technology has already radically transformed our world and will continue to do so for some time to come. Its use has meant that many things are done in new ways. Labour has been replaced. Work has often become more abstract. The world has become more connected. Decisions have to be made faster. The pace of change seems to be constantly accelerating. Patterns of work and living are changed and disrupted. While there are many clear benefits from our use of IT, there have also been human costs. Change can be painful.

Hypermedia may go some way in helping to mitigate some of the more negative aspects of the IT revolution by giving it a more human face and by helping us to communicate and think more effectively. But, the increasing use of hypermedia is also going to be disruptive. By enabling us to communicate and interact with one another in new ways, it will inevitably change many of our patterns of living, working and playing. Creating and learning how to use this new medium is an exciting prospect, but that excitement should be tempered by the hope that we can learn to use it wisely and well.

NoFrontiere:
Interactiveland

The main characteristics of hypermedia are interactivity, computer processing, multimedia and networking. Hypermedia is, first and foremost, about communication, fostering interaction and telematic "action at a distance", but it is also a vehicle for research and thinking, and a medium for publishing on a brand new, universally accessible, global publishing network.

It is not surprising that when hypermedia first became a practical reality it was seen mainly in terms of a publishing medium. It was a view that corresponded to how we had come to think of media. Hypermedia seemed to fit neatly into a succession of media forms, beginning with the book, then working through newspapers, magazines, gramophone records, film, radio, television and video. This view was reinforced by the fact that initially it was a disc-based medium, which made it seem similar to books, records and videos. However, hypermedia publishing has yet to demonstrate the same commercial success as those earlier media forms, and the question remains whether or not hypermedia is a natural publishing medium.

When HyperCard (the earliest widely available hypermedia authoring package) first appeared there was much excitement about the potential of "stackware", HyperCard publications distributed on floppy disks. The subsequent disappearance of stackware foreshadowed many similar disappointments that have followed in the development of hypermedia as a publishing medium. To date, no one has convincingly demonstrated the commercial viability of hypermedia publishing – either as a disc-based medium (such as CD-ROM) or on the World Wide Web. Individual CD-ROM titles may have been successful and possibly some of the Web sites offering "explicit adult material" may make a profit. But the general picture so far seems to be that the cost of designing and producing hypermedia products outweighs the revenue that they can generate.

There is, however, one very important instructive exception to this rule, namely computer games, which are now a multi-billion dollar global industry. Part of their success can be attributed to the fact that games consoles are significantly cheaper than their PC counterparts. However, this can only be a very partial explanation, because games such as "Doom" and "Myst",

which have been designed to be played on personal computers, have also enjoyed phenomenal success. Furthermore, some of the earlier CD-ROM-based systems, such as Philips' CD-i and Commodore's CDTV, were relatively inexpensive, but still failed to seize consumers' imagination and cash. A more likely explanation of their success is that right from the beginning computer games exploited all the potential that the current capabilities of consoles and computers had to offer and gave their users experiences they could find nowhere else.

Other hypermedia programmes, in contrast, have often been hampered by a misleading analogy. They have been seen in terms of "electronic books". Like books many of the early hypermedia programmes have consisted of mainly text and pictures, with some hypertextual links and perhaps some animation or video. Interactivity has often been limited to making a few clicks with a mouse to move from one section to another. Frequently there has been no compelling advantage over more traditional media.

There are numerous exceptions of course. Some of the titles for children are delightful and offer experiences that are quite distinct from either books or videos. Reference works, which offer the opportunity to move quickly and easily through their cross-references, can offer clear advantages over their printed counterparts. Online magazines that develop a dialogue with their users in a manner that traditional magazines cannot match suggest exciting new possibilities. Nevertheless, it still remains the case that while computer games have developed an identity and

Pointcast

Pointcast is a neat technological hybrid of electronic narrowcasting, Web site and screen saver, Pointcast uses "server-push" methods to provide customized news streams direct to the monitor screen. Provided you are online, Pointcast uses downtime on your computer to convert it into a "window" onto a live stream of news. Utilizing every inch of screen "real estate", Pointcast designers employ animated text, pictures and graphics to dramatize the delivery of electronic news.

Electronic Young Telegraph

The floppy disc-based EYT revamped comic club ideas from the 50s, presenting new material in a vivid, animated and interactive comic-strip style. It is full of good interactive multimedia editorial features, interviews, competitions, quizzes and games.

aesthetic of their own and celebrate their nature as a computer-based medium, most other consumer-orientated hypermedia programmes still look to older media for their identity.

Now that we have reached the second stage in hypermedia's development, many of the practical obstacles to making a success of publishing in this medium have been removed. The obstacles that remain are largely conceptual and creative. Books, magazines, newspapers, film, television, radio and video all have their own virtues and appeal. If hypermedia publishing is to compete commercially, it will have to offer a clear identity of its own and offer experiences that are distinctive from other media. This has begun to happen, but the need to focus more clearly on what hypermedia can offer in its own right, without reference to earlier media forms, looks as if it is a precondition for commercial success.

the next media revolution

This discussion began by posing the question of whether or not hypermedia is a natural publishing medium. In one sense it is not. In many other traditional publishing media, most strongly in books, but with echoes in the other media forms, there is a sense of them being definitive statements, once made fixed for all time. Hypermedia, on the other hand, tends to be experienced in a different way. It is more provisional, more open to modification and change, more firmly embedded in a "cut-and-paste" culture, where nothing is permanent and all is process. This, perhaps, is part of the success of computer games, which carry more of a sense of being a process rather than a product. If this perception is correct it may be that the long-term future of hypermedia publishing will be very unlike earlier media forms and much more a process of establishing an ongoing relationship with users, changing and developing over time.

Condé Nast

The home pages of the famous fashion and lifestyle publishers have sites devoted to each of their leading magazines, all produced to provide stylish electronic equivalents of their print counterparts. The daily Vogue site illustrates the fundamentally different approach of publishing through the World Wide Web: here the monthly printed magazine becomes a daily news event, and instead of local country versions, the fashion world is given a global context in a one-stop international editon.

NASA

In the "Information Age", any institutions
with information can become publishers.
NASA has more information than most,
and the NASA Web site reflects this, with
a vast extent of pages covering every
aspect of its activities, from satellite
imaging and space probes, to launch
hardware and 3D imaging.

Cisco

Cisco, makers of routers for the Internet, is
one of the fastest growing companies in the
USA. It has developed a very sophisticated
Web site which provides technical support
to customers.

uriously, even in the early days
when much attention was focused
on hypermedia as a publishing medium,
many of the more successful hypermedia
programmes fell more naturally into the
category of "communicating".
Applications such as kiosk-based
museum and gallery guides proved to be very
popular and accessible, even for people who were
normally frightened of computers. Indeed, kiosks
or point of information services seem to have
been one of the most successful applications of
disc-based hypermedia. There is a not dissimilar
story on the World Wide Web. There, one of the
few applications that has so far had quantifiable
success in commercial terms has been customer
support. One of the largest suppliers of Internet
equipment claims that, without its Web site
offering technical support to their customers, it
would not have been able to maintain its rate of
expansion. Finding enough people with sufficient
technical knowledge to run a conventional
telephone customer support system just would
not have been possible. Even if the company had
been able to find the staff the costs would have
been several times higher.

Communication now looks like the fastest
expanding and the largest of our three main areas
of activity. Communication through
hypermedia falls into three major areas.
The first is communication between
individuals. The second is communicating
within a company or organization.
The third is communication between
companies and their customers
or organizations and their clients.

Currently, one of the most popular
activities on the Internet has been
using e-mail. Up until now this has been
text-based, but now e-mail packages
are beginning to appear that enable
users to include sound, images,
animations, video and hypertext links
to Web sites as well as text. Multimedia
e-mail, combined with the growing
sophistication of tools to build personal
home pages, means that an ever

increasing number of people will find hypermedia communication part of everyday life. Probably, much of that produced will be, initially, the equivalent of much early DTP – a mishmash of effects that communicates very little (other than that they have the software that can do it). In the longer term, however, it will be fascinating to see what demotic forms of hypermedia emerge. It is highly likely that professional designers will be borrowing from the results, in the same sort of way that designers in other media already shamelessly raid street culture for their ideas.

Hypermedia communication within organizations using "intranets" is likely to be more constrained, with a stronger influence from professional designers. There we are likely to find more templates, style sheets and company guidelines influencing what is produced. However, there may be an initial period of design anarchy in some organizations, until the senior managers recognize that issues of corporate identity and branding apply as much (or more so) in cyberspace as in the world of paper, print and signage. But again, witnessing the effects of hypermedia communication in an organization and what it might do to its culture and behaviour will be extremely interesting. It could be that the people with influence and power within an organization that bases its internal communication on hypermedia could be very different from those with power and influence now.

Hypermedia communication with customers or clients will be still more constrained, and the influence of professional hypermedia design teams even greater. The old quip that "on the Internet, nobody knows you're a dog!" may apply more forcibly to companies than it does to individuals. In an increasing number of areas a company will be its Web site and the services or products it offers. Institutions such as banks are already aware of the dangers that a "Webcentric" world would present. Indeed, in the United States, a number of large banks have formed a consortium to develop their own software to communicate with their customers and for their customers to communicate with them, because they are so conscious that their brands and

identities are at risk as more and more people use third-party software to conduct their financial affairs.

As we have seen, communication is going to be and is already the fastest expanding and largest broad hypermedia application area. Much of the day-to-day use of hypermedia to communicate will be done by the same kind of people who now telephone, fax, and write letters, reports and memos as part of their working lives. As people begin using hypermedia to gossip, flirt, arrange their social lives, keep in touch with their families and friends and all the other informal uses they now use the telephone, fax, letters, notes and even e-mail to do, we can expect many demotic cultures of hypermedia communication to emerge. But hypermedia design teams have little to fear from an ever growing use of hypermedia as an everyday form of communication and much to welcome. The explosion in demand for the services of hypermedia design teams is likely to be unprecedented in terms of other designed media. The more familiar hypermedia becomes as a form of communication, the more companies and organizations will depend on the skills and creativity of their hypermedia design teams to maintain their position in the world.

BBC Resources Intranet Site:
Paul Mitchell & Mark Walters

This intranet site incorporates all the facilities and services that BBC Resources offers. Each service is represented by its own specific 3D icon, which animates on each master page. This branding and graphic vehicle is consistent throughout the site.

From the very earliest days, finding ways of helping people think more effectively and creatively has been one of the motivating factors behind much of the key work in developing hypermedia. Vannevar Bush developed his ideas about "Memex" as a more permanent means of recording the way he saw creative researchers working by making associative links between meaningful pieces of information. Douglas Engelbart has been concerned with "augmenting human intelligence" by developing methods of using computers in order to enable people to work and think together. Ted Nelson's long-running Xanadu project has had the ambitious aim of linking together the total sum of human knowledge expressed in all media so that it can be studied, compared, recombined and re-used. Tim Berners-Lee's motivation in developing the World Wide Web project was to create a system where knowledge could be exchanged, linked and improved by scientists working collaboratively.

Of all the three activities we have identified as being the main strands of hypermedia development, this is the most important one. It is also the hardest to achieve. There seem to be five major themes that are being explored. The first is finding ways of linking information and ideas into meaningful webs of connections. The second is by providing multi-sensory simulations so that thinkers can play "what if" games. The third is exploring the idea that by expressing ideas using multiple media we may be able to engage more

aspects of our minds in solving problems. The fourth is that by developing forms of "semantic compression" we may be able to reduce complex systems and problems to something manageable that we can handle and solve. The fifth is finding ways of working and thinking more effectively and creatively as a collaborative activity. Some progress has been made, but there is still much work to do, both technically and conceptually, before these various ambitions can be fully realised.

The World Wide Web and the mini-Webs that are being established within internal intranets provide us with some clues as to how information and

ideas could be linked into meaningful webs of connections. The problem there lies in the word meaningful. We know how to make links, what is more difficult is establishing the conventions, critical standards and methods of making links that make a positive contribution to our understanding and ability to solve problems.

Multi-sensory simulations are proving a more fruitful area of development. Already we have seen them used with some success in areas as various as pharmaceutical development, engineering, and investment strategy. As these techniques are extended to more areas of human activity, and we

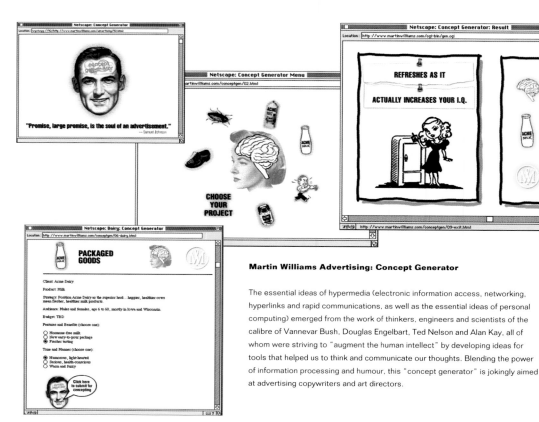

Martin Williams Advertising: Concept Generator

The essential ideas of hypermedia (electronic information access, networking, hyperlinks and rapid communications, as well as the essential ideas of personal computing) emerged from the work of thinkers, engineers and scientists of the calibre of Vannevar Bush, Douglas Engelbart, Ted Nelson and Alan Kay, all of whom were striving to "augment the human intellect" by developing ideas for tools that helped us to think and communicate our thoughts. Blending the power of information processing and humour, this "concept generator" is jokingly aimed at advertising copywriters and art directors.

Saatchi & Saatchi Innovation Award Web Site

The famous advertising agency – whose currency is the quality of its ideas – here promotes its mission with a global innovations competition designed to channel original thinking in new media and communications to a global Web audience. Using the metaphor of the two hemispheres of the brain, representing the left brain's logical, alphanumeric, analytical attributes and the right brain's spatial, creative, emotional aspects, the site is a "virtual venue" for the competition.

learn to involve more of our senses in their creation, our ability to perceive significant events and patterns in the phenomena we study is likely to increase quite dramatically.

The concept of expressing ideas using multiple media in order to engage more aspects of our minds in solving problems is one that we have hardly begun to tackle. However, this is hardly surprising since the technology that allows us to do so has only been generally available for a few years. As people get used to communicating with one another over networks using multiple media, we may find that our ability to think and express our thoughts using all our senses, to people who are physically or temporally distant, may expand at a surprising rate. When that begins to happen, our capacity to analyse a hypermedia argument critically and creatively may be little different from how we now deal with an argument expressed in text; and it may be much richer in terms of its outcomes.

Nicholas Negroponte's notion of "semantic compression" is an idea that still needs to be developed further conceptually before it can be applied practically to hypermedia. In everyday life it happens all the time, Negroponte's example being the wink across the dinner party table. Its meaning is derived from its context and a shared understanding. That one simple action, the equivalent of the smallest unit recognized by a computer (the "bit", or binary "on–off"), would require a lengthy explanation in words – and still not convey the same depth of meaning. The hope is that hypermedia, with its multi-sensory capabilities, may offer us the opportunity to develop a similar economy of means with which to express, and compress, large amounts of information and ideas. The use of "smilies" – typographic expressions of tone of voice in e-mail – may be a primitive pointer to how this could develop on a more sophisticated level, the philosopher Pierre Lévy has suggested that using hypermedia we can develop dynamic ideograms to represent complex ideas and concepts and to explore the relationships between them.

There is much work going on world-wide using computers and hypermedia to find ways of working and thinking more effectively and creatively as a collaborative activity. Again, the World Wide Web was begun with this objective in mind. Much of the subsequent development work carried out by a multitude of companies and organizations, including Netscape and Microsoft, is centred on this task. This "groupware" can take many forms: computer conferences that allow people in different parts of the organization to share ideas and experience; software than allows people who are geographically distant to work collaboratively on a project; and forms of "organizational memory", which collect and classify the material from past projects so that the experience gained can be re-used and reapplied. The obstacles to success here seem to be much more in the realms of politics and psychology than in technology. In the past, the "ownership and hoarding" of ideas and information has often been seen as a form of power within an organization; now this view has become an obstruction to the goal of developing organisations that can learn and change fast enough to compete in a rapidly moving global economy. When and if rewards and prestige flow to those who share the most, then the technology and hypermedia will be there to help the process of creating organizations that learn.

While many applications of hypermedia may be seen as essentially frivolous or just fun, it is worth remembering, as we see the medium expanding and developing so rapidly, that the concerns of its founders were that it should be used to help us live better and more wisely. That may be an idealistic dream, but it is one that, should it come true, would mean more than simply a media revolution.

Marvin Minsky: The Society of Mind

A pioneer in the field of Artificial Intelligence, Minsky, the visionary thinker and co-founder of the MIT Media Laboratory, explores a unified and ingenious theory of how the human mind works, on this "expanded book" CD-ROM.

A hypermedia programme or environment can, perhaps, most usefully be thought of as a matrix of connected media events. Those events will be made up of media elements, such as text, sound, image, animations, or video in a variety of different combinations. The role that each media element can play in offering a compelling hypermedia experience will be discussed in detail in the following pages. Firstly, however, the overall framework in which those elements are used will be looked at, and also why thinking of hypermedia in terms of a matrix of connected media events is discussed as a fruitful approach to the medium.

Describing hypermedia in these terms can sound very abstract and would benefit from a more concrete example. A familiar set of media events for people who have used the World Wide Web is to be presented with some text, and perhaps some images, to read the text, to click on an underlined word or on an image and to be taken to another "page", which in turn presents some more information and another set of links. The expression "surfing the web" comes from this sense of being able to move both within a web site and between web sites connected by links.

The medium is now quite familiar, even people who have not used the World Wide Web or a CD-ROM, or have never played a computer game or used a multimedia kiosk in a museum or other public space, are likely to have at least read about it or seen it being used on television.

These days we are more conscious of the risks of using old media, such as magazines, books, newspapers, film, theatre, television or video as the basis for analogies to describe the experience of hypermedia; namely that this kind of analogy can mislead as much as it can inform. Even people designing for the medium are not immune. The delightfully rude expression "brochureware" describes the all too common practice of simply placing existing printed material on a web site with a few crude links to hold it all together. Many CD-ROMs have fallen into the same trap and are effectively electronic books or videos with some clumsy additions.

The real strength of hypermedia is that it can do things that other media cannot. It may draw on older media, but how those media are used in this new context requires careful thought. The more obvious components of hypermedia – text, typography, image, sound, animation and video – all have their own traditions and conventions. Some of these are applicable to hypermedia, others are not. What works on a printed page may very well fail when presented on a computer screen. On the other hand, considering well established issues in print, such as the optimum number of characters in a line, would benefit many hypermedia programmes.

This need to reconceptualize how more traditional media elements are used in hypermedia is the reason for thinking in terms of a matrix of connected media events, enabling a focus on the important design issues. In particular, it draws our attention to the two components of the media matrix that make it a new medium. The first of these is the interface, the means by which we control what takes place when we use a hypermedia programme. The second is the software, the computer code that controls what the computer does and hence what we experience when we are using such a programme.

When all goes well, both these components are largely invisible. The elements that we notice consciously are the more traditional ones. This is perhaps why the creative contribution

of these crucially important aspects of the medium is too often undervalued. It may also be due to the relative ease with which people without a software background can use an authoring package such as Macromedia Director to produce a hypermedia programme, or use HTML to create web pages. Whatever the reasons, the relative neglect of interface design and software engineering is perhaps one of the major reasons why so many hypermedia programmes disappoint.

As hypermedia becomes more familiar to more people and as its novelty value fades, the importance of integrating and orchestrating every aspect of the media matrix in order to provide engaging experiences will become more apparent. The fact that we can display text, sound, image, animation and video on a computer screen is not particularly interesting in itself. It does become interesting when it can offer an experience which cannot be matched by reading a book, watching a video on television or any of the other ways we have used different media in the past. This requires the full exploitation of all the unique qualities that the medium can offer, and then the results can be magical.

media matrix

3 components of hypermedia

Apple Macintosh:
Graphical User Interface

Apple introduced the first user-friendly personal computer interface in 1984, exploiting many ideas that had been developed at Xerox PARC during the 70s and early 80s. The key features were Windows, Icons, Mouse and Pull-down menus and the Mac interface became famous as the first "WIMP" interface. These ideas were later incorporated into the highly successful Windows interface from Microsoft.

ntil the 19th century, very few humans had to learn how to operate a machine any more complex than a winch, but since the invention of the telegraph, typewriters, cars, and later the radio, television, washing machines, video cassette players and the like, most of us have experienced the act of "interfacing" with (sometimes very complex) equipment. Interfacing means being able to control machines by communicating with them, and receiving feedback from them. Watching the speedometer on a car dashboard and easing up on the throttle or choosing the correct washing machine programme are good examples. We are used to turning knobs, pushing buttons and switching switches, following directional arrows, stopping at red lights or changing gear, so it is natural that metaphors of all these familiar varieties of interface are used in hypermedia. We can control volume as well by turning knobs, as by pulling a slider up or down, whether the knob is real ("hard") or virtual ("soft"). The video cassette control-panel buttons for "play" (an arrow pointing from left to right), "fast forward", "stop" and so on, have frequently been adopted to create "friendly" control devices for hypermedia.

These metaphors, or "user illusions", are embodied as still and animated graphics on the monitor screen, and provide the user with a control panel or "console" through which the programme can be controlled. Interface design does not just concern the look of the control panel, it also encompasses the ergonomics of the user's control of the programme. If, for instance, the "navigational" controls for the programme are placed together in one part of the screen, the user can easily select between them without having to make unreasonable physical efforts. Consistency is another crucial element in creating an interface that is easy to learn and easy to use. Both the physical position of controls on the screen and the results of activating them should remain the same.

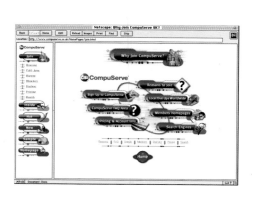

CompuServe

In 1997 CompuServe, one of the longest established subscription networks, was planning the transition from a closed network to becoming an open-access part of the Internet. Originally boasting a membership of highly computerate users, CompuServe is now following AOL (American OnLine) in its repositioning to cater for the average user. Interface design plays a crucial role in the success or failure of such an exercise.

AltaVista and HotBot

Search engines such as AltaVista and HotBot may provide a paradigm for the next generation of computer interfaces, replacing the current metaphor of the desktop used by the Apple Macintosh and Microsoft's Windows.

There is a variety of ways in which these control devices and the interface metaphors can be extended to accommodate the idea of "navigating" around a hypermedia programme. For example, arrows may be clicked on to indicate the direction the user wishes to take from street to street in a surrogate travel programme. Or the user might click on a location in a street map and the screen would display the view from this location. The console metaphor is extended still further in arcade flight and driving simulators, where the dashboard controls and steering wheel, or even the entire cockpit, are available to bolster the relevant illusion.

Currently, most hypermedia control devices are presented as "soft" tools on screen, and supplemented by some general-purpose pointing device such as a mouse or infrared controller. An increasing variety of interface technologies are becoming available, however, each one gradually extending the physical possibilities of interaction

Buttons, icons and navigation devices

The explosion of interest in hypermedia has seen a proliferation of different styles of buttons, icons and navigation devices, such as these.

with computer systems and the range of human senses that are engaged in the hypermedia experience. These hardware devices include digit pads, touchscreen monitors, datagloves, eyephones and complete datasuits. These use a variety of "gesture-sensitive", telematic, force-feedback, eyeball-tracking and position-sensing devices to foster a one-to-one relationship between man and machine.

Interface design is one of the most subtle and demanding aspects of hypermedia design. A successful interface effectively becomes invisible, allowing the user to become immersed in whatever task they are involved in – whether it be playing a game, buying shares, communicating with colleagues or looking for information. An unsuccessful design, on the other hand, intrudes on the task in hand, forcing the user to focus on trying to understand how the system works rather than on what they are actually trying to accomplish. Navigational buttons that appear in different places on different screens, because "they look better that way", or controls that behave in different ways in different contexts without any clear user logic, are all-too-frequent examples of a failure to understand the basic rules of interface design.

Successful interface design depends upon three elements. Firstly, an empathy with the user and the user's perception of the system; secondly, a deep understanding of the system that the user will be using, and its capabilities and weaknesses; and thirdly, a rigorous concern with detail, to ensure that every element of the design is consistent and coherent. The irony is that when all three elements have been fully taken into account, the interface effectively disappears from the awareness of the user. This, perhaps, is the tragedy of the interface designer: the more successful the designer, the less s/he will be noticed.

Broderbund: Kid Pix

Kid Pix set a new standard in interface design for younger children. Visually it looks like a standard bitmap painting programme, but sound effects are attached to different brushes and toolbox actions, and randomness is built into certain tools so that, for example, when one clicks on a tree, a different fractal-generated tree appears each time. The whole programme is highly interactive and dynamic.

Mini Web site: Customize your own Mini

This delightful site is dedicated to Alec Issigoni's cult 60s car. Users can customize their own Mini from an extensive catalogue of parts, and then enter their results into a competition. The interface prompts the user through the process, and provides clever feedback by keeping the car for reference elsewhere in the site.

AMXdigital: D&AD CD-ROM

Here AMX concentrated on a cool, neutral interface, focusing on the design award entries themselves. With such interfaces users should be unaware of the technology and be able to explore the CD-ROM. Sophisticated search tools are built into the programme to access the large database.

Nofrontiere: Interactiveland

The Nofrontiere group's "Interactiveland" is all about the interactive graphical interface. It examines many aspects of interface design in a clever, subtle and gently humorous series of "interface exercises". Providing a visual and sensory coherence across such a wide range of different graphic styles is not easy, but Nofrontiere seems to excel at it.

Cyan-Broderbund: Myst

As a kind of non-realtime counterpoint to the highly successful game Doom, Myst was a radical innovation in games and interface design, using high-resolution 3D architectural models that had navigational and gaming clues and puzzles built into them. The designers also used a variety of cursor shapes to provide feedback in terms of navigation and gaming functions.

id Software: Doom

Justly famous for its radical innovation in three-dimensional realtime gaming, Doom features a "button-free" interface. Using keyboard commands, the user travels unprompted through the arcane virtual architecture of the game environment, facing sudden attacks by rampaging bloodthirsty opponents. Other keyboard commands display the user's health and weapon status – you can change weapons at a keystroke, and restore your health by "driving over" bottles of elixer.

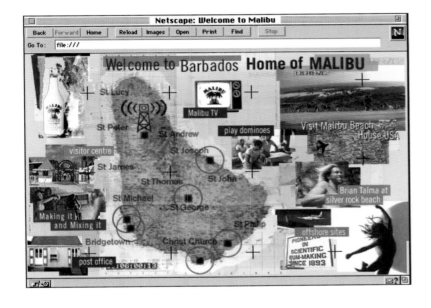

AMXdigital: Malibu

In this "advertainment" site (commissioned by Lowe Howard Spink) for Malibu Rum, AMX has developed an interface based on a geographical metaphor of Barbados, Malibu's island home. This iconic front page menu gives instant access to all the main sections of the site. It is important to keep running menu selections at the top of a Web page, where they are immediately accessible.

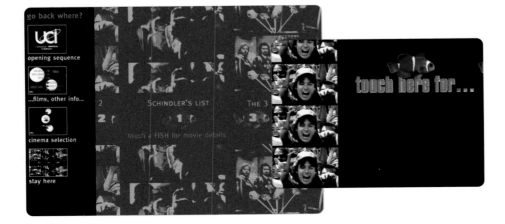

UCI touch interface

There are some obvious special considerations when designing interfaces for touchscreen applications (generally run from stand-alone kiosks). The interface must be simple, responsive and fast – kiosks are not the relatively leisurely environment of the home or office as people use kiosks for fast information rather than relaxed browsing. Also, as the interaction device is the human finger, the interface has to be simple and uncluttered, with good positive or negative feedback to boost the user's confidence in the system. Finally, it has to be attractive to use, positively helping the user to build a predictable mental model of what the system is doing.

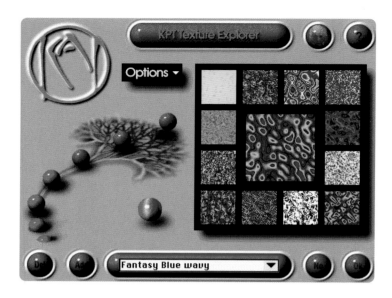

Kai's Power Tools: Texture Explorer

The delight of state-of-the-art interfaces, like this one from KPT, is in experiencing the designer's sense of fun. This, combined with their graphic skills and the functionality of the tools themselves, has resulted in an integrated, visual attractive and "surprising" interface for a suite of leading-edge image processing tools.

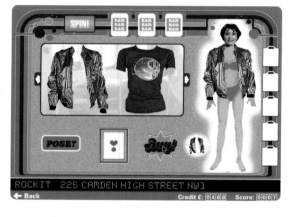

Ian Cater: Popshop

Throughout Popshop, Ian Cater uses several different devices to get the user to interact with what is presented. In this case, the pop star can be dressed in a combination of clothes from a wide range of shops, and she, or a fellow band member, can be asked to comment.

MSN

Microsoft Network offers several channels of entertainment, information and communication, including a 24-hour news service, a lifestyle channel, a channel for those interested in travel, exploration and adventure sports, and a channel aimed at teenagers. By introducing the idea of "programmed Web channels", MSN is positioning Microsoft for content provision in the broadband interactive media networks of the near future. MSN has realized that it is imperative to provide entertaining and informative content that really optimizes the unique technologies of the Internet and of the people and computers that it connects.

CNN Web site

CNN is a hallmark of quality news, and the news network's Web site sports a cool, clear and informative interface that is both graphically attractive and functional. In other words, the interface reflects and introduces the information structure of the site in such a way as to expedite the user building an interior mental model of it.

AMXdigital: Image Bank database

In an image-rich age, the means by which to locate required images quickly and efficiently becomes essential for designers, art directors and other media professionals. The Image Bank CD-ROM is a complete photo-library on disc – with Boolean search tools making the search and selection of images fast and easy. Digitally watermarked images can then be downloaded and tested in a design mock-up before the actual image is ordered by phone.

Warner Music Web site

A quiet, effective interface style, reflecting the mood of this record company Web site.

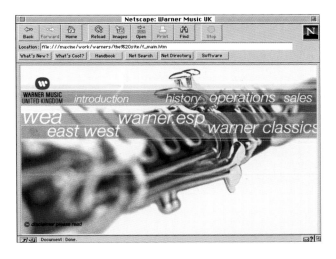

Mattel Media: Barbie Fashion Designer

An interface style which nicely matches the feel and appeal of the Barbie dolls themselves.

Action Man Web site

With a product like this and a target audience of sub-teen boys, this site unashamedly rings all the "military-technological" bells to great effect. The site is built around a series of missions that the user can undertake with Action Man as his avatar. Beautifully designed, fast and responsive, the site combines great content with an interface styling directly relevant to its marketing aim.

Images are used in a multiplicity of ways: to entice, inform, appeal, communicate and enrich. They can excite passions, express feelings, communicate ideas, explain complex relationships, become objects of aesthetic pleasure, meditation and contemplation, and even tell stories.

In hypermedia, images can be used in all these ways, and they can also be linked together with text and other images in order to create new kinds of relationships that can be explored interactively by the user. Just as a film poster, a stained glass window or a painting can tell us a "story" in an iconic, "all-at-once", non-linear way, so images in hypermedia programmes can be devices for providing a variety of different ways of looking at a particular subject or theme.

For example, Hans Holbein's well-known painting *The Ambassadors* could be used in a hypermedia programme as a visual menu for an information base that might include not only astronomy, navigation, music, fashion and anamorphic perspective, but also Renaissance art, Holbein himself, and the political and religious climate of the sixteenth century. Starting by selecting an object within the painting, a user would explore the context and content of the image from a variety of different perspectives. In response to the user clicking on the anamorphic *memento mori* that spans the bottom of the painting, for example, the system would offer a choice of "information trails", on the iconography of death in Renaissance painting, the geometry of anamorphic projection, and so on. These "trails" might include several different art historical, critical, anthropological and mathematical perspectives, suggested by individual experts. The user would have the freedom to follow these trails, gradually building up a more complete understanding of many aspects of the painting.

Innovative hypermedia designers use a variety of such image-based techniques to offer the user a choice of approaches to the information content of the programme. These range from pictorial menus and catalogues through interactive illustrations and diagrams, to providing sets of image creation, manipulation and processing tools. Still images can be programmed to gradually reveal themselves in whole or in part according to the user's actions; the image, or components of the image, can be linked to text, diagrams or other images, or to animations, video or audio sequences; or the user can create an

Hans Holbein: *The Ambassadors*

A painting such as Holbein's *The Ambassadors* can provide a pictorial "menu" of options. Were this a hypermedia interface, navigational buttons would be included to survey other paintings and to take the user back to the beginning of the programme. Otherwise, the picture does all the talking. Small text labels would appear as the mouse pointer is passed over the picture, signalling the options available.

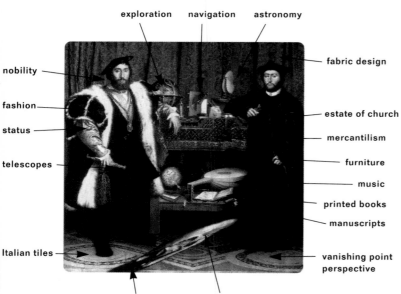

exploration navigation astronomy

nobility

fashion

status

telescopes

Italian tiles

fabric design

estate of church

mercantilism

furniture

music

printed books

manuscripts

vanishing point perspective

memento mori anamorphic projection

Voyager: BLAM!

BLAM!'s use of stark black and white images is powerfully effective.

image by finding and juxtaposing a set of component parts just as a jigsaw puzzle, a montage or a collage is assembled.

It was Sergei Eisenstein who identified "montage" as a basic principle used by all artists in the exposition of a theme, pointing out that when two images (or sequences of images) are placed together they inevitably combine "to create a new concept, a new quality, arising out of that juxtaposition". In other words, the act of perceiving two or more images (or sounds, or words) in juxtaposition is in itself "interactive": it is the observer who is creating the "new concept" in the space "between" the different stimuli. In hypermedia, artists and designers have a communications tool that offers a multiplicity of means by which this principle may be applied. From simple sequences of still images (effectively a digital slide show) through the visual kaleidoscopes of multi-image screens, to the complex matting and collage of images within other images, all these techniques can be put under the direct control of the user, so that physical interaction can supplement the "perceptual" interaction of montage. In this way the user gains access to a wide variety of means with which to approach the subject matter. It becomes possible for users to "browse" through these approaches, select the most appropriate, and "fine tune" them in order to optimize their own understanding.

As hypermedia develops, the use of images to communicate, to inform, to arouse emotion and to develop arguments is likely to become ever more sophisticated. The generations who have known television all their lives are generally more visually aware than their text-dominated elders. They are used to reading images as being more than simply illustrations of what has been spoken or written. As time goes on, images are going to become an increasingly important carrier of meaning in what is now largely a text-dominated medium. Watching this transition will be one of the more fascinating aspects of looking at hypermedia's development over the next few years.

Intro: Introactive

These colourful pictures, mixing photographic, video and computer imaging techniques, provide a good example of image as interface. Clicking on each screw brings up a different choice of video.

Le CD-ROM

Repetitive banks of imagery – like these frames from Le CD-ROM ROM-zine – have been fascinating ever since woodblock printing techniques made them possible in the Middle Ages. The American artist Andy Warhol capitalized on our fascination with mechanical reproduction and, of course, such repetition is even more a signature of the digital media era. Here the designers have provided a full-screen experience using only part of the system's bandwidth.

Darren Poore: Showreel

An fine example of a 3D rendered image on a personal computer – not long ago this would have required a sophisticated workstation to produce.

Spice to see you, to see you, Spice!!!

SPICE GIRLS Rule OK!

Peter Lourenco and Sarah Brown: Spice Girls

A cheeky 2 ½ D illustration of the girlpower band, for Neon Online.

MSN: Listings

The lively illustrative treatment of these listing pages moves them from being just lists, to being fun.

Art of Memory: The Story of Glass

High quality studio photography can produce memorable images in CD-ROMs, as in this example from London's Victoria and Albert Museum.

NASA Web site: 3D imaging library section

NASA has been in the forefront of remote-scanning and computer imaging technology for many years. Their on-line gallery of imaging examples includes these 3D images created from interferometry data captured by instruments on the space shuttle and high-flying AIRSAR laboratories. NASA has recreated similar 3D landscapes from space probe data of Mars and Venus.

Bob Aufuldish and Eric Donelan: Zeitguys

Zeitguys demonstrates the kind of fertile convergences that are a feature of digital design tools when in the hands of inspired designers. Here tools are used to create a galaxy of responsive and interactive ideographic illustrations.

Peter Lourenco and Sarah Brown: Ziggy's Big Adventure
Working Knowledge Transfer: Water Quality
Random House New Media: Jump Ahead Toddlers

These three projects show a variety of illustration styles
in hypermedia projects aimed at children.

**Mosby Multimedia: Interactive
Immunology**

3D rendered images images provide a clean,
clear explanation of a complex subject.

**Macmillan Interactive: Scrutiny in
the Great Round**

Built around illustrations by Tennessee
Rice Dixon, and supported by music and
poetry, this CD-ROM creates a
mysterious and evocative mood.

Modified: frEQuency

Photocollage is one of the many illustrative techniques used in
this exciting music CD-ROM.

Hypermedia is still predominately a text-based medium. As the medium develops, the balance between the different media elements is likely to change, with images, sound, animation and video taking on a greater prominence and text becoming a less dominant – though still important – element in the media matrix. But for the moment, text is still the major vehicle for communicating ideas, information and emotion within the medium. There are a number of reasons for this, some of them technical and some of them historical.

Technically, text currently enjoys a number of advantages over the other media types that can be used in hypermedia. It is very compact. Anyone who has waited seconds or even minutes for an image to download on the World Wide Web will recognize its comparative advantage. Several thousand words of text can be stored in the same space it takes to store a single image. Similarly, a couple of spoken sentences can take up more space than many pages of text.

Text is more than just compact, it is also something with which computers can do amazing things. Text can be searched, sorted and manipulated by computer programmes in ways that are simply not yet possible with other media types. To take but one example, a search engine such as Alta Vista or Hotbot can search for a word or phrase in all the text in several million documents on the Web and within seconds return a list of all the documents containing that word or phrase. One can do something very similar with images using Alta Vista, but with one very big exception: Alta Vista does not actually search for images, rather, it looks for the textual tags that identify images. This is true for any search engine or database. While many databases can now contain many different media types, the searching and sorting takes place using their text identifiers not the objects themselves.

So, technically, it is true to say that text will continue to enjoy a number of advantages over other media types for the forseeable future. However, the predominance of text is not simply technical, it is also historical. The roots of much of the material on the World Wide Web and in many CD-ROMs lie in work originally intended to appear in print. Thinking of digital media as an electronic printing press is a habit that we still have to break. However, there is another tradition which may be more fruitful in encouraging an approach to writing that is more appropriate for the medium. One of the most popular and long standing uses of the Internet is e-mail. E-mail is a subject worthy of a book to itself. It seems to encourage a spontaneous style of writing that is often surprisingly revealing about the characters and personalities of its authors. Something of the informal, participatory style of writing associated with e-mail seems to have spilled over into some of the best writing on the Web. Such writing invites dialogue and comment, the author becomes someone speaking to his/her peers, rather than the voice of authority engaged in a monologue.

Writing for hypermedia is still an art that is in the process of being invented. It is also an art that is complicated, like so much in hypermedia, by a kind of generational split. This is perhaps more accurately described as a split between those

Eudora

The informal and expressive styles of writing used in e-mail are becoming an important influence on writing for hypermedia.

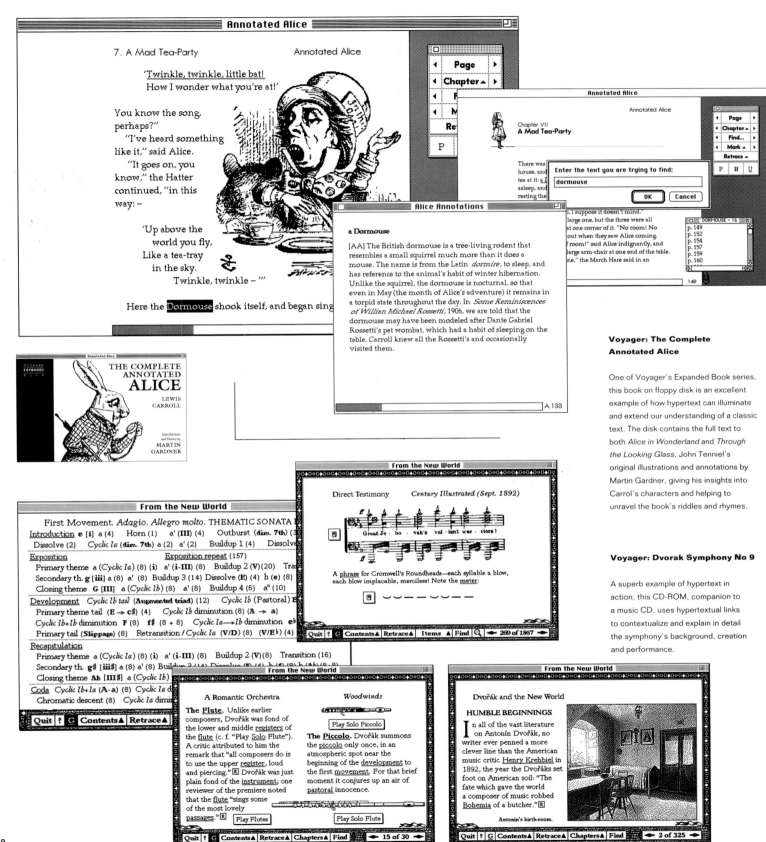

Voyager: The Complete Annotated Alice

One of Voyager's Expanded Book series, this book on floppy disk is an excellent example of how hypertext can illuminate and extend our understanding of a classic text. The disk contains the full text to both *Alice in Wonderland* and *Through the Looking Glass*, John Tenniel's original illustrations and annotations by Martin Gardner, giving his insights into Carrol's characters and helping to unravel the book's riddles and rhymes.

Voyager: Dvorak Symphony No 9

A superb example of hypertext in action, this CD-ROM, companion to a music CD, uses hypertextual links to contextualize and explain in detail the symphony's background, creation and performance.

Virgin: Superior CD Extra

An example of hypertext tracking the lyrics of
a song on an enhanced CD single. As the song
plays, the lyrics are highlighted on the left-hand
side of the screen and animate in synchronization
with the music on the right. The user can click
on a specific line and jump directly to that point
in the song.

Ellipsis: The Phone

Jonathan Moberly's typogram, based on John Chris Jones's
insightful work, The Phone, demonstrates that hypertext can
be used to create a tighter "reading" than conventional text.
The idea that hypertext always gives the reader more control
may be misplaced.

http://ellipsis.com/softopia/index.html

who are media literate and those who are not. As a crude generalization, people can be divided into those for whom TV and computer games are a taken-for-granted part of everyday life, and those who still see them as new media that are trivial in comparison to print.

For the media literate, hypertext (where clicking on a word or phrase takes you to another related piece of text) may seem little different and a great deal more comprehensible than flicking between channels on cable television. For those more steeped in the literary tradition, a textual link that behaves in the same way as a reference to a footnote or an entry in an index or contents page may be just about acceptable, but some of the wilder reaches of hypertext will simply be incomprehensible.

Writing for hypermedia, then, makes a knowledge of the audience being targeted even more important than it already is in print. One needs to know whether the audience is going to need to be gently introduced to the medium or whether it will find such an approach patronizing. It is also a medium that makes its own demands in terms of

what does and does not work. Unfortunately, the rules of thumb for determining the requirements of those demands are still not clear. No sooner does one seem to become clear than experience seems to contradict it. For example, it would seem obvious that text should be written in screen-sized chunks rather than forcing the user to scroll through a long piece of it, however, it does not always seem to work that way. Clicking through a series of text-chunks can often seem like a discontinuous process, where the thread of sense gets lost in the mechanics of moving through the text, whereas the ability to move up and down a piece of text can feel more natural. As yet, however, there seems to be one firm rule – it all depends on what you are trying to do and how you do it.

Like so much in hypermedia writing, text or hypertext needs to be approached with a degree of humility, a willingness to learn and an openness to experiment. Above all, the opportunity for instant feedback from readers offered by the Web is something anyone writing for this new medium should seize willingly and gratefully as a priceless advantage in learning their craft.

Alta Vista and Hotbot

Full text searches such as Alta Vista and Hotbot make the World Wide Web a powerful research resource. The only problem is that they may find too much!

Bob Cotton and Matthew Mayes: Punkzine

In this unusual use of text as interface, joining the right bits of the text together moves the user on to the next part of the programme.

FontShop

The FontShop International company, founded by Berlin-based designer and typographer Erik Spiekermann, was a pioneer in the production of new digital typefaces for designers. This Web site makes available the entire font library, with information about the designs and the designers.

We use language as our main method of communicating, and we use the visible language of writing as our main method of storing and transmitting our knowledge and ideas. We have developed the arts of calligraphy and typography to allow us to modify the visible word, to clothe it with additional qualities that are expressive (brand names), personal (the signature), authoritative (legal documents), informative (road signs), funny (comic book mastheads), ephemeral (dot matrix alphanumerics on tickets and receipts), and so forth. Over the last five hundred years several thousand typefaces have been designed that offer designers a broad spectrum of these modes. Typefaces are a typographer's "palette", and can be selected and combined to compress additional meaning into the words being represented.

Hypermedia accommodates many of these conventions from the printed page, and adds other graphic features such as animation (of both words and pictures); context-sensitive fonts that change size and style in response to the user's actions; variable "page" sizes (pages even up to 30-feet square); text notes, glosses, captions and cross-references that can pop-up on demand; automatic bookmarks; and, of course, the powerful linking features of hypertext.

Typographers have developed a range of conventions for the treatment of printed matter, some of which are directly transferable to the display screen format of hypermedia. For example, the typographic designer has to consider the infrastructure of the programme: titles, menus, help messages, credits and other textual elements. These components, and the textual contents of the programme, can be prepared by the typographer using a combination of graphic skills and techniques derived from both print and television production. Good typography and layout are as important in hypermedia as they are in magazines and television news broadcasts. Unlike print, hypermedia has fewer restrictions on the use of colour or texture for both type and background and, like television, hypermedia can accommodate animated and even three-dimensional typography.

Over the last five centuries typographers have developed a number of ways of making information more accessible to readers. Alongside appropriate legible and readable typefaces, there are conventions for the very organization of information itself: tables of contents, glossaries and indexes, the arrangement of text as headline, subhead, main text, footnotes, marginalia and captions. Further conventions govern the use of the subtle "body language" of visual communications, the colours, textures, graphic elements and layout that modify

the information content. Graphic designers working in advertising have extended the language of print to produce hybrid image-text juxtapositions that are very powerful communications tools.

The "hypergraphic" designer faces some very interesting problems. In addition to considering the actual two-dimensional space of the screen, and of windows within the screen (which can be windows on to much larger virtual spaces), the designer also has to accommodate the "latent" two-dimensional space of, for instance, "invisible" text, images and graphics (items that become visible as a result of the user's interaction). How these latent components fit into or overlay the current display, and how efficiently the designer can employ programming techniques to display text in real-time, as the user is watching, make hypermedia typography and graphics an art quite different to designing for print. Like television graphics, hypergraphics are always "soft", and the graphic designer must consider screen resolution, viewing distance, colour saturation and contrast; indeed all the physical constraints of video display systems.

The two new opportunities for typographic expression that represent the most radical break with designing for print are animation and hypertext. Animated text has been used in film and television graphics, mainly for title

T-26

This Chicago-based font foundry, set up by Carlos Segura, has an international programme to explore the boundaries of legibility in typeface design by making available radical designs from young designers from around the world.

sequences, but its potential applications in hypermedia are much greater. Animation adds the dimensions of movement and time to the expressive capabilities of typography. So far the potential of using it to enhance the meaning of the written word has barely been explored, but already there are signs that the possibilities of using type dynamically in hypermedia will develop rapidly. Increasingly, hypermedia designers are abandoning the metaphor of the printed page and as this happens animated text is likely to become an ever more important expressive element in the media matrix.

Hypertext represents an even greater challenge for there are fewer direct precedents here to guide the typographer. The two issues that need addressing are how to show links and how to show the status of to what they have been linked. Presently links are shown by devices like underlining, using bold or italic text. The problem here is that the user is given little information about the nature of the link. It could be the equivalent of a footnote, a related argument or a link to another site altogether. Developing conventions and devices to signal to what a link will take the user is a key task facing typographers working in hypermedia.

Similarly, work needs to be done in finding ways of showing typographically the relative status and relationships of different textual elements within a

Fuse

Set up in 1990 by Neville Brody, the Fuse project brought together experimental design and innovative thought on language and communication in the digital era. Fuse releases previously unavailable designs by young pioneering designers and students, and also hosts annual conferences on type design where delegates can contribute to FuseLab, an on-line forum for design and discussion.

hypertext. This requires close collboration between writers and typographers, because the hypertextual equivalents of print conventions are still being established and are likely to be very different in this new medium.

Currently, the level of control that a typographer can exercise within a hypermedia programme is much less than with print. But then the same was true of many of the early desk top publishing programs. As the software for using type on the screen becomes more sophisticated the real issues of how type can best be used in this new medium will become more apparent. Clearly, there are lessons to be learnt from the past. Equally, there is a need to develop new conventions and standards for a medium with qualities very different from those of paper. Finding the successful fusion between the two is the key challenge for the hypermedia typographer.

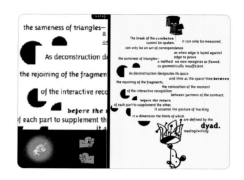

1/0 360: Weathervane

A deceptively simple combination of
user interaction, animated type and three
dimensional layout, this recipient of an
Award of Distinction from *iD Magazine* is
an excellent example of the new possibilities
opened up for typographers in cyberspace.
See for yourself on their Web site at:
http://www.io360.com/v2/yo/weathervane

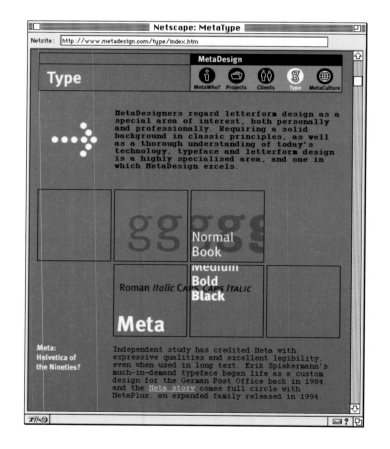

Bob Aufuldish and Eric Dontlan: Zeitguys

Zeitguys demonstrates the dynamic possibilities available to designers of digital typography.

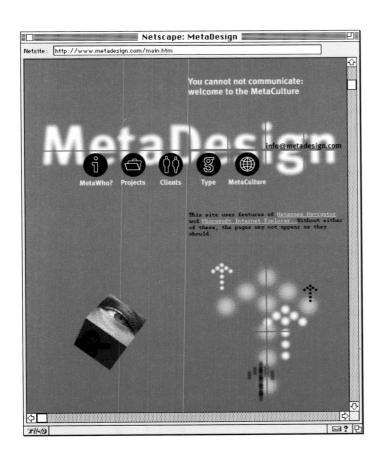

MetaDesign

The Web site for MetaDesign, by Erik Spiekermann. His typefaces Meta and Officina have set a new world standard for commercial and business typography – threatening the ubiquitous use of Helvetica.

REM diskette mailer

The designers of this multimedia presentation for the band REM have excelled at cramming audio tracks, sound clips, band biographies and tour dates, onto one floppy disk. By using a variety of algorithmic effects, such as randomness and the use of Boolean links, many visual effects can be delivered with little memory overhead.

Inform: Texas Homestores kiosk

3D computer graphics and animation can be used most effectively to guide users through complex technical points. The 3D designer, like the technical illustrator, can leave out all the visual irrelevancies and "noise" that would otherwise clutter and confuse the central message. Andrew White, working with the design group Inform, has produced a crystal clear consumer guide to DIY plumbing (kiosk project for Texas Homestores). These simple computer graphics can be modelled and rendered on standard desktop machines, and are integrated as interactive sequences using Macromedia Director.

Animation is the media element that can most easily express the dynamic nature of hypermedia. In some forms of hypermedia, such as computer games, animation (whether in two or three dimensions) may be the predominant type. In other forms of hypermedia its use may be more subtle, quietly providing a dynamic element in what otherwise might be perceived as a series of static events. There are several ways in which animation can be used in hypermedia programmes. These include: "animation bites", short sequences of full- or part-screen linear animation that illustrate or explain processes and are progressively or automatically played in response to the user's interaction; longer sequences in which the user has to make branching choices; as attention-seeking devices for expressive or decorative effect; transitional effects; feedback to the user; and "autoplay" or "default" devices that activate when the user is not interacting with the programme.

Animation bites are used wherever the special informational, explanatory or expressive qualities of animation are required, such as in the illustration of systems and processes that are too large, small, fast or slow to be perceived, or that can best be apprehended in abstract form (like plant or cell growth, manufacturing processes, the workings of an internal combustion engine, and so on). Animations may be linked together in longer sequences, so that an overall animation of the circulation of blood in a human body may serve as a menu through which progressively more detailed animations of the workings of the heart, lungs and kidneys, for example, may be viewed.

Animations can be effective attention-grabbers within an otherwise static information frame or menu. They can take the form of small, looped animations that act as "self advertising" buttons; as animated typography and graphics in a title sequence, dynamic headline or subtitle; as instructional or help messages explaining a diagram or a software tool; or to draw the user's attention to programme sections that have not been accessed.

Animations can also be used as mood setters, providing abstract, pictorial or expressive accompaniments to music tracks, monologues or sound effects. Looped animations, fractal generators (computer programs that produce intricate graphic displays), colour lookup table animations (where a still image is "animated" by progressively altering its component colours) and animations derived from mathematical formulae and random number generation (such as the "screen savers" used on personal computers) can all be used to create mood. Transitional effects include digital versions of those developed by film and video-makers (dissolves, wipes, cuts, flash pans and the like) as well as various familiar televisual effects, such as zooms, tumbles, peel offs, wraps and pop-ups, and the multi-screen effects derived from PC graphical user interfaces and digital video paintboxes.

Transitional effects are often a form of feedback – they let users know that the system is responding to a command. Most hypermedia programmes involve some sort of information hierarchy. The user will have to select the required section, then the sub-section and eventually the frame that is of interest. This frame may link to other frames in other parts of the programme. The transitional effects that signal these frame changes can provide important feedback to the user, signalling which level of the programme they are currently on, and giving the user a sense of "place" within the programme. Another situation in which simple animations can give important feedback to the user is the "wait state" – where the action taken by the user cannot be performed within the time it takes for the system to display a new screen. The conventions here are a ticking clock, emptying egg timer, moving bar chart, flashing "alert" icon, animated cursor or highlight changing colour.

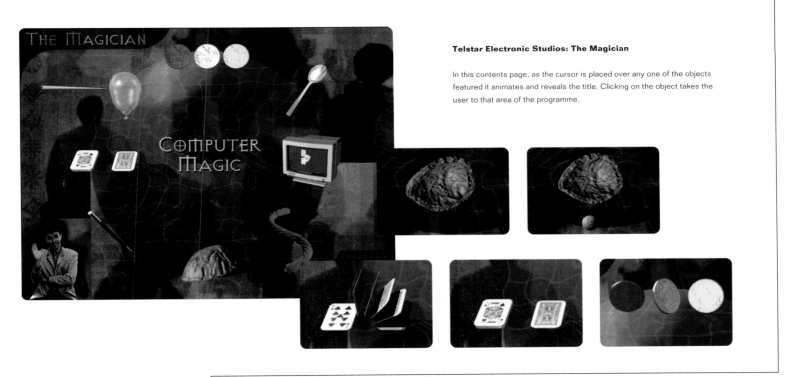

Telstar Electronic Studios: The Magician

In this contents page, as the cursor is placed over any one of the objects featured it animates and reveals the title. Clicking on the object takes the user to that area of the programme.

CD Media: Le CD-ROM titles sequence

In this dynamic titles sequence for the French ROM-zine, the designers disguise the limited bandwidth of the CD-ROM by updating only small parts of the full-screen image. This gives the illusion that the whole screen is changing.

Intro: Introactive

An effective use of animated 3D icons in the Interactive Portfolio for design company Intro.

Animation can also play an important role when the user chooses not to interact, or, in the case of a public kiosk for instance, when there is no one there with whom to interact. In such a situation the programme could just sit there displaying the frame where the user left off, but there are advantages in designing a "default" or "autoplay" condition – where a specific animation is looped as a "trailer" or attractor for the programme should no user-interaction have taken place for some minutes. This default condition can be driven by a program that selects parts of the hypermedia programme at random – providing an ever-changing montage of features, or more simply a set of slow lap dissolves between graphic frames, or even a specially designed screen saver.

Animation has featured widely in hypermedia ever since the authoring package HyperCard was bundled with Macintosh computers in the early 80s. Like so much else in the medium, designers are still learning how to employ it to best effect in this new context. It will, of course be used in many different ways, to communicate many different things. But perhaps one of its most interesting uses, as hypermedia programmes and environments get larger and more complex, will be to aid users in knowing where they are, where they have been and where they could go. Just as film and television have established a set of conventions and effects to help their audience locate themselves in the action, animation may provide a similar set of conventions and effects to help users locate themselves in hyperspace.

Middlesex University: Russian Roulette

Mike Gouda's combination of user interaction and animation creates a surprising level of tension. The user places the bullet in the gun, spins the cylinder, pulls the trigger and waits for the result!

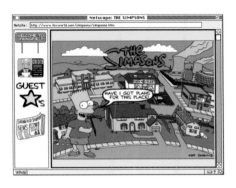
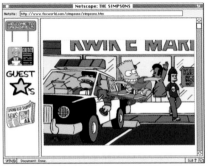

Fox Interactive: The Simpsons

Discover Bart doing his skateboarding thing on-line. This site uses animated drawings that are vector based – these are very small file sizes and are, therefore, very quick to download.

The Residents: Freak Show

Jim Ludtke was one of the first multimedia artists designing and producing animated CD-ROMs. In it he developed a quirky individualistic style that draws on a fascination with the fairground and the circus, creating an eerie atmosphere. Ludtke's animations are seamlessly integrated, often within full-screen images, successfully creating a "full motion video" illusion, and optimizing the limited bandwidth of the CD-ROM.

Nofrontiere: Interactiveland

The Nofrontiere group makes extensive use of animation to allow the transitions between the different areas of their exploration of the changing mediascape.

Sound is a very powerful element in the media matrix, rarely fully exploited until recently. In part, this is due to technical reasons. Sound is memory-hungry and limitations on the amount of memory available to the hypermedia designer meant that often it was used sparingly, if at all. But, equally importantly, perhaps our sense of hearing is surprisingly complex. Learning how to use sound effectively in this new context presents a number of challenges to the design team.

There are three aspects to sound that need to be considered very carefully in relation to hypermedia. Firstly, sound seems to engage our emotions and imagination in a particularly powerful way, but how we use this in hypermedia is less obvious than in a medium such as film. Secondly, our hearing is a strongly connective sense: it is hard to hear many sounds without evoking other senses, particularly sight. Finally, although sound can be thought of as a time-based medium, similar to full motion video and animation, it can also work as a single event in time.

Sound carries a surprisingly high "information load". As an experiment to demonstrate this, try watching a film with the sound turned right down. Then turn up the sound and stop looking at the screen. What you are likely to find is that with the sound turned down the images you see become emotionally more distant, the experience more detached. On the other hand, simply listening to the soundtrack you are likely to find yourself picturing the action in your mind and becoming more emotionally involved.

A similar effect can be experienced by playing a computer game with the sound turned off. Indeed, here the effects can be more pronounced, because not only does the sense of involvement diminish, but without aural feedback the game can become more difficult to play.

So sound can play a number of different, but related roles in a hypermedia programme or environment.

**Steve Nelson/Brilliant Media: Xplora 1
– Peter Gabriel's Secret World**

Peter Gabriel is at the forefront of the new wave of musicians who are exploring the synaesthetic nature of the digital media.

Berkeley Systems: You don't know Jack

This innovative game creates the experience of taking part in a TV game show, with sophisticated use of interactive sound.

Cat Hill Productions: King's Cross Unveiled

This touch screen application allows the user to move their finger over the screen in order to hear different voices. Moving the finger rapidly produces a cacophony; settling in one place allows one to hear a whole passage.

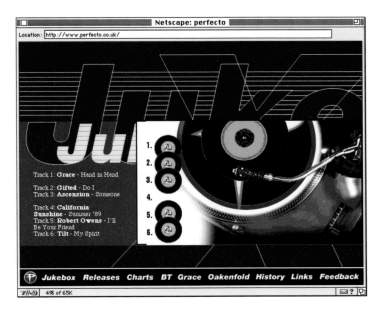

Perfecto Records: Online Jukebox!

Streamed Audio is becoming an increasingly important element in many Web sites.

It can generate an inclusive space that creates a greater sense of involvement with all the other media elements for the user. This may be achieved by the use of music, sound effects and voice-overs. It can provide confirmatory feedback for the user by signalling the effects of an action, for example an aural "click" when clicking a check box with a mouse. It can provide information, help and instruction about how to use a hypermedia media programme. In fact, it can be used in a multitude of different ways, many of which have barely begun to be explored.

Voyager: BLAM!

The use of harsh, industrial sound contributes to making BLAM! a vivid experience.

As the medium develops, sound is likely to take over the role of text as one of the primary carriers of argument, opinion and information. Already on the Web many interviews and speeches are only available as recordings. At the moment this is largely because recording is quicker and easier than transcribing them, but the practice is likely to grow as it is recognized that the "TV generation" has become used to gathering information through hearing and seeing, rather than reading. The great advantage that hypermedia presents is that some of the tactics which we use to read critically and analytically can be applied to what we hear. For example, we can very easily repeat sections that are not clear, and can move around speech in a very similar way to how we move around text, comparing one section with another. The added advantage is that we can also hear the tone of voice, intonation, pace and rhythm, which can further clarify and illuminate what is being said.

Every media element within hypermedia presents intriguing possibilities for development. But the issue of how we use sound may be one of the most important factors in making hypermedia a truly distinctive medium, with unique characteristics and qualities. From Vannevar Bush onwards, one of hypermedia's primary metaphors up to now has been print. As we learn to use sound more intelligently and more effectively this metaphor may break down. Already many of the other metaphors we use to describe the experience of using hypermedia are spatial. The increasing use of sound to create a sense of an inclusive space, where we are within the experience rather than simply observing, may be a crucial element in establishing the new, more fruitful, spatial metaphors that the medium demands.

Nude records:
Suede CD Extra

CD Extra is a new digital format which allows band biographies, and other digital visual material, to be combined with the audio tracks. When played on a computer, the CD liberates the extra material.

Voyager: This is Spinal Tap

This CD-ROM from the spoof heavy-metal "rockumentary" film *Spinal Tap* offers the user three different sound channels at any one time, giving the viewpoints of the cast and crew, as well as the original film soundtrack. The volume control can be turned up to eleven.

Modified: frEQuency

This "interactive pop video" lets users do their own mixing. Graphically brilliant, it utilizes clever, built-in audio manipulation tools allowing users to create their own mixes from the samples included on the disc.

Webcasting

Webcasting is a form of live multimedia "narrowcasting", where an event is reported upon in a wide range of media. Typically, narrowcasting on the Web includes text reportage (via e-mail), photojournalism using digital cameras and lap-tops, video coverage using CUSeeMe technology, and Real Video and audio narrowcasting using Real Audio.

Microsoft and Dorling Kindersley:
Musical Instruments

One of the great advantages of hypermedia is that in a reference work of this kind not only can the users read about and see what an instrument looks like, but they can also hear the sound that it makes.

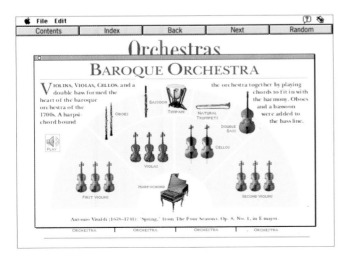

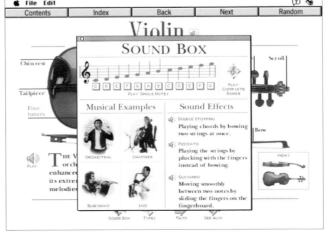

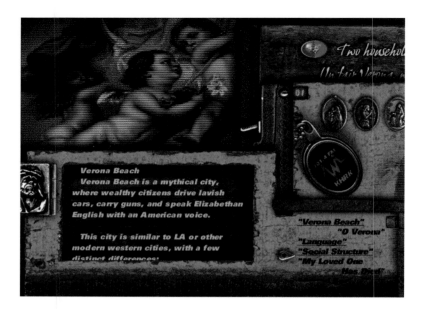

Fox Interactive: Romeo and Juliet

Based on Baz Luhrmann's modern interpretation of Shakespeare's tragedy, this CD-ROM features the complete text of the play, the motion picture screenplay, stills, research material and footage from the film. This allows the user to explore in more depth many of the issues raised by the film.

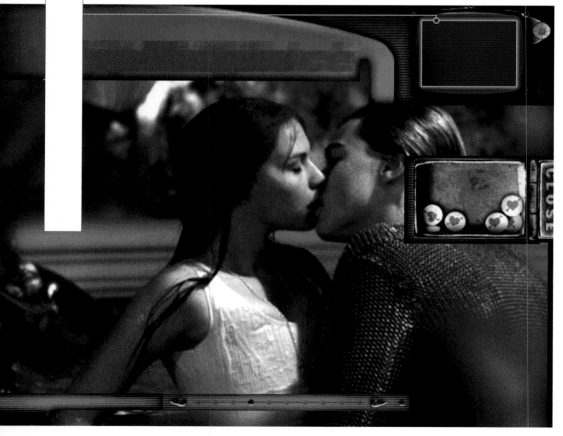

Video has featured in hypermedia right from the beginning. Indeed, it was the key media element in MIT's "Aspen Movie Map", designed in 1978, which many consider to be the first real example of hypermedia. However, there are problems with the successful integration of video into hypermedia programmes. Video, like sound, is a time-based medium and there is a difficulty in combining linear, time-based media into the random access (non-linear) structure of hypermedia programmes.

Andy Lapping, who directed the "Aspen Movie Map", highlighted the central problem:

> Look at the Movie Map ... You can: continue, back up, change your view, change the season, or talk to any of ten buildings – there are fifteen different things that you can do at any instant ... Now, if I made you wait until the end of the block – you couldn't touch the buildings, all you could do was control the direction you drive ...okay? Then it's not interactive, it's selective, because you made the decision to go down that street, and having made that decision there is no productive thing you can do until the end of it, until it's your turn again. (Quoted in Stewart Brand, *The Media Lab*, p. 49.)

Curiously, the lessons of the "Aspen Movie Map" have often been ignored in the subsequent uses of this media element in hypermedia programmes. Too often, time-based media elements such as full motion video, animation and sound become interruptions in the flow of moving through a programme. A difference between hypermedia and other time-based media is the user's sense of some control over the pace and direction of the material presented. Even a relatively short video sequence that does not offer the user some means of taking control, if only to stop and get out of it, can seem startlingly oppressive. While undoubtedly, full motion video is going to be an important component in the media matrix, learning how to integrate it within the context of

hypermedia programmes and environments is going to require considerable experiment and practice.

It is only in recent years that full motion video has become a realistic option in hypermedia. Initially, it called for hybrid technologies with the computer controlling a video disc (an analog medium) or in some cases a video player. The relative expense and complication of this hybrid technology limited the contexts in which it could be used. It was really only in the early 90s with the introduction of digital systems to compress and play videos directly on PCs (such as Intel's DVI and Apple's QuickTime) that the use of full motion video in hypermedia programmes became a reality. Even then, the size and quality of what could be shown was relatively limited, with only small sections of the screen available for display and the motion itself being often jerky and crude.

The adoption of DVD (digital video disc) will be the next leap forward. DVD has several times the storage capacity of CD-ROM, and has been designed from its inception to carry full-length movies, making the use of full motion video in hypermedia programmes a more compelling design issue. DVD is currently being largely promoted as an alternative to video tape for distributing movies. But the combination of the continuing improvements in compression techniques and the massive increase in the storage capacity of this technology makes it a very attractive vehicle for hypermedia designers who have found the storage capacities of CD-ROMs restrictive, particularly in relation to full motion video. Freed from some of these technical restraints we may find that, at last, the potential of full motion video can find its proper place as an engaging interactive component within the media matrix of hypermedia.

Voyager: A Hard Day's Night

The Beatles' *A Hard Day's Night* was the first entire feature film on CD-ROM. A QuickTime movie with cast information, 160 pages of text and hypertext, and biographies on the cast and director, it even includes the cinema trailer.

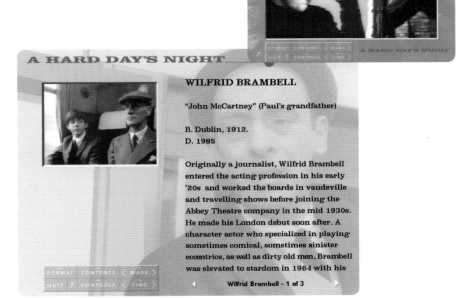

Voyager: This is Spinal Tap

The innovative feature of this CD-ROM is that the user can search for any word in the movie soundtrack or key visual references, and be taken directly to the relevant section of the video. The progress of the movie can also be accessed via virtual maps of the band's progress on tour across the USA.

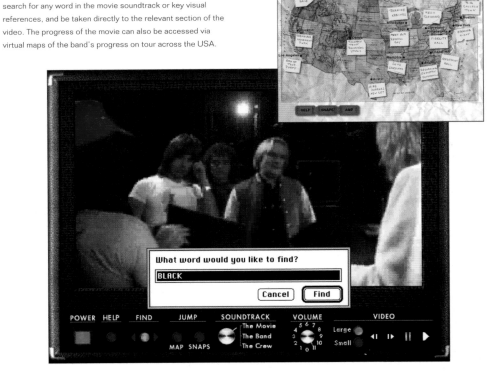

media matrix – video

AMXdigital: D&AD

One of the first problems in creating the first CD-ROM for the UK's Design and Art Direction annual awards was the sheer volume of graphics, audio and video material that needed to be put on the disc. AMX has created effective visual browsers for video clips in their work for clients.

MIT Media Lab: Movie Map

The first "interactive video" produced at Media Lab in 1978. A surrogate travel programme, it allowed users to travel around a video recreation of Aspen, Colorado.

Television and Cinema Advertising Crafts Direction
Accepted Abbott Mead Vickers. BBDO

Twister
Volvo Car UK Ltd

Sponsored by Tony Kaye Films

Bob Cotton and Matthew Mayes: Punkzine

The audio and visual controls in this prototype CD-ROM, produced by FIT Vision for Castle Multimedia, are invisibly "embedded" within the exploratory freeform interface. Art Director, Bob Cotton, and designer, Matthew Mayes, both believe that programmes which encourage exploration are eminently replayable.
The mouse movements that control the music tracks and video clips encourage "mouse dancing" – exploring Punkzine allows a real feeling for the period.

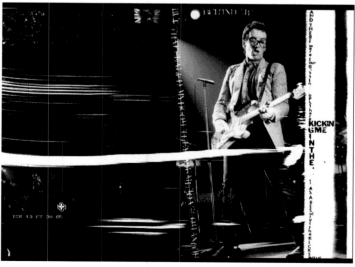

86

Penthouse Interactive:
Virtual Photoshoot

Using extensive video footage, the user
is able to choose a Penthouse Pet, pose
them in a virtual photoshoot, view their
contact sheets and receive a critique of
their efforts from Bob Guccione.

AMXdigital: CSN ADchannel

High quality video is now available over
broadband (1.5 mbit/sec.) networks,
allowing advertising agencies, for
example, access to a potentially vast
database of resources.

id Software: Doom

As Doom illustrates brilliantly,
computer games have now
developed a series of techniques
and conventions that not only
create convincing, engaging
virtual spaces, but also enable
users to learn quickly and easily
how to navigate through them.

Silicon Graphics: The Reality Centre

The Reality Centre is Silicon Graphics's showcase for
demonstrating leading-edge simulation technology. Partners and
customers can experiment, test their ideas and see how this
exciting technology can solve their problems. Perhaps more
importantly, the centre is also a place where the growing ability
to create 3D simulations, as well as the opportunities to develop
new kinds of entertainment, is creating new conceptual tools
that should enable us to deal more effectively with a wide range
of problems.

One of the more intriguing aspects of our experience of using computers has been the long-standing sense that they create a kind of three-dimensional information space. Even in the early days of interactive computing, when green text-based screens were used with apparently no three-dimensional cues, many people saw their screens as windows into a virtual space. Interestingly, this experience was reinforced and reflected in much of the language used – such as software "architecture" and memory "locations". In part this was a set of literal rather than metaphorical descriptions: computer hardware after all does have a physical presence and its components do have spatial relationships with one another. But the more powerful sense of dimensionality owes nothing to the physical properties of the computer, seeming to have more to do with how we experience and classify relationships between different kinds of information.

From the very early days, computer games have exploited this feature. Text-based games such as Dungeons and Dragons were built around the idea of quests through an imaginary geography. In 1980 Roy Trubshaw and Richard Bartle launched the first networked multi-user Dungeon, MUD1, at Essex University, which allowed those with a computer, telephone line and modem to participate in the game either as competitors or collaborators or a mixture of both. Text-based multi-user adventure games spread in popularity and by the early 90s there were sites all over the world, many of them accessible via the Internet.

In 1992 id software launched a violent adventure game, Wolfenstein 3D, that featured a surprisingly realistic three-dimensional graphical environment in which the user moved through a maze of rooms picking up increasingly powerful weapons and slaughtering enemies as they went along. This was rapidly followed by Doom, which became one of the most popular games in the world, and its successor Quake. Doom and

Quake can both be played as single-user games, but much of their popularity can be ascribed to the fact that they are also multi-user games that can be played on a local area network or over the Internet.

The early MUDs and Doom and Quake have all been subject to criticism. MUDs because they were seen to be dangerously addictive fantasies, Doom and Quake, because they are extremely violent as well. However you regard the criticisms, these games and indeed computer games in general are well worth serious consideration by hypermedia designers. Games seem to have developed a whole series of techniques and conventions that not only create convincing, engaging virtual spaces, but also enable their users to learn quickly and easily how to navigate and locate themselves in those spaces without too much conscious effort. Few other kinds of hypermedia programmes and environment have yet displayed this level of skill in handling virtual space.

The very rapid emergence of hypermedia intranets (internal organizational computer networks using Internet technology), the continuing growth and complexity of the World Wide Web, and the development of much larger, more complex hypermedia programmes and environments make the creation of comprehensible, expressive hypermedia architectures a pressing demand. Hypermedia users need to know where they are, where they can go, and where they have been. When people are collaborating together in virtual space, such considerations become even more important.

It may well be that much of the vocabulary and the conventions which we need in order to develop such an architecture already exist in computer games. The challenge to hypermedia designers is to look coolly and objectively at what already exists and to adapt and modify what they find to the broader and more varied requirements and applications of hypermedia in general.

Command line interface

All computers, prior to using pictures and icons, used a command line interface. Later graphical user interfaces adopted a desktop metaphor. As Donald Norman said, "In a design world what we have to do is decide the metaphor we need to use as a conceptual model."

Segaworld: Space Mission

Virtual theme parks, offering virtual experiences affecting all the senses, have moved out of science fiction and into a venue near you.

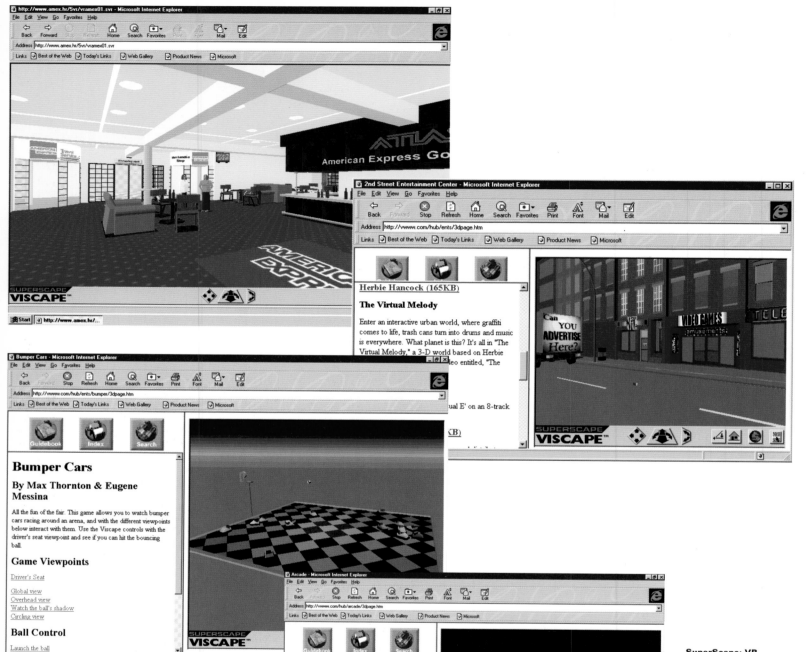

SuperScape: VR

Representations of 3D spaces through which the user can navigate have moved very rapidly from being used exclusively in the realm of the powerful, expensive workstations to games consoles, personal computers and the World Wide Web. The examples here show 3D spaces on the Web using SuperScapes's own propriety VR (Virtual Reality) technology.

Trip Media: Virtual Nightclub

A brilliantly realized early sketch for the kind of 3D virtual social environments that look set to become commonplace in networked telemedia. Initially conceived for compact disc interactive (CDi) format, Virtual Nightclub was planned to work as a disc/Web/social entertainment environment, set in a futuristic club featuring different activities and media events in different rooms.

Trip Media: Burn Cycle

Originally coded for CDi, Burn Cycle enjoyed great success on CD-ROM format. An adventure set within a highly realistic futuristic cityscape, Burn Cycle demonstrates the effectiveness of a combination of virtual environments and bluescreen matted video live-action actors. Motion parallax effects are ingeniously exploited.

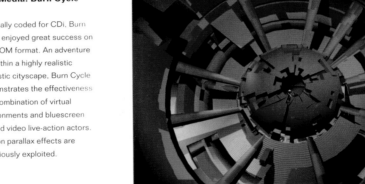

MacPlay: Virtual Pool

Chalk your cue and enter the three-dimensional world of virtual pool.

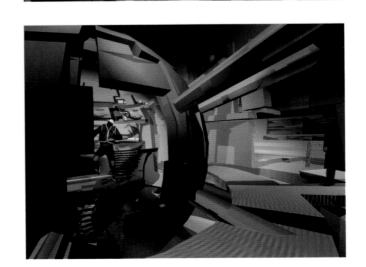

Hypermedia is a form of computer software. This obvious statement is one that can too easily be forgotten in our excitement at seeing the media elements of text, images, sound, animation and full motion video deployed within a computing environment. This forgetfulness is perhaps reinforced by the use of authoring programs that are often as easy to use as many word processing or desktop publishing packages. It is further emphasized by the fact that many of the tools used to produce the images, words, animations and sounds in hypermedia are the same computer application packages deployed in producing those elements in more traditional media.

There is, however, an important distinction that needs to be made between using a computer to produce work that is destined to be viewed on paper or on television, and using one to produce work that will be experienced on another computer system. The experience of a hypermedia programme or environment will depend very heavily on how successfully it exploits the capabilities of the particular computer system that is being used. This is where the software engineer comes in.

Unlike many other areas in hypermedia, the computer games industry is dominated by software engineers who have an intimate and very detailed knowledge of the machines on which their games will be played. To do this, the software engineer must understand how the processor works in conjunction with the storage media, the display monitor, the controlling devices, and the various co-processors that are responsible for audio and video compression. They must know how the programme data is stored, how the different types of data are separated (so that, for example, audio data is directed through digital-analog converters and amplifiers to

the speakers, and video data is sent to the monitor screen), and the limitations of the system in terms of amount of storage, speed of delivery, screen resolutions, and degree of user control. Armed with this knowledge they can then design the software architecture and the program code to fully exploit the technical capabilities of a particular delivery platform.

In other areas of hypermedia design, software engineers have often played a subordinate role if they have been involved at all. Where they have been, they have frequently been brought in too late in the project after all the main decisions have been made with their role being seen as "just to bolt it all together". Many of the minor irritations that make some hypermedia programmes unpleasant to use are due to a simple lack of understanding of how computers actually work – the kind of things that any competent software engineer could easily avoid.

Anyone who has used the World Wide Web is likely to have experienced those sites that once connected display a blank screen, sometimes for minutes, while everything loads. With a more intelligent understanding of how the Web actually works, something to look at or read almost instantly while the rest of the content is transferred could have been produced. Similarly, users of disc-based hypermedia will almost certainly have experienced programmes that are sluggish in response: clicking a button appears to produce no result, and clicking it again finds you whirling to somewhere you did not expect or want to be. Again, this is something that input from a software engineer could have avoided.

But the need for the active involvement of software engineers as full creative members of the design team goes deeper than simply avoiding irritations and glitches for the user. With the knowledge and experience that they bring to a project, they can often suggest possibilities and approaches that someone without that background could not imagine. Much of the magic which we can experience when using a hypermedia programme will come down to the fact that the programme is fully exploiting the

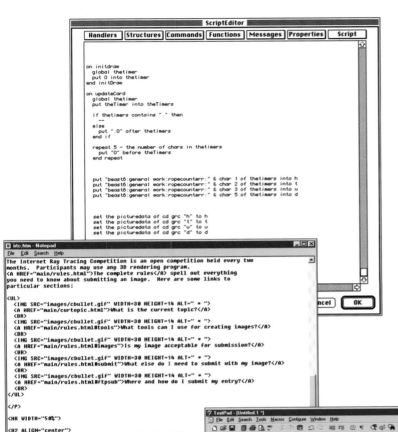

capabilities of the computer as a medium, rather than simply mimicking some of the characteristics of older media.

Of course, authoring packages such as HyperCard and Macromedia Director have allowed people with no knowledge of software engineering to produce interesting and innovative hypermedia programmes. As authoring packages become more sophisticated and powerful, this will no doubt continue to be the case. Nevertheless, it becomes clearer all the time that if the medium is to progress fully, an active and creative contribution from software engineers will be required. We will know that it has truly matured when specialists in every aspect of the media matrix, including software engineers, are confident in what they have to contribute and have an understanding and respect for what each has to bring to the process of creating compelling, engaging hypermedia experiences that fully exploit its exciting capabilities.

Programme code

Software code is the engine that drives hypermedia. It can range in difficulty from the near-English of scripting languages, such as HyperTalk or Lingo, to sophisticated high level programming languages, such as C.

The debate about what is the most appropriate model for the hypermedia design and production process is still very much a live issue. As designers, editors and producers from "conventional" media (television, print publishing, music and radio) have begun to specialize in interactive media, many have naturally based their work on their familiar design and production models. Too often the technical element (the programming or authoring) is little more than "tacked on" to the end of their normal production cycle.

The central problem is that all too often computer people fail to understand media people, and vice versa. This is a fundamental issue, affecting equally the small production company and some of the largest software companies in the world.

Typically, software engineers regard designers as fuzzy and illogical, while the designers and content team find the programmers obstructive and unhelpful. This is partly due to a wide difference in working vocabulary between the different disciplines, but is more to do with a fundamental variance of approach. This difference is something to do with the fact that most media are linear and sequential and that, by and large, computer software is non-linear. However, the main difference is that media designers are used to working towards producing a "finished" product, while software engineering is generally geared towards

producing "versions" or "releases", with an implicit sense that what has been produced is always capable of further improvement or elaboration.

The greatest problem, however, often lies in an artificial distinction made by many media people between the creative and the technical. The design part of the process is seen as being creative, the production part as being technical. Hypermedia is not like that. It is a form of software, and designing and producing software is essentially a craft activity. The two aspects of the process are inextricably bound up together.

It is true that hypermedia projects vary in scope and complexity. Designing a simple Web site for a small business, for example, could be done by one designer handling every aspect of the project in the same kind of way that a designer/maker might design and build a single piece of furniture.

Other projects are much larger and more complex and resemble a craft activity like making a film or television programme, involving many people with specialist skills. Here, planning and coordination becomes vital. The initial design aspects, which involve strategy and planning, assume a much greater importance and have a more distinctive identity than in a small-scale project.

Finding a working method that will successfully integrate and exploit the wide range of skills and disciplines necessary for producing compelling hypermedia experiences is still one of the central tasks in the development of the medium. One of the key problems is, as with any other design discipline, that any attempt to model the process as a neat sequence of events is contradicted by the reality, which is that design is always a messy business. There may be a rough sequence of events, but there is almost always much movement backwards and forwards through the different stages. For this reason design is often described as an iterative process, a kind of spiral movement of activities moving from initial idea to final resolution. Indeed, one fundamental issue that has now emerged and will become increasingly important is that of how we view the process:

whether it is an activity that produces finished, complete products or (as seems more likely), one that creates environments that continue to develop and evolve over time. In the current Internet-led environment, the latter seems more likely.

4

design and production

defining the design process

E very hypermedia project begins with an idea. This first phase of the design process involves exploring and testing the strength of that idea and defining the design space in which it can be developed. In many ways this may be the most important part of the design process. If this first phase is carried out rigorously, problems that may arise later can be avoided and creative opportunities that might otherwise have been overlooked can be identified.

The purpose of this first stage, then, is to establish the limits of the design space and to identify the constraints and the creative opportunities that exist within them. Much of this first phase is concerned with formulating and asking the right questions. Most of these are fairly obvious: what are we trying to say, to whom, in what way and why are we saying it anyway? Ideally, at least a core team of hypermedia designer, software engineer and project manager will be involved in this process, with input from the client or backer where appropriate.

This stage has three main outputs: a concept, a design brief and a proposal. The order in which they are produced may vary from project to project, and each may be further refined and revised as more information becomes available and the scope of the project becomes clearer.

A concept is a very short statement, preferably only a sentence, that expresses the essence of a project. Defining a concept involves thinking very clearly about what is to be achieved and expressing it succinctly. The value of having a clearly defined concept is that it aids communication among members of the design team by providing a simple benchmark against which design decisions and ideas can be tested. It is also invaluable for helping to communicate with the client and others outside the design team.

A design brief is the outcome of a period of negotiation, in which the client and hypermedia designer, software engineer and project manager will strive for the creative marriage of what the client wants, what is technically possible, and what works best for the end-user. In working towards this goal, the client's initial brief (if there is one) is merely the starting point. Essentially, a design brief is a clear statement about what the

AMXdigital: Superior CD design in development

Several briefing meetings, between the artist, record label, management company and multimedia developer, take place early on in the production process to establish design parameters.

96

project is trying achieve, who its users will be and what are the principal constraints, including the time and budget available.

A proposal will provide much of the same kind of information as a design brief, but contain more detail about how it will be achieved. In particular, it will consist of a project plan describing what activities will be taking place, when they will occur, how much they will cost and what their outputs will be. It will also state (in much greater detail than the brief) the range of skills that will be required to realise the project, and who will be doing what. A proposal can be seen as a kind of organizational blueprint for the whole project which will form the basis of all the planning and coordination that needs to take place. It also often forms a crucial part of the contract between the client and the creative team.

By the end of this stage it should be very clear what is trying to be achieved and what needs to be done to achieve it. How it is to be achieved is what the next stage of the process, "developing initial ideas", is about.

This second stage of the design process is often seen as the time when design really begins. The first stage was very much about establishing boundaries and defining all the things that cannot be done. Now the focus is on exploring the creative possibilities of the design space that has been established and finding out what can be done within the limits of time, budget, resources and the overall objectives of the project.

It is also the time when the project seems to come alive and begin to take on a real personality of its own. The ideas and concept that were hitherto largely expressed in words now begin to taken a more concrete form. The shape and feel of the project starts to emerge through a variety of predominantly visual analogues representing how this project will be experienced by its intended audience. Ideally these ideas would emerge from discussion and debate between the different members of the

creative team. This will consist of the project coordinator, the hypermedia designer and software engineer, and may also include other specialists such as graphic designers, illustrators, writers and information designers.

There is a variety of ways of developing and presenting these ideas and in most projects a number of different approaches will be used. These methods include mood boards, sketch visuals, structural schematics, storyboards, scenarios, treatments and prototypes.

Mood boards can be a very quick way of establishing the overall "look and feel" of a project. They consist of a collage of images, typography and colours derived from found objects, such as pictures from magazines, that begin to establish a visual and emotional style for a project. They are a very useful way of communicating the approach to both the client and to the members of the design team.

Sketch visuals are the first set of ideas developing the visual look of the project. They may be produced on screen or as a mix of paper sketches and screen shots. Their function is to begin to establish the visual feel and style of the project.

Structural schematics are a formal way of mapping out the structure of the "space" the users will be able to move through. They define what events occur and where they are located. In very many cases those events will be defined in terms of information to be presented to the user. In others they will be defined in terms of the transactions or actions the user participates in.

Storyboards are an informal kind of structural schematic which can be very illuminating both in terms of exploring how users may move within a hypermedia environment and in describing that space. Unlike a traditional, linear storyboard for a film, a hypermedia storyboard will look more like a flow chart and can even take up several walls to show all the possible interactions.

AMXdigital: Saatchi & Saatchi Innovation Award Internet site

First sketch of possible Internet site structure.

A scenario is a means of describing how a user may move through one session within a hypermedia environment. Scenarios, being time-based, are always linear and may be described in text or images or a mixture of both. Scenarios should always begin and end with events in the real world, such as someone deciding they need to find something out and going to the product to find it. A well-chosen scenario can often reveal problems and opportunities that can be concealed while looking at the bigger picture.

Like storyboards, a treatment is another technique that originated in the film industry. Just as a film treatment expresses in a few pages the essence of the mood, story and style of a movie, so does a treatment for a hypermedia project. Unlike a film

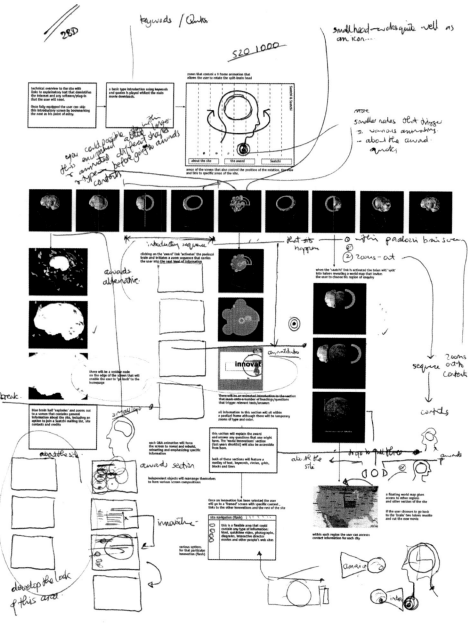

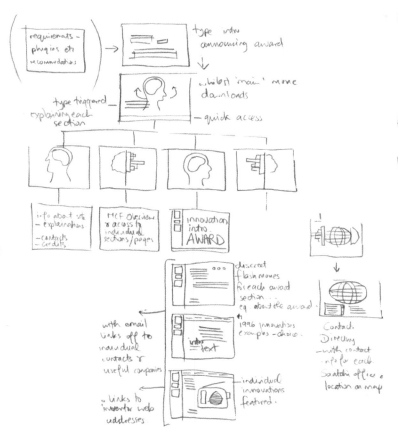

AMXdigital: Saatchi & Saatchi Innovation Award Internet site

The project flow chart begins to take shape. Many iterations of the site will be considered as potential content, structure and navigation issues are explored.

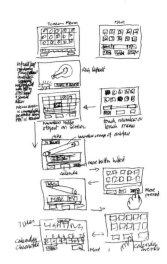

treatment, however, it will almost certainly use images, diagrams and words to evoke a sense of the experience that the finished product will ultimately provide.

All the techniques described so far have been paper-based or have used static screens. As such, they require considerable imagination and experience to see how they would work as hypermedia. This is why from a very early point it is vital to be producing "demos" or prototypes using hypermedia tools themselves. These can be very crude screens simply labelled with descriptive text and some means of navigating between them, or they may be a simplified expression of some of the major elements of the project shown in a relatively sophisticated way. They may be produced by the hypermedia designer using an authoring package such as Macromedia Director or in HTML. In more software-intensive projects the hypermedia designer may collaborate with the software engineer to produce prototypes using a programming environment such as Microsoft's Visual Basic or Borland's Delphi.

This stage of the design process is about defining, in very practical ways, the design direction and strategy of a project. The outputs of the techniques outlined here are the visible manifestations of that direction and strategy. When these are combined with those from the first stage the design team will know what is to be achieved, and what needs to be done to achieve it. They can then move on to the next stage of producing the detailed design.

developing a detailed design

It is worth remembering that hypermedia is still a very young medium. It is here, at this third stage of our proposed model, that this becomes most apparent. The two stages we have described so far can be applied to any hypermedia project and will no doubt remain broadly the same in the future. It is at this stage of developing a detailed design where difficulties begin to appear in proposing a generalized model. Not long ago this would not have been the case, but the emergence of the World Wide Web has thrown many earlier certainties in to confusion. To explain why, and to map a route out of these confusions, requires stepping back and looking at both the current state of the art of designing hypermedia and how it is changing.

Until very recently hypermedia design was seen in terms of producing a self-contained, finished product. This stage was primarily concerned with defining in detail what that product would be. In some cases this process of definition consisted of extending and refining the prototype that had been developed until it became the finished product; the process of design and production would thus merge seamlessly. In others, there was a clearer break, with the detailed design produced at this stage being handed over to the software engineers who would complete the process by assembling all the media elements. In either case the goal was closure, the production of a finished thing, in the same way that a book, film or television programme is complete in itself.

The nature of the World Wide Web challenges this paradigm, in ways that have implications for disc-based hypermedia as well. There are three main attributes of the Web that present the hypermedia designer with exciting new possibilities requiring a mode of creative thinking very different from more traditional media and the paradigm of hypermedia as a published product. Firstly, a Web site can be seen more as a hypermedia environment that can grow and evolve over time rather than as a finished, contained product. Secondly, the physical and practical constraints that limit the size and complexity of more traditional media types do

AMXdigital: Saatchi & Saatchi Innovation Award Internet site

Preparing the structural plan for client sign-off.

not apply in the same way to networked hypermedia, so that we can see very large and complex sites emerging. Thirdly, since the World Wide Web can be seen as one very large hypermedia system, the question of where a Web site is "located" (in terms of its connections with other Web sites) itself becomes a design issue.

The practical implications of this paradigm shift are still being digested and it will take time and experience for the appropriate methods and approaches to deal with them to be developed. However, what is already clear is that increasingly the emphasis in hypermedia design is going to shift from products to processes. This is certainly true for Web design and may even affect disc-based hypermedia, with the contents of a disc being seen as part of a larger, evolving system, rather than something complete in itself.

What this means in practice is that this stage of the design process is increasingly going to be concerned with establishing guidelines and procedures, rather than simply refining and implementing the initial ideas for a finished design. In other words, it becomes a process of defining a framework and strategy for how a hypermedia environment will develop and evolve, its overall visual style and identity, and the criteria for editing, modifying and adding to it. Of course, a shift as dramatic as this is unlikely to take place very quickly, and for some time to come the "product" mindset is likely to be very strong, particularly among designers from a more traditional media background. However, as we have already seen, things change very fast on the Web and a shift to a "process" mindset has already begun.

This is likely to mean that this stage of the design process assumes a more distinctive identity and importance. Indeed, the guidelines, style guides, templates, processes and procedures produced at this stage may become the principal outputs of many hypermedia design studios rather than the design and production of finished hypermedia products.

AMXdigital: Saatchi & Saatchi Innovation Award Internet site

Having established a theme and navigational structure, work on the front page, from which all parts of the site can be accessed, is begun. Exploring the concept of the human brain as a visual metaphor for the origin of ideas, a 3D model begins to be formulated. Rotating the model gives the user access to different paths for travel through the site. The human brain is conveniently composed of two halves – each dealing with different aspects of activity and thinking. AMXdigital emphasized this in their model and use an anatomically correct drawing style to represent the historical and purely information-based parts of the site. The other half, drawing on the works of Eduardo Paolozzi for its inspiration, allows access to the award itself. It is intended that the site will become a forum for creative discussion on all matters of invention and innovation.

**AMXdigital: video editing
on desktop equipment**

Video and audio media
elements form a central part of
many multimedia projects. Raw
material can be gathered using
inexpensive Hi8 or digital video
cameras and edited with
software tools such as Adobe
Premier and Macromedia
SoundEdit Pro.

A s we have seen in the "Media Matrix" section of the book, any hypermedia product or environment will consist of a combination of different media elements. The role of the hypermedia designer is to create the structure in which those different media elements will fit. In some cases they will already exist, though not necessarily in the right form. In other cases they will have to be specially created. While the hypermedia designer will specify what is to be used or created it is the role of the project coordinator to ensure that all the media elements required are brought together at the right time and in the right form. The issues here are very similar in both the "product" and the "process" model of designing and producing hypermedia.

First of all there are legal and commercial issues. If all the material to be used is already owned by the client or is being generated by the design team this is no problem. But in other cases negotiating the right to use material such as a piece of music can be very time-consuming and may have significant implications for the overall budget of the project. Clarifying who owns what and what media elements need to be acquired or created is something that needs to be resolved very early in a project.

Secondly, practical and technical issues need consideration. The process of converting pre-existing material, particularly when it is in non-digital form such as photographs or video, is one that needs careful consideration because it can be both time-consuming and expensive. Two points need to considered simultaneously here. First, the particular form of delivery platform (the user's system) will have its own requirements in terms of resolution of images and file types and the material will have to be in the correct form to take account of this. Second, since digitizing material is expensive it may be worthwhile to consider whether this material may be used again in other contexts. If that seems likely it may be sensible to digitize it to the highest possible

```
-- script for DTP Index 'Inkjet'
on mouseUp   -- when mouse button is released

  hide card field id 5   -- hide help text
  save                   -- save current state
  set pattern to 12      -- set spray pattern

  repeat with i = 1 to 9   -- starts repeat cycle
    spray 175,150 + i* 10  -- spray the dots, left edge of 'N'
  end repeat               -- ends repeat cycle

  repeat with i = 0 to 6       -- spray the dots, diagonal bar of 'N'
    shift 165 + i*5
    spray 180+i*5,170+i*10
  end repeat

  shift 200
  repeat with i = 1 to 9       -- spray the dots, right edge of 'N'
    spray 215,150 + i* 10
  end repeat

  wait 3 secs
  revert                 -- revert to current state
  choose browse tool     -- selects the 'finger' mouse pointer
end mouseUp              -- terminator

-- subroutine 'spray'
on spray x,y                  -- spray a single dot at position x,y
  choose brush tool
  set brush to 31             -- selects brush style
  play "spray"                - play spray sound
  drag from x-1,y-1 to x-24,y-24   -- spray lines
  set brush to 5              -- new brush style
  click at x-36,y-36          -- paint dot
  lock screen                 -- disable screen updates
  choose select tool          -- selects rectangular marguee
  set dragspeed to 0          -- sets the fastest dragspeed
  drag from x-21,y-21 to x+13,y+13  -- selects this area
  cut                         -- cuts this area
  unlock screen               - update screen
end spray

-- subroutine 'shft val'
on shift val                  --- move print head right 6 pixels
  lock screen
  choose select tool
  drag from val,140 to val+72,370
  drag from val + 1,141 to val+6,141
  choose browse tool
  unlock screen
end shift val
```

Asif Choudhary: Script from DTP Index

HyperTalk scripts are the programming language of HyperCard. Simple HyperTalk scripts can be easily written by non-programmers, and scripting is an excellent introduction to programming. Professional programmers like Asif Choudhary can write elegant programs for on-card animations such as this, which uses HyperCard's painting tools to create drawings in real-time.

resolution and in a file type that will offer the greatest flexibility in terms of its possible future use.

Thirdly, there are creative and organizational issues. This is the part of the process that is most likely to require input from many different specialists including writers, illustrators, photographers, recording engineers, composers, animators, video-makers and software engineers. In many cases these specialists will be working to a very precise brief and will not have the overall picture of the project that the central design team has. Making sure that what is being produced is right for the job and is being delivered at the right time becomes a key issue in the success or failure of the whole project.

It is perhaps most clear at this stage that creating successful hypermedia products requires a complex mixture of creative, technical and organizational skills, which can best be achieved by teams of people who respect and understand the contribution that each needs to make.

```
-- script for DTP Index 'Frisk Film'
on mouseUp    -- when mouse button is released
  hide card field id 6        -- hide help text
  save                -- save current state
  choose spray tool      -- uses Supercard's paint spray tool
  set pattern to 12        -- set spray pattern
  set dragspeed to 2        -- sets speed of spray action
  drag from 250,145 to 150,145    -- spray line from x,y to x1,y1
  choose bucket tool      -- uses Supercard's paint fill tool
  click at 140,147        -- fill letter R
  wait 2 seconds      -- displays the finished result for 2 secs
  revert            -- revert to saved state
                   ...ts the 'finger' mouse pointer
```

Script error: Handler not defined

⚠

#count

[Quit] [Continue]

Authoring windows

Media elements are combined and controlled using authoring tools such as Allegiant SuperCard. In SuperCard, any object in the project can contain a script – a computer program written in simple commands – which determines what happens when the mouse pointer is over the object and the mouse button is clicked. Object scripts can be edited easily in the attached "script window".

This is the final aspect of the design and production process. Its three components are distinct but closely related activities. However, as we have seen before with other aspects of the process, whilst it is useful to think of this as the last stage both conceptually and, in some cases, practically, these may all be activities that need to be considered very early on in the design process. It is also here that the greatest practical differences between the "product" and the "process" model of designing and producing hypermedia appear.

In the "product" model integrating the media elements is often an elaboration of the detailed design stage with design and production merging seamlessly. In a limited number of cases there may be a more distinct break, with the design and "creative" aspects of the project being completed before handing over to the software engineers to "put it all together". In the "process" model it is very different. Here new media elements will continue to be added over time and the design issue is how this should be done.

The testing phase involves ensuring that what has been produced works both technically and functionally. In the "product" model this is something which has to take place after the product is effectively complete, and before it is released to its intended audience. However, even here, there are opportunities to test different aspects of the product right from the creation of the first prototype. Indeed, developing a testing strategy that runs throughout the project should be part of the very first phase of the design process. In complex or innovative projects this should include user-testing at the earliest opportunity.

This point applies equally to the "process" model, but if anything a testing strategy is even more important in this case and takes on a creative as well as practical aspect. In the "process" model testing is an on-going activity and feedback from the user (both directly, in terms of their comments and suggestions, and indirectly in terms of studying their behaviour) can play a vitally important role in shaping the direction, development and evolution of a hypermedia environment.

Maintenance is the term given to the updating of a product after its first release; it may also involve fixing certain software "bugs" or content errors. Until the development of the Word Wide Web maintenance was rarely seen as anything more than a peripheral issue except, perhaps, in terms of updating reference works. But with on-line projects such as Web sites, and with disc-based projects such as kiosks or information systems, the question of maintenance and updating has become a key design issue that needs consideration when the project is first being formulated.

Maintenance may on one level involve the development of manuals, templates and style guides but can also involve a more fundamental set of strategic guidelines about the future development of a hypermedia project. This becomes a central concern in the "process" model, where we are dealing with hypermedia environments that have, right from the start, been designed to evolve as they are used. This is perhaps one of the most exciting potentials of hypermedia and may be the one that transforms our notion of maintenance from being a rather dreary design problem tagged on to the end of a project, to being one of the most challenging and stimulating issues facing the design team. It is here that testing and maintenance may cease to be seen as separate issues and join together to become the central focus of hypermedia design itself.

Both the range and number of hypermedia applications have expanded very rapidly during the 90s and look likely to continue their explosive growth for at least the next decade. In this section we look at a number of examples of how the medium is currently being used. Our criteria for selecting examples has been twofold. Firstly, we wanted to show the wide variety of uses and approaches to the medium that have already been adopted. Secondly, and perhaps more importantly, we hope that some of the examples we have selected provide pointers to the future development of the medium.

This section can be used in many ways. For some it will simply be a way of getting a snapshot of how the medium has developed to date. For others it will be a means of making more concrete several of the issues we have raised in other sections of the book. This section may be used as a source of inspiration and for hypermedia project ideas. It may also be used as a way of mapping out the new opportunities of communicating and of doing business that the medium presents.

One thing that this section should communicate is a sense of flux. The landscape of hypermedia, its applications and the technologies that support and deliver it are constantly moving and shifting. The categories in which we have placed our various examples reflect this instability and are areas of focus without clearly defined boundaries. Some of our examples could fit into a number of different categories depending on the perspective of the viewer. This blurring and redefinition of categories is likely to continue in the immediate future until the medium matures and until we can clearly establish where it fits into the network of activities that it can support and facilitate.

The eleven categories or areas of focus that we have identified represent different sets of creative problems and opportunities for hypermedia designers. They could be described as growth points, where the particular nature of the problems and opportunities presented encourage different characteristics of the medium to be emphasized and developed, before migrating to other areas where they may be useful. For example, we could realistically expect issues of storytelling and narrative to be most thoroughly explored in the world of entertainment, but what one discovers there may be equally relevant to hypermedia focused on learning. Similarly, creative work in what we call socialware (convivial places in cyberspace where people go to interact with one another socially) could have important implications for hypermedia designers creating business environments.

Throughout this book we have made many references to the future, because in hypermedia the future is always very close at hand. What may seem impossibly futuristic today, may become a practical reality tomorrow. Indeed, the pace of technical change and the flurry of novelty can often seem relentless. When this is combined with the scale of change that some of these developments imply there is a temptation to draw back and dismiss many of the claims made for the medium as hysterically extravagant. Such a stance is misguided. While it is true that much of the marketing of the medium has been marked by hype and hyperbole and that this is still a very young medium with a long way to go, it is also true that there is now a considerable body of work in the area that is performing practical and useful functions in the "real world".

Readers of the first edition of this book can judge for themselves the rate of progress that has been made in the few years since it was first published. We hope that many of the examples we have chosen, as well as the pointers to future development provided, will demonstrate that we are now dealing with a medium that does not need to be spoken of in the future tense, but has immediate, practical, working applications, right now.

5

hypermedia **applications** making use of the media

There are now several generations of young people for whom the screen has been a more potent stimulus to their imaginations, and a more powerful source of information, and ideas than the page. These are the people who have grown up with multi-channel television and video games and are used to making sense of what to older generations seems like a fragmented and disjointed media world. For this group, making links and connections and actively exploring screen-based media is something quite natural and unexceptional. These people are the key constituency for groundbreaking hypermedia, because they already have the conceptual framework and the skills to deal with it. They are hypermedia literate and their numbers grow inexorably each year.

Children have been enjoying the new media since the days of the first video games and programmable micro-computers in the early 70s. In the last ten years, with the global success of Nintendo and Sega, and more recently 3DO and Sony (not to mention Atari, Amiga, Macs and the ubiquitous PC), children have rapidly acquired the core skills necessary for mastery of the new computer-based media. These include both the physical, manipulative skills of mouse, keyboard,

joystick and thumbpad control; and the cognitive skills necessary to navigate through cyberspace, to induct and deduct rules from a simple interface and a rapidly evolving gaming environment, and to solve complex spatial and logical problems.

This set of skills is now widely shared by a global population of technophiliac youngsters that cyber-writer Doug Rushkoff calls "screenagers". These young people not only share this common skill-base, but have evolved a more or less generally held set of criteria for assessing the worth of new media products.

Given the size, trend-setting and spending power of this critically aware screenager market, publishers and designers have gone to great lengths to develop ever more sophisticated and ingenious gaming and programme experiences. Several products stand out as important milestones in the development of great screenager interactive entertainment (and, incidentally, demonstrate the enormous range of approaches). For the real youngsters, there is Broderbund's KidPix and related products (practical creative tools with high levels of interactivity, good use of randomness and innovative use of multimedia such as paint brushes with sound effects). For older children there are Myst (setting the style for a gentler, intensely visual, problem-solving interactive narrative) and Doom (for the intense realism of realtime 3D environments and the creepy

dazzeloids
voyager

Rodney Alan Greenblatt has created a delightful set of characters in this children's interactive "comic strip". He developed new multimedia techniques to create the drawings, and imported them into Photoshop for colouring, using a pre-set range of colours and custom palette. With a simple but successful "interrupted linear" narrative structure, children can follow the story while exploring each frame for interactive pop-ups, sound effects and comments.

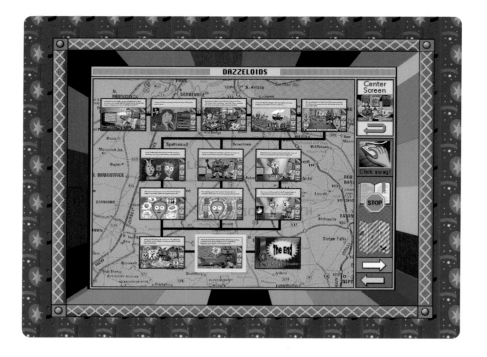

suspension of disbelief as you suspect someone or something is "behind you"). Maxis' SimCity also stands out as probably the most successful in the "god game" genre (you are given control of an entire city, and are responsible to the inhabitants for their welfare). Nintendo's Super Mario and Sega's Sonic set global standards for gameplay, interaction and the optimum use of processing power and hardware capabilities. In the arcades, the introduction of virtual reality multi-player games by companies like Battletech and Virtuality has brought new levels of sensory immersion to the gaming experience.

Every medium needs an audience with critical standards and expectations that are high enough to drive up the quality of what is being produced and to encourage the creators to push the boundaries of what they can deliver. Screenagers are just such an audience and we can predict with confidence that the most innovative and creative uses of hypermedia will be directed at them.

PAWS, the "personal automated wagging system" sowed the seed of "virtual pet" software. The witty and engaging game has something to appeal to screenagers of every age – being lively and direct, appealing to the young, and with visual jokes and asides attracting the older user.

paws – dog simulator

voyager

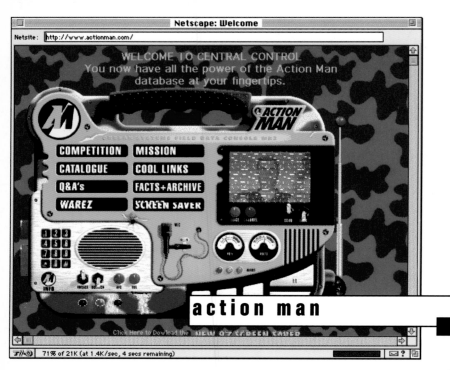

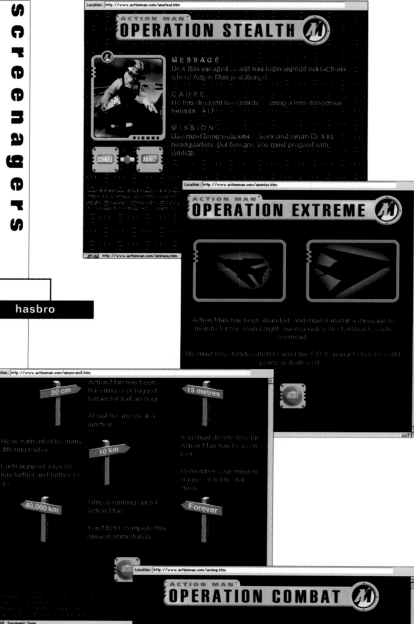

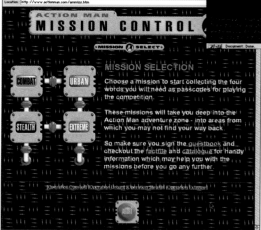

Actionman.com is a *tour de force* of "advertainment" – an ingenious mix of brand projection and product features, combining interactive missions that users are challenged to perform. The sense of engagement that is engendered between the sub-teen male audience and the product is reinforced by military-industrial graphics and high-tech control panels throughout the site.

http://www.actionman.com

By 1976 ...cene was ...ated by aging rock star...
with mass... ...played th... ...stadium gig. In reactio...
againsthe early 1... had seen the emergence...
of a numb... ...hat worked ...etwork of pubs and clubs
throughou...For many ...s brought music back to
a grassat was more ...ccessible and visceral.
While cl... ...k like Max's Kansas City and CBGB's
providedcious counte... point for this trend with
the New Iggy Pop leading the way, the point
was partad of musical excellence: The Sex
Pistolsf being lousy musicians.

punkzine

bob cotton & matthew mayes

Matthew Mayes is one of the designers who successfully
integrates graphics, media design and programming
into his work. Perfect for "Punkzine", Matthew was
given a free hand by art director Bob Cotton, whose role
became that of structuring the programme and critiquing
details of treatments. The result is a seamless exploration
of punk rock, in which freeform user-interaction is
encouraged with a wide range of interactive navigational
tools. Digital audio is used here both to contextualize and
to link the video, graphic and photographic information.
It is often adjustable with mouse movements across
the screen.

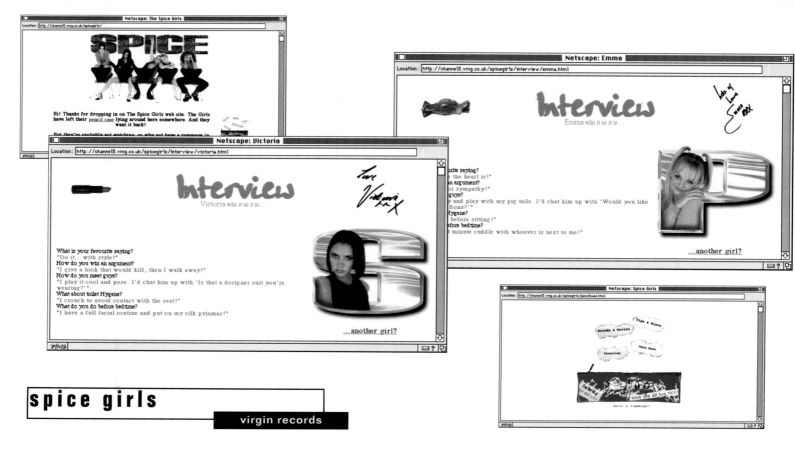

spice girls

virgin records

Very soon every popular entertainer will have to have their own Web site. It is rapidly becoming as important a part of the image-building process as exposure in any one of the more traditional media.

http://channel3.vmg.co.uk/spicegirls

114

Netscape: Melanie C

Location: http://channel3.vmg.co.uk/spicegirls/interview/melc.html

Interview
Melanie C tells it as it is...

What is your favourite saying?
"You'll never walk alone!"
How do you win an argument?
"I DECK 'EM!"
How do you meet guys?
"I give a shy glance then flex my biceps. I'd chat him up with 'I've got two tickets for a Liverpool match, do you fancy commin'?'"
What about toilet Hygene?
"Me? I use the urinals mate!"
What do you do before bedtime?
"I do 50 stomach crunches!"

...ano[ther]

Netscape: Melanie B

Location: http://channel3.vmg.co.uk/spicegirls/interview/melb.html

Interview
Melanie B tells it as it is...

What is your favourite saying?
"Get'em out for the lasses!"
How do you win an argument?
"Shout and shout and shout more...even when they've gone!"
How do you meet guys?
"No hesitation, I'd bowl over to him and tell him I fancy him. I'd chat him up with 'Forget the small talk what's your......?'"
What about toilet Hygene?
"I don't go!"
What do you do before bedtime?
"I just fall down in a comfy position anywhere!"

...another girl?

Netscape: Spice Girls - Tips 'O Hints

Location: http://channel3.vmg.co.uk/spicegirls/tips+hints/index.html

click on the girl of your choice and discover the secrets behind...
...Girl Power!
victoria · emma · melanie c · geri · melanie b

Location: http://channel3.vmg.co.uk/spicegirls/interview/g[...]

What is your favourite saying?
"This what we're going to do...!"
How do you win an argument?
"I throw in a lot of big words and a lot of verbal to confuse the situation!"
How do you meet guys?
"I go for eye to eye contact then I lunge. I'd chat him up with 'Hey Mr Scorpio here's 10p...call your Mum 'cos you're not going home tonight!'"
What about toilet Hygene?
"I put a pattern of toilet paper down first!"
What do you do before bedtime?
"Plan the next day!"

...another girl?

blam !

voyager

BLAM! is proof that you do not need the most advanced technology to create an exciting hypermedia product. Designed to be used on the early b/w Apple Powerbooks, BLAM!'s tough graphics and aggressive use of sound still provides a compelling experience.

Some of the most exciting and ground-breaking hypermedia is created when designers and design groups create promotional pieces for themselves. Unconstrained by such everyday restrictions as an external art director, a client's branding manager or a corporate identity manual, they can focus on showing what they can do best, experimenting with interface, navigation devices, use of media and content to sell their creative and technical skills to potential clients.

These promotional pieces are often elegant demonstrations of the designer's media and programming skills, as well as indicators of how well they organize information (the content of their portfolios, their career resumé, client list, and so on), how good they are as interface designers (in terms of navigation as well as screen design), and importantly, how well they blend fluid user interaction with a seamless multimedia experience.

By this we mean that the great virtues of hypermedia are twofold: it is interactive and it is multimedia. Blending these two together and creating that seamless experience for the user, an experience where the user is offered a variety of "ways in" to a body of information, in a range

of different media, is the great challenge for the hypermedia designer.

To do this well, the hypermedia designer has to synthesize knowledge from many different disciplines – including human-computer interface design, information design, graphics and typography and programming – and combine it with technical knowledge of the chosen medium (floppy disk, CD-ROM, DVD, Internet, local area network, kiosk, and so on). They may

also draw on their familiarity with and critical knowledge of the various media (such as animation, video, games, 3D and VR) that are incorporated in the work. The result should not only provide users with an informative, easy to navigate programme in which they can browse or access information directly but, ideally, should also provide users with a truly multimedia experience. This should make optimum use of whatever bandwidth is available, optimum use of the processing power of the user's machine to enhance the programme's interactivity, and (rare as yet) optimum use of the telecommunications aspects of the Internet work.

portfolio

joshua dixler

This stylish portfolio by Joshua Dixler uses the typographic designer's grid as a design motif that is reinforced in the miniscule navigational grid, lower right. These colour-coded squares indicate which items in his portfolio are related to the work being viewed.

click the green squares to display the artwork. the purple squares indicate other relevant pieces. the white square displays address info. to quit and return to the finder press command-q.

help

While the market for people with hypermedia skills will undoubtedly expand greatly over the next few years, it may well be a bumpy ride, with severe contractions interrupting the overall trend. This volatility will be part of the process of the medium's progress, which will make some narrower skills obsolete, such as the ability to use a particular applications package or programming language, and in turn create the demand for creative people who can keep ahead of developments.

This is why, despite the overall growth trend, the market is likely to remain very competitive. It is also why self-promotional work is likely to remain a key driver in pushing the capabilities of the medium forward. This looks set to continue to be one of the major areas of research and development within the hypermedia industry because it combines the freedom and challenge of expressing the best of what a design group can do creatively with the discipline of producing work that will attract good clients in a very competitive market.

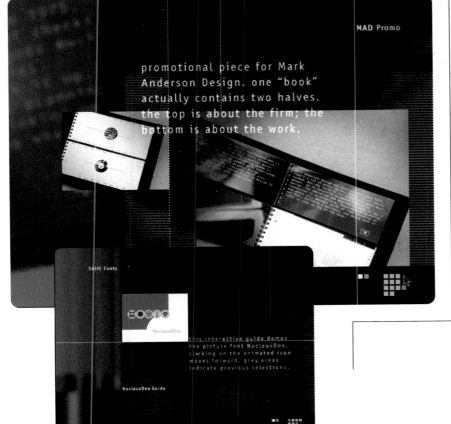

MAD Promo

promotional piece for Mark Anderson Design. one "book" actually contains two halves. the top is about the firm; the bottom is about the work.

Shift Fonts

NucleusOne

this interactive guide demos the picture font NucleusOne. clicking on the animated icon moves forward. grey areas indicate previous selections.

NucleusOne Guide

self-promotion

david de angelis

Designer and producer David de Angelis uses both CD-ROM and his own Web site, www.joycatcher.com, to promote his own work.

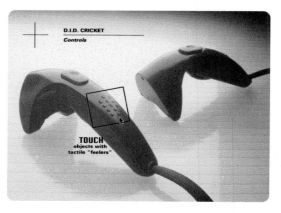

This CD-ROM, showcasing the work of the Ecco Design Studio, is itself a showcase of how to present 3D product design projects effectively and interactively (without complex VR technology). In a restrained, formal approach, Ecco has included stylish rollover sound effects, such as clanking streetcars on the San Francisco address.

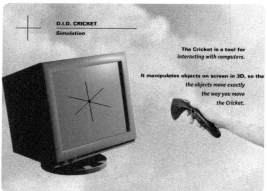

ecco

ecco design

cyderspace

middlesex university

This elegant and witty Web site was designed by MA students, Vassilios Alexiou, Lars Eberle and Ines Pach, for a competition organized by D&AD and Apple, for a site promoting Apple products to students.

portfolio
sally coe

Sally Coe's self promotional portfolio features some inventive touches, such as panning to the next frame when the user expects a cut; a particularly effective means of gaining attention for her work.

cognitive overhead
maxine gregson & rory hamilton

A witty, playful and very creative deconstruction of the Apple Macintosh desktop. Maxine Gregson and Rory Hamilton worked on this project while students on the postgraduate interactive multimedia course at Central St Martin's, London. Filled with inventive ideas and visual gags, this delightful piece has proved to be a very effective form of self-promotion.

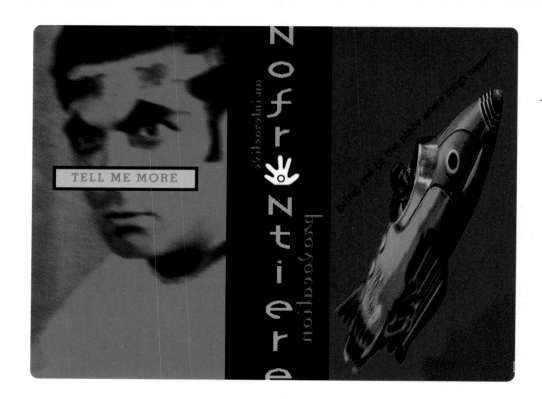

TELL ME MORE

digital portfolios

interactiveland

noFrontiere

In Interactiveland, the Nofrontiere group focused on the liberating
aspects of the new media (the tangible possibility of global
communications systems created ideas of universal education
and access to the new technologies) and presented these ideas
with characteristic verve and style.

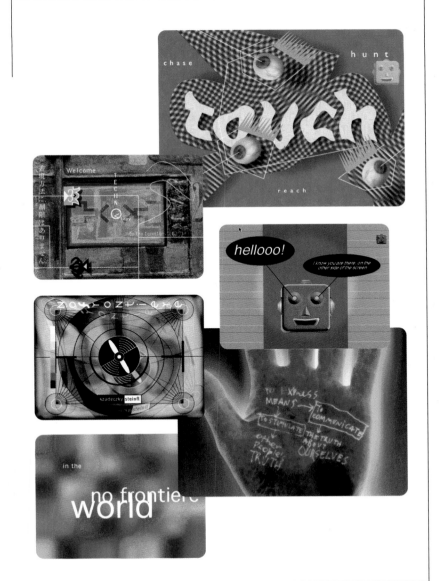

from paper to pixels

D igital publishing represents an interesting paradox. On the one hand, it appears to be flourishing, with an extraordinarily wide range and high volume of published material on the Internet and CD-ROM. On the other, many publishers who had been moving heavily into the area in the early 90s seem to be moving out again in the second half of the decade.

Stewart Brand, the American inventor, designer and author expressed a similar paradox in his seminal book, *The Media Lab*. In it he coined the phrase "Information wants to be free; information also wants to be expensive". Information "wants to be free" in that digital technology makes information extremely cheap to reproduce, distribute and copy. It also wants to be "expensive", however, because it can be very valuable to the recipient. What he did not say, but could also be added, is that it also wants to be expensive because it can cost so much to conceive and produce.

Digital publishing is flourishing because it is cheap to reproduce and distribute. On the World Wide Web such costs are effectively zero and this has led many people to publish there – both commercially and non-commercially. The costs of reproducing CD-ROMs are also relatively low, but many publishers have been moving out of that area, which at one time was seen as the future of publishing, because the costs of actually creating them have been too high in relation to the number of people willing to buy them. Some of the large publishing corporations who ventured on to the Web have also withdrawn because their potential advertising revenue has not matched the costs of producing content. While this paradox may seem confusing, it may be a sign

of health rather than failure. Hypermedia is a very young medium with new possibilities. Simply producing what are effectively digital books or magazines or newspapers seems a sure recipe for commercial and creative failure. Creating new kinds of media experience, which exploits the unique capabilities of hypermedia, may turn out to be the recipe for commercial and creative success.

As the American media mogul Barry Diller has argued, in a speech (accessible on the Web) that should be compulsory reading for anyone intending to publish commercially in this new medium, the task is this: "Redefine, don't repackage." This process of redefinition includes creating new business models and new kinds of relationship with the audience, as well as offering new kinds of media experience. Technological developments such as "push" technology, which feeds previously selected kinds of information directly to a user's

electronic telegraph

One of the first British national newspapers to go online, the Electronic Telegraph has a "youthful" feel. Its established editorial style exploits the advantages of hypertext links to related news and hot-links to relevant outside Internet sites.

http://www.telegraph.co.uk

fast company

Launched simultaneously as a monthly business magazine and as an online publication, Fast co exemplifies the emergent growth of media publishing where on-line and traditional forms mutually support and promote each other.

http://www.fastcompany.com

computer without them having to look for it, may be one example of this process of redefinition. But there will be many others which are simply the result of a brilliant new creative concept rather than any particular advance in technology. The confusions and paradoxes of this area are what make it one of the most exhilarating areas of all; meaning that it is wide open for innovators, entrepreneurs and designers with creative ideas. Even in the few years that work has been produced in this area, we have seen glimpses of something quite new and creatively very exciting beginning to emerge, promising much for the future of a medium freed from the legacy of paper and enjoying what its pixels can show.

The on-line offshoot of the influential *Wired* magazine, Hotwired very rapidly acquired its own distinctive identity. Generating much of its own material, it also offers on-line access to articles in its parent magazine, such as Barry Diller's key "Redefine, don't repackage".

http://www.hotwired.com

hotwired

The first of a new kind of online publishing, Pointcast utilizes "push" technology to deliver customized news directly to the user's computer. Users select the information they want – such as business news, sports results, weather forecasts and so on. Information can be updated continuously, at intervals or at point-of-connection (depending on the Internet connection).

http://www.pointcast.com

pointcast

Feed is a Webmagazine of culture, politics and technology, focused on quality writing and an innovative use of the two-way nature of the medium. Readers make an active contribution by providing comments and opinions on its contents.

http://www.feedmag.com

feed

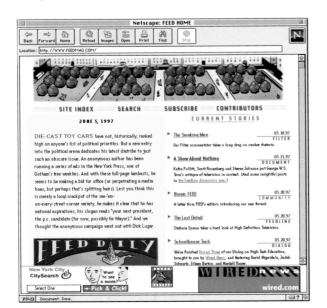

the complete maus

voyager

from paper to pixels

Art Spiegelman's Maus started life as a comic strip, recording his family's personal experiences of the Holocaust; it became the first really successful interactive treatment of the comic strip medium. Voyager's Maus CD-ROM not only contains the complete strip (in a format that allows the user to view the whole page, or zoom to individual frames) but also Spiegelman's sketches and notes, an interview between him and his father, several other contextual sections, and his studio notes on the creation of the work. Voyager has brought much work from traditional media into the digital domain, and this is the best CD-ROM in the comic-strip genre.

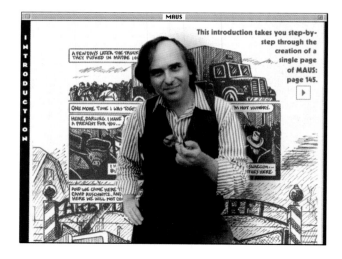

This introduction takes you step-by-step through the creation of a single page of MAUS: page 145.

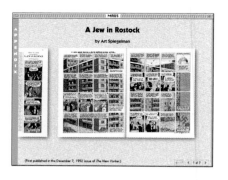

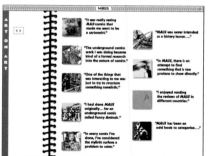

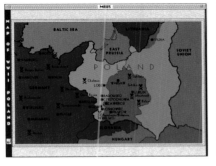

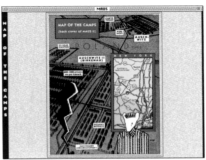

MAUS Find : Vladek Audio

Double-click item to go to page :

Page : 7
Page : 10
Page : 11
Page : 12
Page : 13
Page : 24
Page : 25
Page : 26
Page : 27
Page : 28
Page : 31
Page : 37
Page : 38

Vladek : Page 24

HIDE TEXT 1 of 1

Once I got a telephone from my parent, from her parents, that I have to come immediately home and to lock up the factory. Of course, "immediately home," I was afraid what happened. But I came home. I have seen that she is sick, how she is laying. She started crying when she has seen me. And the doctor said that she has to go to a specially sanitarium. In Czechoslovakia there is a sanitarium what is called Freiwaldau, and this sanitarium is for such people like her. But she cannot go alone. She has to go with somebody else; not only with somebody else, but with somebody who loves her dearly. Only a mother or how is the husband. They told the doctor that the husband is like the mother. He loves her, and he will do everything for her. So my father-in-law said, "We picked out you, and we arrange passports, and you with Anne will go to Freiwaldau, to Czechoslovakia. And I will go back to Bielsko, and I will take care of the factory."

Edited from April 27, 1978 Interview

MAUS Find : Video

Double-click item to go to page :

Page : 58
Page : 67
Page : 73
Page : 143
Page : 179
Page : 184
Page : 188
Page : 193
Page : 207
Page : 220
Page : 271

LES7UNIVERS

CYBER

Kraftwerk
"We are the robots"

Björk
"Enjoy"

CONSOLES COW-BOYS
TECHNO DELIRIUM
et CYBER JUS DE CRANE

Le CD-ROM was one of the first CD-ROM magazines, and is still one of the most successful. The best electronic magazines marry high-quality content with a good level of interactivity; packaging the entire product in a well designed, easily navigable interface. The next significant transition in this genre looks set to be the adoption of "televisual" DVD format disc, which will bring interactive television in disc form to a mass audience.

from paper to pixels

unzip

Unzip was IPC's entry into the e-zine market. Aesthetically and editorially, it is a feast of well thought-through interactive content, with Zone's creative team, including many well-respected interactive media designers and producers. The exceptional contribution of Unzip is the navigation and interface styling – especially the use of the phrenological head with its different exposed features revealing the sections of the CD-ROM.

launch #11

Launch #11 is an entertainment magazine on CD-ROM with direct links to a Web site. Aimed at the 18–34-year-old market, it covers music, movies and computer games. Its great advantage over traditional print media is that its users can actually hear samples of the music reviewed and experience clips from the films and examples from the games, as well as seeing and hearing interviews from their favourite artists.

F or more than two decades, large organizations have been automating their routine tasks. This process has been gradually, if unevenly, spreading throughout the business world and an office without a computer is now a surprising sight. However, this organizational revolution has been largely invisible to the observer except for the ever-growing lumps of hardware that have defined its progress. If one looked at any one of the glowing screens anywhere in the world, it would have been hard to tell which organization it was, what it did and how well it did it.

At a deeper level, there are important differences in the way that information technology has

been adopted. Some organizations have used it to make themselves more agile and responsive. In others the technology has simply reinforced a bureaucratic nature. None of these differences are immediately visible on the screen, however. To get a sense of a company's values and culture one would have to turn to the physical world of its building and its furniture, the clothes worn by its staff, and the masses of printed paper and signage that defined and proclaimed its personality.

We are now on the edge of another revolution. Soon what one sees on the screen will become as much an expression of an organization's identity as any physical artefact in the office. Indeed, what the screen shows may reveal far more about an organization than anything that we have ever been able to see before. As more and more activities, both routine and non-routine, become computer-mediated, the screen will become a window into the soul of an organization, a visible record of how it conducts its business and who it is.

At the heart of this revolution is the World Wide Web. At the beginning of the 90s the paragraph above would have seemed implausibly futuristic in tone. Now, in the second half of the decade, it has become immediate and practical. Those glowing screens that could only display anonymous alpha-numerical characters can now show the whole range of media elements that make up the media matrix. Web technology has suddenly transformed what is possible. Amid a flurry of talk about intranets and extranets and indeed the Internet itself, what we are seeing is the extremely rapid movement of the hypermedia revolution into the very heart of our economic life.

The examples we show in the following pages can barely hint at the scale of change we will see over the next decade, because this move into a richer, more sensuous expression of organizational life has only just begun. A better picture might emerge from looking at all the examples given throughout the book, and imagining how they might be applied within an organizational setting.

adas: intranet

AMXdigital

Intranets such as this are rapidly becoming a key communication channel in any organization. These private networks, only accessible by authorized people, can be accessed from anywhere in the world via the Internet. ADAS consultants, for example, are often out in the field all over the globe, and their intranet enables them to draw on knowledge as easily as if they were in the office.

denny & denny / AMXdigital

Landmarks was one of the first all-digital annual company reports. Designed to be distributed on CD-ROM, the file formats enable the user to print out whole reports or sections as required. Digital versions of such legal and financial company documents offer practical advantages over paper, using the computer's ability to search, find, sort and compare information contained within them — to say nothing of their environmental impact. However, current legislation in many countries still needs to catch up fully with this innovation.

toward the virtual organization

cybernetic imagineering

art, science and technology

The new digital domain of hypermedia and cyberspace is where C.P. Snow's "two cultures" collide and interact together to generate rich new hybrids of art and science. Thus we have computer animation, new forms of simulation, multimedia art, events and interactive applications not possible in any other medium.

Ever since Jascia Reichardt's influential Cybernetic Serendipity exhibition at London's Institute of Contemporary Arts in 1968, which featured the work of artists grappling with the only computers available at that time (large mainframe computers with punch-card input), the technology for simulating all forms of art, and visualizing the invisible, has developed rapidly. This has involved two main strands of research: the hardware and the software of computer imaging and graphics, and the mathematics of complex processes – including chaotic systems and indeed of life itself.

All through the 70s and 80s, research in university computer departments all around the world gradually built up such a repository of computer graphic algorithms, input technologies and display technologies that by the early 90s, artists and animators could create highly realistic, completely convincing images and animations of anything they could imagine. Also by this time, scientists and mathematicians had developed algorithms for exploring chaotic systems and for creating simulations of highly complex processes – even of evolution itself.

While multimedia artists as diverse as Laurie Anderson, Brian Eno and Peter Gabriel have been instrumental in working with professional programmers and hypermedia designers in exploring the new hybrid digital media of the CD-ROM and the World Wide Web, many thousands of student artists and designers have been busy experimenting hands-on with the same media. Meanwhile, artists coming from the science end of the "two cultures" spectrum, such as William Latham and Clifford Pickover,

who have access to very powerful computing facilities, have been instrumental in the popularization of formula-based graphics through their books and, in Latham's case, through his videos for the UK band The Shamen.

Artists, writers, performers and poets are bringing a wide diversity of working practices and philosophies to the new digital hypermedia. Because they subsume all previous media, and incorporate new media such as interactive gaming, telecommunications, simulation and emulation, they present a wealth of new opportunities for wholly new multiple-media art forms.

laurie anderson: puppet motel

voyager

Laurie Anderson, a truly multimedia artist, continues her exploration of the relationship between technology, culture and human emotion in her work with CD-ROM and Web sites.

Similarly, mathematicians, programmers and scientists are using computers in many different ways. These can be summarized as follows: computation – performing highly complex arithmetical and data-processing applications; simulation – the computer modelling of natural processes; and visualization – using the graphics capability of computers to visualize otherwise invisible processes (for example, in particle physics and biology). Computer visualization allows scientist and non-scientist alike to appreciate the otherwise hidden beauty of fractal geometry, strange attractors and other aspects of chaos theory. Biologists, such as Richard Dawkins, and programmers, like Karl Sims, have invented virtual worlds which are a repository of every kind of biological form, and provide the natural selection means to explore this space.

The results of this often collaborative exploration of both the physical world and the world of the imagination by scientists, artists and technologists, pushing computer technology to its limits, will continue to feed through into hypermedia, enriching its vocabulary and its creative possibilities.

The DNC – dance, networks, computing – project was established by Nik Brown as "an attempt to get dancers more involved in the act of creation of digital tools as well as tailoring existing software for use in dance". This includes adapting existing 3D modelling software for set design, digital manipulation software for costume design, dvd technology for archiving dance film/video, networking software for building virtual communities and database software for quickly accessing information.

http://www.websciences.org/dnc

dance network

DNC project

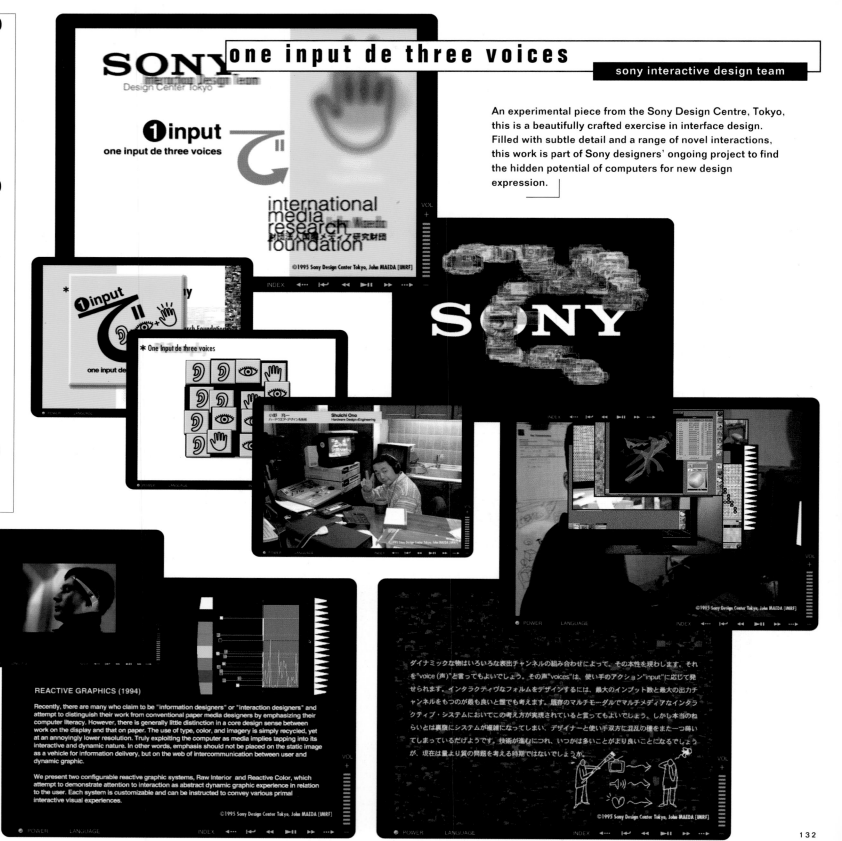

one input de three voices

sony interactive design team

An experimental piece from the Sony Design Centre, Tokyo, this is a beautifully crafted exercise in interface design. Filled with subtle detail and a range of novel interactions, this work is part of Sony designers' ongoing project to find the hidden potential of computers for new design expression.

❶ input
one input de three voices

international media research foundation

©1995 Sony Design Center Tokyo, John MAEDA [IMRF]

REACTIVE GRAPHICS (1994)

Recently, there are many who claim to be "information designers" or "interaction designers" and attempt to distinguish their work from conventional paper media designers by emphasizing their computer literacy. However, there is generally little distinction in a core design sense between work on the display and that on paper. The use of type, color, and imagery is simply recycled, yet at an annoyingly lower resolution. Truly exploiting the computer as media implies tapping into its interactive and dynamic nature. In other words, emphasis should not be placed on the static image as a vehicle for information delivery, but on the web of intercommunication between user and dynamic graphic.

We present two configurable reactive graphic systems, Raw Interior and Reactive Color, which attempt to demonstrate attention to interaction as abstract dynamic graphic experience in relation to the user. Each system is customizable and can be instructed to convey various primal interactive visual experiences.

©1995 Sony Design Center Tokyo, John MAEDA [IMRF]

ダイナミックな物はいろいろな表出チャンネルの組み合わせによって、その本性を現わします。それを"voice (声)"と言ってもよいでしょう。その声"voices"は、使い手のアクション"input"に応じて発せられます。インタラクティヴなフォルムをデザインするには、最大のインプット数と最大の出力チャンネルをもつのが最も良いと誰でも考えます。既存のマルチモーダルでマルチメディアなインタラクティブ・システムにおいてこの考え方が実現されていると言ってもよいでしょう。しかし本当のねらいとは裏腹にシステムが複雑になってしまい、デザイナーと使い手双方に混乱の種をまた一つ蒔いてしまっているだけようです。技術が進むにつれ、いつかは多いことがより良いことになるでしょうが、現在は量より質の問題を考える時期ではないでしょうか。

©1995 Sony Design Center Tokyo, John MAEDA [IMRF]

132

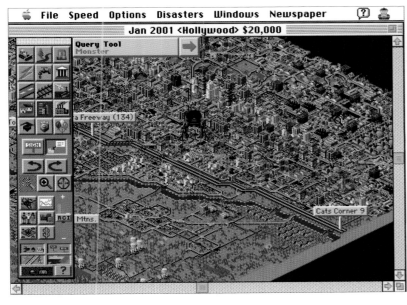

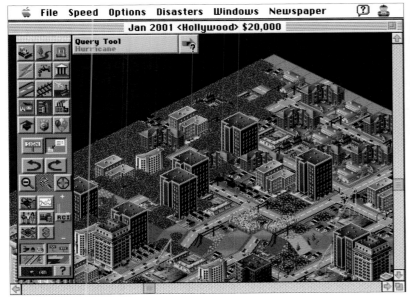

sim city

maxis

Now a popular game, Sim City 2000 (along with its earlier variants Sim Earth, Sim Ants and Sim Farm), is a striking example of simulations – moving out of the research laboratory and on to the desktop computer in the home and office, it involves the detailed modelling of complex systems from the weather to the dynamics of cities.

Commerce is no stranger to cyberspace, though until very recently it has been the province of big business and financial institutions. The volume of buying and selling that already takes place electronically is quite staggering. Take currency trading, for example. Up until the 70s, when electronic trading on a global scale began, the highest trading volumes per year were around three trillion dollars. By 1984 this figure had exploded to about 32 trillion dollars, by 1985 it doubled to 65 trillion and by 1987 it had reached 87 trillion dollars – 23 times the US GNP. In the late 90s it is now estimated that something like one trillion dollars'-worth of currency changes hands each day.

So, trading in cyberspace is nothing new. What is new art the opportunities the World Wide Web presents for trading and shopping on a more ordinary, more human scale. Broadly speaking, buying and selling in cyberspace can be divided into two camps: goods and services that can be put into digital form and distributed over a network, and goods and services that have to be delivered in some physical form after they have been purchased. In both cases, the move into cyberspace requires a careful examination of the

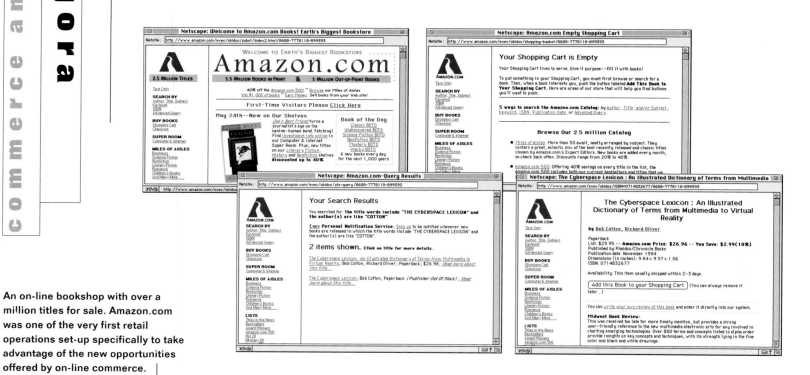

An on-line bookshop with over a million titles for sale. Amazon.com was one of the very first retail operations set-up specifically to take advantage of the new opportunities offered by on-line commerce.

http://www.amazon.com

Amazon.com

different stages between someone becoming aware that they need or want something, and actually receiving and paying for it. This means looking at the new opportunities that digital technology and hypermedia present, and seeing where they can be fitted into this chain of events to offer the purchaser real benefits over more traditional methods.

Currently, this shift into cyberspace is on a point of cusp. There are some obvious technical problems to overcome, such as how to ensure secure payment, and the need for a greater bandwidth to enable digital goods to be delivered at an acceptable speed. These problems are all solvable, however, and perhaps fairly swiftly at that. In fact, what is really surprising is not so much that there are

some practical difficulties, but rather how quickly an infrastructure (enabling people to carry out the different aspects of the quite complex process of buying and selling) is emerging. After all the World Wide Web was only created in 1991 and in a quite uncommercial context. While what had developed by 1997 may look quite primitive in the future, if it continues to develop at the same rate it should soon be capable of offering a real alternative to more traditional means of purchasing a whole range of goods and services.

For hypermedia designers this area presents fascinating problems and creative challenges, for

selling everyday goods and services in cyberspace is largely unexplored territory with few precedents to build on. However, learning should be fast because here, more than in any other area, the feedback is immediate and measurable. Consumers will either respond or not, and their behaviour can be closely monitored and analysed, because every action in cyberspace can be recorded and stored for later examination. This combination of extraordinary opportunities for imagination and innovation, along with rigorous feedback about its effects, will probably drive forward the medium, faster here than in any other area.

tidycat

duffy design/ralston purina

A witty and charming Web site promoting cat litter, a product not usually associated with either quality.

http://www.tidycat.com

This site for Guinness is a big-brand "advertainment" that provides a range of producer-related information and entertainment for the user. The site's impressive full-screen animated opening sequence of rising bubbles offers a choice of several actions, from exploring the brewery's history to brewing your own pint.

http://www.guinness.ie

st james's gate

ogilvy and mather / AMXdigital

Interactive Brewing

In the Guinness virtual brewery, the user is challenged to control the brewing process and brew the perfect pint, in a series of step-by-step frames. Users learn about ingredients and timings, for example, and each frame demands a series of user decisions. In the final frame these are collated and critiqued.

The user can access the history of Guinness and explore the advertising and packaging of the world-famous brand down the ages. One can also click on the "widget" to be led through a sequence of cutaway cans that demonstrate how the device can effect a freshly poured pint of draught Guinness.

YOUR PINT:
Is too watery
Doesn't have that familiar, creamy head

THIS IS BECAUSE:
You left out the Hops
You chilled at too low a temperature

BY THE WAY:
You filled the right number of kegs. All of Ireland's pub landlords are happy!

tesco

Tesco was one of the first major supermarket chains to start exploring how the World Wide Web might be exploited – not just as a way of establishing corporate presence, but in terms of how it might be used as a home-shopping tool. The site is already valuable for providing information on customer services; Web sites will become an important component in the building of brand bonding and customer trust and loyalty.

This stylish and modern Web site, promoting
Fabris Lane's ranges of high-fashion sunglasses is
a good example of how quickly both the quality of
visual design and the technology to support it have
advanced on the Web.

http://www.fabrislane.co.uk

fabris lane

AMXdigital

139

In this quirky, off-beat Web site the overall mood is one of sharing a passion, rather than making a commercial transaction. Everything from the graphics to the tone of voice makes this a fine example of the creation of a "sense of place" on the net. This site is also notable because it was one of the first in which CyberCash's CyberCoin could be used in order to make a purchase.

http://www.peets.com

peet's coffee + tea

cyberCoin

cyberCash

Anyone interested in the future of commerce and shopping in cyberspace should visit CyberCash's Web site. CyberCash's CyberCoin is electronic money that enables very small transactions (under $10) to take place. The development of e-money of this kind will be a crucial step in making cyberspace a place where small businesses and entrepreneurs can thrive.

http://www.cybercash.com

ADchannel

AMXdigital

The ADchannel from Creative Services Network, inspired and produced by Gary Fairfull, is a broadband (1.5 mbit/sec.) network that allows advertising agencies and facilities houses access to a potentially huge database of resources. The database includes thousands of commercials, stills and graphics. Agencies can search for ads on specific products, review them as thumbnail clips and half-screen MPEG files, or download them to include in presentations, "animatics" or "stealomatics" (mocked-up advertisements using extant material).

the on-line agora

kodak professional

eastman kodak

A Web site can create a valuable communications channel for any corporation or brand, through which a multimedia, multiple-perspective set of images and information can be communicated directly to a world audience of customers, shareholders, employees and financiers. Sites, such as these examples from Kodak, Nikon, BMW, etc, can provide a media experience rather than being mere corporate manuals.

bmw

bmw

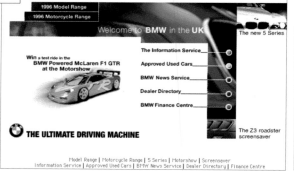

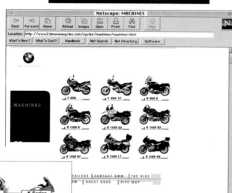

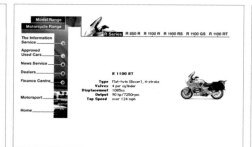

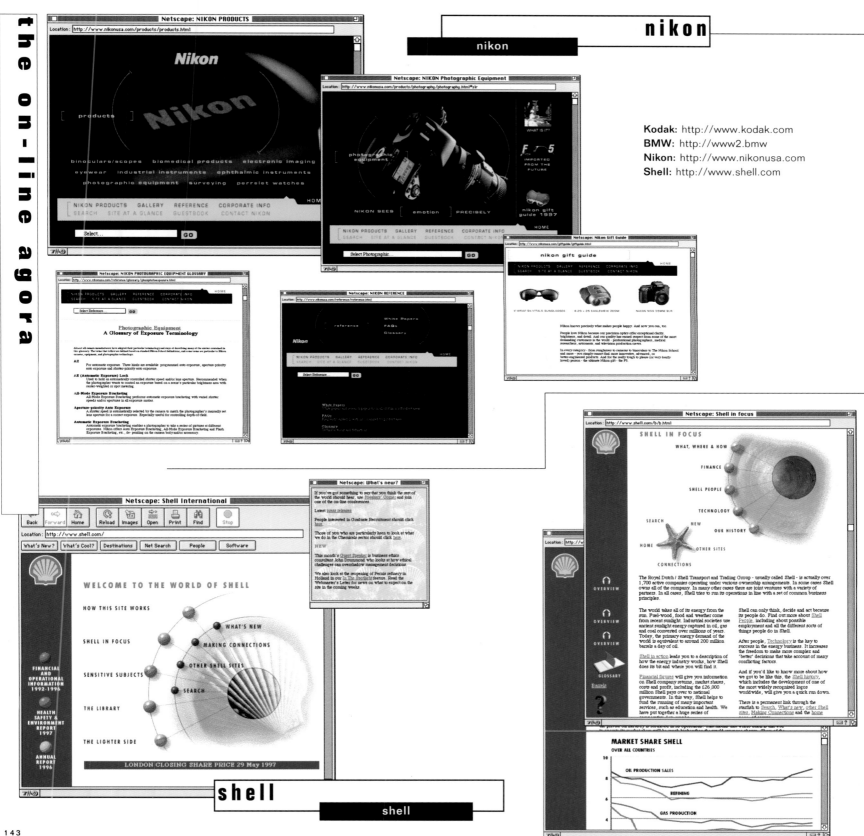

Kodak: http://www.kodak.com
BMW: http://www2.bmw
Nikon: http://www.nikonusa.com
Shell: http://www.shell.com

the on-line agora

From a cover-mounted CD-ROM designed for
Lawrence Publishing, and produced by FIT Vision,
designer Bob Cotton art directed the 3D animator
Mark Prettyman to create a set of panoramic
animations of Wembley Stadium, that were
formatted as Quicktime VR files. Quicktime VR
allows users to experience the realtime animation of
pre-rendered images, and is ideal for virtual
"walkthroughs". In the virtual stadium, the user
could access "advertainments" from the disc's
commercial sponsors.

virtual wembley

FIT vision

Users could travel into the Wembley
team dressing rooms and click on menus
of sponsors, accessing video clips of
Reebok-sponsored players and the
Adidas "Quizball" virtual table soccer
simulator, for example. The Reebok Ryan
Giggs section was an interactive
interview with the Manchester United
striker. Throughout EFC 96, great efforts
were made to integrate advertising and
sponsorship slots within the editorial
contents of the disc, treating them as a
kind of editorial hybrid.

144

Travelling Around Malibu Island

1. This is your navigational menubar for the Malibu site.

 The main menu page shows a map of Barbados, home of Malibu Rum. This arial view of the island shows various hot spots which will take you to all the sections of the site.

2. After you have entered a section you are free to explore. To return to the begining of any section use this menu bar. To go to another section you can either choose one from the menu bar, or return to the main map.

3. Once you've grasped this simple logic, you are ready to enter the Malibu site. "Happy Travelling".

 "Come in to land at Malibu Island"

In this "advertainment" or brand channel site commissioned by Lowe Howard Spink for Malibu Rum, AMXdigital created a front-end menu based on the map of Barbados, with access to all major parts of the site as montaged icons. Produced using Director and Shockwave, the site brought full interactive multimedia to the Web. Features include access to "Malibu TV"; a profile of their sponsored champion windsurfer, Brian Talma; a distillery; a "Dominoes Bar", and a post office from where the user can select a Malibu/Barbados postcard for e-mailing to friends.

http://www.malibu-rum.bb

malibu rum

Lowe Howard Spink/AMXdigital

from shoot-em-ups to imaginary worlds

Computers have been used for entertainment since the first games designed for them were developed in the early 60s. Since that time these games have developed into a huge multi-billion dollar global industry. This industry represents the first real commercially successful application of hypermedia. It is also likely to provide the foundation for the further development of hypermedia as an entertainment medium.

An area as dynamic and successful as the games industry is always likely to produce surprises and unexpected developments, but there are two trends that seem almost certain to shape the development of this area over the coming decade. The first, and probably the most significant in terms of its wider implications, is a shift towards designing games for girls. For most of its history the games industry has been a high-testosterone business. In part, this has been a reflection of the past technical limitations that governed what was possible – using simple sprites on a screen, which placed an emphasis on action over emotional expression in the early days. More importantly the games industry, like the rest of the computer industry, was heavily male-dominated and what was produced reflected the interests and enthusiasms of its male designers. The shift towards more female-oriented games is likely to extend the emotional range and place a much greater emphasis on providing environments that provide opportunities to exercise imagination and social interaction.

This links to the second trend, which is a movement away from games pitting person against machine, to games which provide an environment in which people play against and with each other. Games that can be played on local area networks and over the Internet, such as

Marathon, have already been shown to be very popular, as indeed have MUDs (multi-user Dungeons and Dragons) which, in some cases, have become more social spaces than games.

While competitive games will clearly continue to be an important component of hypermedia as an entertainment medium, the creation of imaginary worlds providing a platform for imaginative play seem likely to become equally important. It is perhaps from here that hypermedia will develop as an expressive medium capable of dealing in its own way with human

emotions and dilemmas and become a 21st-century art form. That, however, lies some way off. In the shorter term we are likely to see computer games becoming more sophisticated examples of hypermedia, and appealing to a broader audience by utilizing a wider range of expressive techniques drawn from older media, such as cinema and comic strips. Media cross-fertilization will be encouraged by hypermedia's other role in this area, which could be called "entertainment support", where it is used to add an extra dimension to a more traditional media form. It can range from the use of hypermedia to enhance predominately music-based products, to Web sites providing more information and context to films, television programmes and sporting events.

Hypermedia's role in entertainment should continue to develop both its range and sophistication of expression as "screenagers" grow up.

The launch of the Barbie series signals a significant change in the nature of computer games. This is partly because they link with the real world (for example, users can print out the patterns of the clothes that they have selected for Barbie) and partly because they focus on enjoying an activity rather than just competing. In this example, users can design outfits for Barbie to wear and then see her modelling them on the catwalk. With its excellent use of both 2D and 3D graphics and a very high level of user involvement, Barbie is likely to be seen as a landmark in the development of computer games as a form of entertainment.

barbie fashion designer

mattel media

An English-language prototype for a Japanese release, Popshop creates a lively picture of young London, integrating sound, animation, video, image and text to provide a tourist's guide with "attitude". It takes the user to the shops, clubs, fashion and music venues that make up "the scene".

the magician

telstar electronic studios

Designed by Matthew Mayes and Olof Schybergson, The Magician uses many hypermedia features, including video and close-up photography, in order to teach over fifty tricks, in an inventive, entertaining and effective way that would be hard for more traditional media to match.

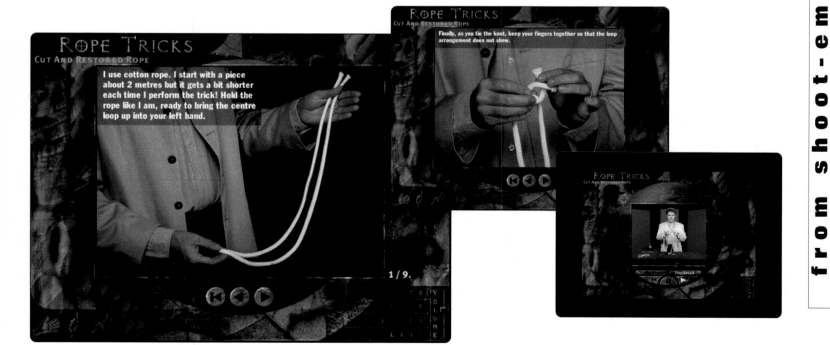

popshop

ian cater

man U double double

FIT Vision

Produced to celebrate Manchester United Football Team's second double UK championship in 1996, the Double Double was art directed by Bob Cotton, with graphics by Peter Lourenco and programming by Steve Poskit. Released as a double CD-ROM, one disc carried a week-by-week countdown to the championship and a "Matchquiz" game, and the other featured the team's hit single and promotional videos.

the spot

The user-illusion sustained throughout this Web interactive "soap" is that we, the users, are eavesdropping on the daily experiences of a real community of young people living in a beach house in Santa Monica, California. The different sections of the site are each a kind of media pastiche, together providing a multimedia narrative of the characters and the developing storylines. It is a truly multimedia experience, with videos, audio clips, photos, script archives and classic episodes. The aim of media sites like this is to provide entertainment that forms a bond between users and producers, and to create a community of users/fans.

http://www.thespot.com

ID4

fox interactive

Inspired by the blockbuster movie, *Independence Day*, this arcade-style flying adventure is available both on personal computers and a wide range of game consoles. It is another example of the growing synergy between the games and movie industries that will surely lead to games taking on many of the high production values associated with film.

freak show

voyager

In the Residents' Freak Show, Jim Ludtke has developed an individualistic style which draws on a fascination with eerie atmospheres – akin to the 1932 movie, *Freaks* and Hitchcock's *The Saboteur*, 1942 – and mixes it with fairground-style music and animated imagery. The animations are well integrated and fully optimize the limited bandwidth of the CD-ROM.

The computer's ability to sort and to search through mountains of text makes it an ideal medium for information and reference. Add hypermedia's capability to present that information in the most appropriate medium or combination of media and the possibilities grow. Join hypermedia computers together in a global network and Ted Nelson's dream of linking the sum total of the world's knowledge in text, pictures, video and sound, any element of which can be accessed, combined and recombined in a variety of ways by anyone anywhere, starts to look less of a fantasy and more of an achievable reality.

In 1990 such a dream would still have seemed way out of reach. In 1991, when the World Wide Web was first created, it would have still seemed a long way away. By 1997 it was more a question of how quickly can we get there and what still stands in the way. With more than 30 million "documents" accessible through the Web and the number growing every day, with the Web's technical capabilities improving at a staggering rate, and with the network of Web users now numbered in the tens of millions and still increasing, Ted Nelson's dream is thundering towards us like a tidal wave.

But simply having the ability to access large amounts of information is as much a problem as it is a solution. A word or phrase entered into a search engine such as Alta Vista or Hotbot may return ten or twenty thousand references. Even a request yielding a much smaller return can be very laborious to go through, and important material may be missed.

This problem is not new. As Vannevar Bush, the inspiration for much work in hypermedia, wrote in 1945: "Mendel's concept of the laws of genetics was lost to the world for a generation because his publication did not reach the few who were

red shift
maris multimedia

This CD-ROM contains a wealth of information about the solar system. Realistic 3D models of the planets can be explored, the sky observed from any point, stars and galaxies identified and astronomical events from history simulated. It contains over 700 photographs and 2,000 hypertext – linked entries from *The Penguin Dictionary of Astronomy*.

capable of grasping and extending it; and this sort of catastrophe is undoubtedly being repeated all about us, as truly significant attainments become lost in the mass of the inconsequential." The danger of the significant being lost in the inconsequential is if anything even greater in computer-based systems than in print.

The challenge facing hypermedia designers, software engineers and information designers is to devise information systems that help us find what is relevant and to filter out what is not. The key must be to focus on the essential nature of hypermedia – its capability to create patterns of meaningful connections between items of knowledge – by using the most appropriate combinations of media, rather than using systems that simply make crude matches between strings of text. While some of the examples of hypermedia information and reference systems we show here may seem insignificant in comparison with the ever growing mountains of information on the Web, they do point to a developing language of design. This should, in time, provide us with the means to navigate pleasurably through large information spaces picking up what we need as we go along.

AMXdigital's D&AD annual on CD-ROM is a great example of how hypermedia can provide a perfect vehicle for reviews and reference works dealing with multiple media. See the video, search the database. Who would want to go back to the book after using this?

D&AD

AMXdigital

the global knowledge machine

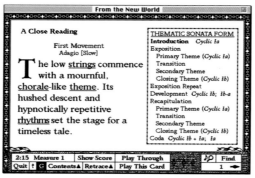

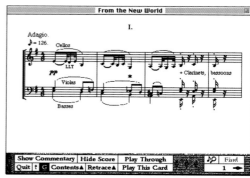

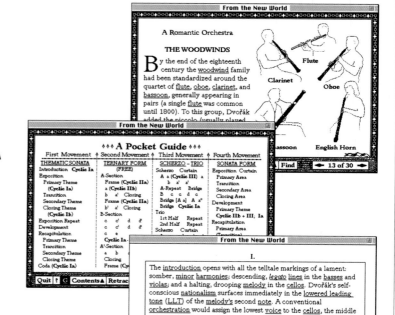

symphony no 9 in e minor

voyager

A massive network of hyperlinked information, this CD-ROM remains one of the best examples of hypermedia's ability to create patterns of meaningful connections between different kinds of information and different media forms. While limited by the technology available when it was created, its use of text, sound, image – and the links between them – contextualize and illuminate. The disc still holds lessons for hypermedia designers.

the global knowledge machine

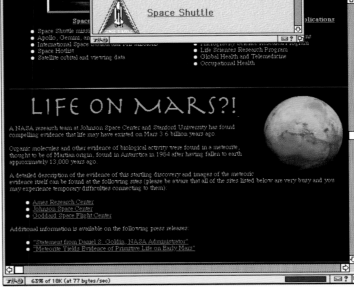

The NASA Web site is huge, presenting a comprehensive coverage of the organization's aerospace activities, including access to thousands of unique images – space probes, space station and shuttle photographs, computer-generated imagery and earth satellite remote scans. Web users can browse through hundreds of low resolution images and then order a copy of the original from NASA.

http://www.nasa.gov

nasa

nasa

the global knowledge machine

155

Glass around the World

Middle East & Asia Germany & Central Europe

United Kingdom Northern Europe

USA France & Spain

Italy

Masterpieces through Time

1066 William of Normandy conquers England
1271 Marco Polo departs Venice for China
1492 Columbus lands in New World
c.1503 Leonardo da Vinci paints Mona Lisa

1588 England de

1291 Venetian glassmakers move to Murano
c.1420-50 Invention of 'cristallo' in Venice

1574 Verzelini granted

1500

| Before 50BC | 50BC - 499 | 500 - 1499 | 1500 - 1599 | 1600 - 1699 | 1700 - 1799 | 1800 - 1899 | After 1900 |

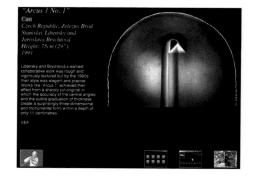

"Arcus 1 No. 1"
Cast
Czech Republic, Zelezny Brod
Stanislav Libensky and
Jaroslava Brychtová
Height: 75cm (29")
1991

Libensky and Brychtová's earliest
collaborative work was rough and
vigorously textured but by the 1990s
their style was elegant and precise.
Works like 'Arcus 1' achieved their
effect from a sharply cut original in
which the accuracy of the central angles
and the subtle graduation of thickness
create a surprisingly three-dimensional
and monumental form within a depth of
only 11 centimetres.

V&A

Beginning life as kiosk application in the Glass Gallery at London's Victoria and Albert Museum, The Story of Glass is now available as a CD-ROM. Using a mixture of high quality photography, period illustration, video demonstrations and authoritative text, it provides a comprehensive guide to the glassmaker's art.

the story of glass

art of memory

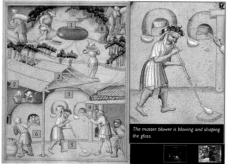

The master blower is blowing and shaping the glass.

Properties of Glass

Manipulating Hot Glass

Colour Change

Joining

Shaping

Crystals of these alkalis can also form on the surface

Middle East & Asia

The Middle East has enjoyed one of the longest and most central roles in glass history. Glass was invented in Mesopotamia (Iraq) some 2500 years before Christ. Later, in developed pre-Roman, Roman and early Islamic times, the making of glass developed into a great industry and the Middle East produced some of its greatest masterpieces. Glassmaking history in India and the Far East has been less consistent, and often follows western inspiration.

1 2 3 4

Macchia Sea Form Group
Threaded
United States
Dale Chihuly
Width: 70cm (27.5")
1982

In the 1970s, inspired by a nested group of American Indian baskets, Dale Chihuly began to make the "Pilchuck Basket" series. This led him to develop delicate, shell-like forms such as this "Macchia Sea Form Group".
In 1976, Chihuly lost the sight of one eye. Since that time, others have made the objects under his direction.

Corning Gallery 7

project gutenberg

Netscape: PROJECT GUTENBERG INDEX

Location: http://www.promo.net/pg/

PROJECT GUTENBERG
menu

- What is PG?
- Etext Listings
- Recent Releases
- PG Newsletters
- PG Articles
- Making a Donation...
- Other Etext Archives
- Search
- Etexts and Publishing
- How to Volunteer

UP-SET approved

What's *new*

PROJECT GUTENBERG
Fine Literature Digitally Re-Published
The Official and Original Project Gutenberg Web Site and Home Page

News

May 31, 1997
Books for May released!

May, 1997
Project Gutenberg Newsletter, May, 1997

May 5, 1997
NEW!
Project Gutenberg Listings
By Author and By Title.

April 30, 1997
PROJECT GUTENBERG NEEDS YOU!
The Project Gutenberg Request for Support for April 30, 1997

April, 1997

Mentions and Awards

COOL BANANAS! Project Gutenberg was "Banana(!) of the day" on May 31st, 1997 at Cool Bananas (Web Guide). "...the best place to find e-books (electronic books) is Project Gutenberg ... Truly amazing ... Making a great site even better is the fact that it's all free - and legal ... One very Cool Banana in every way."

The Cybergrrl Web Guide Project Gutenberg is the **Month's Featured Site** at Cybergrrl Web Guide. Read the **Interview** with Michael Hart, Project Gutenberg Executive Director.

Editor's Choice UKplus Project Gutenberg Web Site has been recognised as an "Editor's Choice" by UK Plus. UK Plus Editor's Choice sites are effectively the 'Top 0.225% of the Web': " PG is one of the great treasures of the Internet... Magnificent".

Connect: Host www.promo.net contacted. Waiting for reply...

Project Gutenburg is an ambitious project to make out-of-copyright information available online. Books are converted into ASCII text (the simplest form of digital text) so that they can be used on almost any computer. Books on offer range from *Aesop's Fables* to *Webster's Dictionary*.

http://www.promo.net/pg

157

From Vannevar Bush on, many of the key figures in the history of hypermedia have had a deep interest in developing the medium as an aid to learning. One of the main obstacles to this was that the technology needed in order to deliver it either did not exist or was too expensive to be a practical proposition. Now most of those obstacles have been overcome and we are faced with more profound questions regarding what we actually mean by learning, education and training. As with many other areas where hypermedia can be used, simply grafting the medium on to existing practices seems likely to miss the new opportunities that the medium presents. This includes the opportunity to reflect on both the purposes and processes of what is being done and whether or not they can be improved.

One such vision of "doing it better" is the idea of developing a machine that would act as a personal tutor or mentor for each and every learner. Such a machine would have to be easy to use, have an encyclopedic information-base and be capable of learning the strengths, weaknesses, and preferences of its user. It would have an accurate and up-to-date record of each user's progress, have limitless patience, the ability to customize learning materials for each student and to mix modes of teaching from games to multimedia. Ideally, such a machine would be networked so that learners could interact with one another and with their human tutors and mentors.

As early as 1963, long before we had the technology to support it, the American designer and visionary Richard Buckminster Fuller had sketched out a similar vision in his book *Education Automation*. Alan Kay's concept of the Dynabook was another variation on this theme, proposing a system based on a highly portable computer. This had an A4 (letter-size) paper-white screen, linked by wireless to other Dynabooks and large databases, and was designed specifically to be used and programmed by the youngest child as well as by adults. In recent years such grand visions have been rather more rare and the emphasis has tended to be on producing teaching and learning material used in a similar way to books.

This **CD-ROM** offers a comprehensive guide to the wide range of vocational qualifications offered by the City & Guilds.

why City & Guilds?

Click on the text box to return to Menu 4.

flexibility You can choose from the largest range of courses in the country. From the most basic to the very highest qualifications. Most of the time you can study where you like (though some of the more specialised subjects may only be available at certain places in the country) and also at your own pace. Normally there's no age limit and City & Guilds is fully committed to Equal Opportunities.

2 how does it all work?

where can I study?
how long does it take?
how am I assessed?
> do I have to pay?

MENU 123456

city & guilds

intro

With the invention of the laserdisc in the late 70s, the attention of the advocates of computer-based teaching focused on the use of interactive video, and with the arrival of the Apple Macintosh in 1984, on the use of interactive multimedia – computer-assisted learning programmes that combined video, animation and sound as well as text and graphics often carried on CD-ROM.

By the early 90s most of the technological ingredients of the earlier grand visions had been developed: we had personal portable multimedia computers, good authoring software and the ability to build multimedia databases and expert systems – creating software guides and agents that learners could use in order to help them explore a particular subject. With the development of the Internet, and the invention of the World Wide Web in 1991, the means to network educational software and to deliver whole curricula and distance learning services to anywhere in the world became available.

Whether this capability will give rise to new grand visions that will actually be put into practice or, as seems more likely, development will be more fragmented and pragmatic, is still open to question. What does seem certain is that the long-standing relationship between hypermedia and learning will be maintained and that we can expect very exciting and perhaps surprising developments within this ever-expanding area.

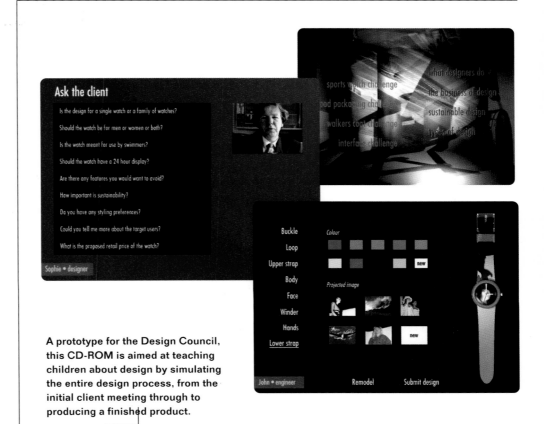

A prototype for the Design Council, this CD-ROM is aimed at teaching children about design by simulating the entire design process, from the initial client meeting through to producing a finished product.

design challenge

art of memory

This innovative training disk, made for Boehringer Mannheim, combines hypertext with the opportunity for users to make their own linked notes and prepare their own action plan.

new managerial skills

mahony associates

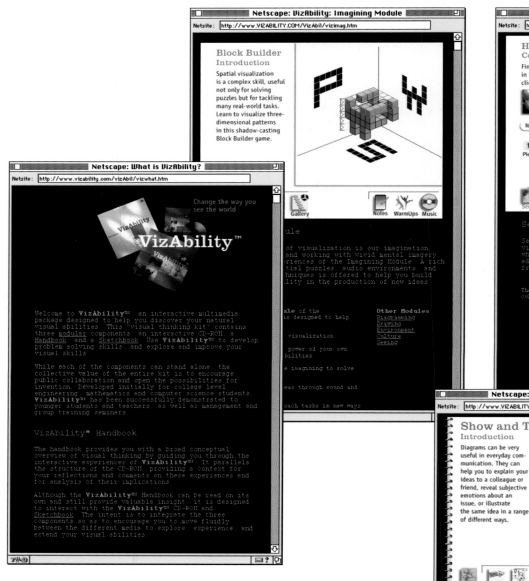

Netscape: VizAbility: Imagining Module
Netsite: http://www.VIZABILITY.COM/VizAbil/vizimag.htm

Block Builder
Introduction

Spatial visualization is a complex skill, useful not only for solving puzzles but for tackling many real-world tasks. Learn to visualize three-dimensional patterns in this shadow-casting Block Builder game.

Gallery

Netscape: What is VizAbility?
Netsite: http://www.vizability.com/vizAbil/vizwhat.htm

Change the way you see the world

VizAbility™

Welcome to **VizAbility™**, an interactive multimedia package designed to help you discover your natural visual abilities. This "visual thinking kit" contains three modular components: an interactive CD-ROM, a Handbook, and a Sketchbook. Use **VizAbility™** to develop problem solving skills, and explore and improve your visual skills.

While each of the components can stand alone, the collective value of the entire kit is to encourage public collaboration and open the possibilities for invention. Developed initially for college level engineering, mathematics and computer science students, **VizAbility™** has been successfully demonstrated to younger students and teachers, as well as management and group training seminars.

VizAbility™ Handbook

The handbook provides you with a broad conceptual overview of visual thinking by guiding you through the interactive experiences of **VizAbility™**. It parallels the structure of the CD-ROM, providing a context for your reflections and comments on these experiences and for analysis of their implications.

Although the **VizAbility™** Handbook can be read on its own and still provide valuable insight, it is designed to intersect with the **VizAbility™** CD-ROM and Sketchbook. The intent is to integrate the three components so as to encourage you to move fluidly between the different media to explore, experience, and extend your visual abilities.

Netscape: VizAbility: Seeing Module
Netsite: http://www.VIZABILITY.COM/VizAbil/Vizsee.htm

Hidden Pictures
Color

Find the small piece in the big picture and click on it.

Next Grid Answer

16 Pieces 0 Hits 1 Misses

New

Seeing Intro B&W Color Notes WarmUps Music

Seeing Module

Seeing is more than just looking : by shifting your visual perception you can enhance your ability to see what is as well as what might be. You can learn to take advantage of what is already around you and to benefit from what others see.

The **Seeing Module** of the **VizAbility™** cube is designed to help you

- Become aware of how you see
- Unblock visual stereotypes
- Translate motion into form
- Learn to notice details
- Sort, categorize, and group elements visually
- Experience how differently people view the same thing

Other Modules
Culture
Diagramming
Drawing
Environment
Imagining

Netscape: VizAbility: Diagramming Module
Netsite: http://www.VIZABILITY.COM/VizAbil/vizdiag.htm

Show and Tell
Introduction

Diagrams can be very useful in everyday communication. They can help you to explain your ideas to a colleague or friend, reveal subjective emotions about an issue, or illustrate the same idea in a range of different ways.

Diagramming Intro Map Event Life Idea Notes WarmUps Music

Diagramming Module

Diagrams provide a format for making abstract ideas concrete enough to share with others. They allow you to hold pictorial conversations, to record events over time and space, and to sketch out interrelationships. Diagrams let you describe and illustrate an idea whose details are still in progress, thereby inviting the input and collaboration of others.

The **Diagramming Module** of the **VizAbility™** cube is designed to help you

- Familiarize yourself with diagrammatic forms
- Learn how to use and create symbols
- Gain skill in rendering ideas
- Appreciate diagramming in everyday contexts

Other Modules
Culture
Drawing
Environment
Imagining
Seeing

vizability

MetaDesign

Aimed at a wide market, from engineering, maths and psychology students to marketing managers, VizAbility sets out to train non-designers in visual skills and the creative process that designers follow. As well as covering such areas as "seeing", "drawing", "diagramming" and "imagining", the disc features visits to studios where the user can learn about working methods. A collection of games is also included, teaching the principles of shading, pattern recognition and other visual ideas.

http://www.vizability.com

on the way to school

sally coe

...make lots of sentences about what **happens** as you **walk** to school.

name words

I
me
sky
stream

_____ **walk** past the _____ .

A prototype CD-ROM for children who have difficulties reading and writing. Based around a journey to school, the children are encouraged to form sentences from the words presented which describe the experience.

Choose a pair of shoes to **wear** on the way to school.

name word shoes

name words

he
Them

chips

They are talking about _____ .

interactive skeleton

mosby multimedia

Many medical students will welcome the Interactive Skeleton, a fully 3D skeleton on disc, in which bones and joints can be viewd from any angle. Clicking on a bone will give its name and related clinical text. The CD-ROM also features dissection stills showing the relation of muscles to the skeleton. There is a self-testing exam and, as a bonus, professors' tips and specialist information.

One of the most intriguing aspects of cyberspace is that almost as soon as computers began to be connected to one another, via networks, people used them to interact socially. The seemingly spontaneous creation of a whole variety of social spaces in cyberspace is particularly interesting given that for much of the 50s and 60s the general perception of computers was that they were anti-human, cold, calculating, logical and a fundamental threat to human values. The perception that computers represent a threat to our humanity still persists, particularly among intellectuals. The fact that one of the most popular uses of the internet and other forms of networked computing is for that most human of activities, chat, gossip and just "being" with other people, is often dismissed as trivial and sad, the computer equivalent of CB radio.

If one were to examine the content of much that is said around coffee machines in the workplace throughout the world, very similar conclusions could be drawn. Those interactions could also be dismissed as peripheral and insignificant, but we know that as well as the trivia, the jokes, the gossip, the idle conversations and flirtations that take place many of the most important decisions and ideas originate in such informal, social contexts. The fact that "chat" in one form or another has been such an important driving force in the rapid growth of the Internet as a communications medium is something that needs to be taken very seriously by people designing hypermedia systems for business, commerce and learning.

There is a wealth of examples of different ways in which people have interacted socially in cyberspace: everything from e-mail to bulletin boards, computer conferences to IRC (Internet Relay Chat), MUDs to MOOs, video conferencing to on-line computer games. Most of these interactions have in the past been based on text, although often used in a very inventive way. Now, particularly after the invention of VRML (Virtual Reality Modelling Language), we are beginning to see the creation of three-dimensional cyberspace environments populated by avatars (representations of people within this space), some of whom may be directed by real people and some of whom may be artefacts of the system.

The lessons of the Internet and other network systems is that given the slightest opportunity people will use cyberspace for informal social interactions. In that sense, cyberspace is no different from any other place where people gather. It seems to follow that the virtual equivalents of coffee machines, or any other place where people can simply "be", are a necessary part of social organizations that work effectively. It is for this reason that the development of convivial hypermedia socialware may be one of the most important tasks facing hypermedia designers and developers. Socialware may be the key to making many other hypermedia applications work as real environments in which real things can be done.

geocities

Geocities is one of a growing number of service providers offering free e-mail accounts and homepages, supported by advertising. Home pages are grouped in neighbourhoods of shared interests, for example, someone interested in film and entertainment might locate their home page in "Hollywood".

http://www.geocities.com

le deuxième monde

canal plus

Frames from Canal Plus's mega-project.
Le Deuxième Monde is a faithfully reconstructed
digital model of Paris – a virtual environment in
which networked users can explore features of
the real city, and in which they can control the
movements of humanoid "avatars". Le Deuxième
Monde follows in the tradition of the Lucasfilm
/Fujitzu Habitat as an example of the kind
of socialware that will become more realistic
and responsive.

163

When the network that became the Internet was first established by ARPA (the Advance Research Projects Agency of the US Department of Defence) in the early 70s most of those responsible for setting it up saw it as a means by which computers could communicate with other computers. The facility for e-mail was added almost as an afterthought. To the surprise of many of its founders, very soon the largest volume of traffic being carried by the embryo network was e-mail. People were using the system in order to communicate with one another. E-mail has proved to be one of the key drivers in the development of network computing, not only with the Internet but also with subscription networks such as CompuServe and AOL (America On Line) and the small dial-up bulletin board systems. As well as being the digital equivalent of letters and postcards e-mail and variants of e-mail also form the basis of computer conferencing, archives of messages organized around a particular topic or issue providing the structure for an on-going debate or discussion. The users of such computer conferences quickly saw them in terms of virtual communities.

Today almost any interest or issue you can think of, and many more that would never have crossed your mind, will have its own virtual community or communities in cyberspace. Some of them will seem bizarre, some trivial, some forums for serious debate on important topics and some, such as support groups for people with life-threatening illnesses, literally a matter of life and death. For some, denied access to official mass communication channels, networked computing has provided the means of both organizing politically and disseminating their views and their version of events to the wider world. From the Zapatistas in Mexico to the opposition in Serbia, and many more around the world, computer-mediated communication has given a voice to those who might otherwise not have been heard.

Until very recently these virtual communities have been text-based. This is still true to a very large extent, but hypermedia seems set to enter the virtual community very soon. This raises some very interesting questions. Part of the success of these activities can be attributed to the anonymous nature of plain text on the screen. The advantage of this is that issues of the appearance, race, gender, accent and status of the participants become invisible. On the other hand, it has placed a premium on writing skills and, of course, some people can communicate more effectively either verbally or by using images than they can by writing. Similarly, many people can understand more through what they see or hear than they can through reading.

It is going to be exciting to see the effects of the use of hypermedia in this area of community-building and politics. Of course, much will be produced by governments, official bodies, political parties, large pressure groups, charities and all the other kinds of organization that make up a civilized society and which need to communicate with their constituents, clients and supporters. This is likely to be little different, except in terms of content, from what we will see in other areas such in business, commerce and even entertainment. Where we may find surprises and innovations is among the kind of grassroots groups of enthusiasts, whose energy, commitment and inventiveness first built up the human infrastructure of network computing. As William Gibson wrote in *Neuromancer*: "the street finds its own uses for technology". The communities that make up "the street" will surely find their own unexpected uses for hypermedia.

kings cross unveiled

cat hill productions

Designers Mediha Boran, Mimi Escudero, Lena Hassan and Simon Pickford began this project on the Design for Interactive Media MA at Middlesex University. A touch-screen kiosk, it helps support a sense of community by linking present realities with the past. The present is shown by local residents who voice their concerns and views; the past is evoked by illustrating elements from an epic poem about the area, "Vale Royal", by Aidan Dunn.

CompuServe

AMXdigital

On-line services such as CompuServe have been providing a home for hundreds of "virtual communities" for many years. Recently they have begun the move from proprietory software to make their service more Web-orientated.

greenpeace

greenpeace UK

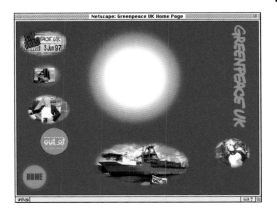

The World Wide Web is proving to be a powerful vehicle for campaigning groups, such as Greenpeace, to communicate ideas and views. The two-way nature of networked hypermedia means that it is likely to become an increasingly important forum for democratic debate.

http://www.greenpeace.org

the digital town meeting

As we enter the new Millennium the pace of change in the development of the technologies for delivering hypemedia is likely to continue to accelerate. In this section we examine what some of those changes may be. The unexpected and very rapid emergence of the World Wide Web should have taught us that there will be some surprises in store. Nevertheless, we also need to remember that while the Web was surprising in terms of its timing and its origins, it was predictable that some form of networked hypermedia would emerge at some point. What was hard to predict was that it should emerge so soon. That, perhaps, is the most important lesson to learn: radical changes are likely to take place more quickly than any of us expect.

Three main areas of technological development are likely to see the most activity over the next two decades. The first is a massive increase in the computing power available to the individual. The second is an increasing complexity and capacity of network systems, both on a local and on a global scale. The third is a proliferation of different kinds of devices carrying hypermedia; some of these will be much smaller and considerably more portable than the

millennial media

hypermedia futures

familiar desktop computer, and some will be
very much larger, more like small cinema
screens, built in to the fabric of our buildings.

Anyone who has bought a computer in the
last few years will know how it seems that the
moment you actually get it, you see a machine
advertised that is twice as powerful as yours
at the same price. Actually, the cycle of
improvement is probably close to eighteen
months long, even though perceptually it often
seems faster. There is little sign of this pace of
the increase in computer power slowing down
in the foreseeable future. Indeed, not only is the
power of individual machines likely to continue
increasing but, as the capacity of networks

improve, people will have access to as much processing power as they need by harnessing the capabilities of other computers on the network.

Supercomputing power will, of course, be essential to serve television-quality media to millions of simultaneous Web surfers. However, this is really only the beginning. Just as supercomputers are currently used to model extremely complex phenomena like the weather, macro economies and nuclear explosions, in future we believe that ultra computers will provide extremely detailed and highly realistic interactive simulations spanning a whole range of familiar and radically new entertainments, from sports to role-playing battle simulations. Furthermore, we believe that ultra-computing power will fuel the development of realtime simulations of complex social

environments – virtual cities of the kind that Canal Plus in France is prototyping in its Deuxieme Monde virtual Paris – but navigable in realtime, and with a credible simulation of the city's population, traffic, trading and industry built-in to the model.

Just as computers are becoming ever more powerful, a similar phenomenon can be observed with networks and access to networks. The modems which we use to connect our computers to the Internet and other on-line services, via the telephone network, have been doubling in speed on the same kind of eighteen-month cycle. However, even with ever increasing speeds, the modem and copper-wire telephone network represents one of the bottlenecks in delivering the kind of high-bandwidth, high-resolution networked hypermedia we expect to see developing in the next century. What is likely

to happen is that the combination of the fibre optic, satellite and microwave networks that form the basis of the large national and international telephony systems will increasingly connect directly into the home and workplace rather than to the copper wires that currently make the last few miles of the journey.

Perhaps the most visible change that looks set to take place is a move away from the desktop computer as the main delivery vehicle for hypermedia, to a much wider range of specialist devices, ranging from something very similar to Dick Tracy's famous wristwatch communicator, to rooms whose walls form very large screens. Already in the marketplace there are mobile phones that can access the World Wide Web, as well as sending and receiving e-mail, faxes and conventional voice communication, and there are also powerful portable computers with built-in

CD-ROM drives, colour screens and loudspeakers, capable of delivering hypermedia at near desktop computer quality. Both are examples of how devices are becoming smaller, more mobile and more widely useful. At the other end of the scale, the use of video projectors to provide relatively large screen displays of hypermedia presentations has become commonplace.

This trend towards producing computer-based devices that are more closely adapted to the tasks and purposes for which they are being used is one that will continue to increase over the next two decades. As this happens, and as we are surrounded by a variety of computer-based devices, the computer as an object will become less intrusive and our attention will focus much more on the quality of the medium which they carry. As Mark Weisser of Xerox PARC (and one

of the advocates of what he calls "ubiquitous computing") has put it, "There is more information available at our fingertips during a walk in the woods than in any computer system, yet people find a walk among trees relaxing and computers frustrating. Machines that fit the human environment, instead of forcing humans to enter theirs, will make using a computer as refreshing as taking a walk in the woods." This, then, may be the future of hypermedia in the next millennium: to move from being something new, exciting and special to becoming as natural and as human as walking in the woods or down a busy city street.

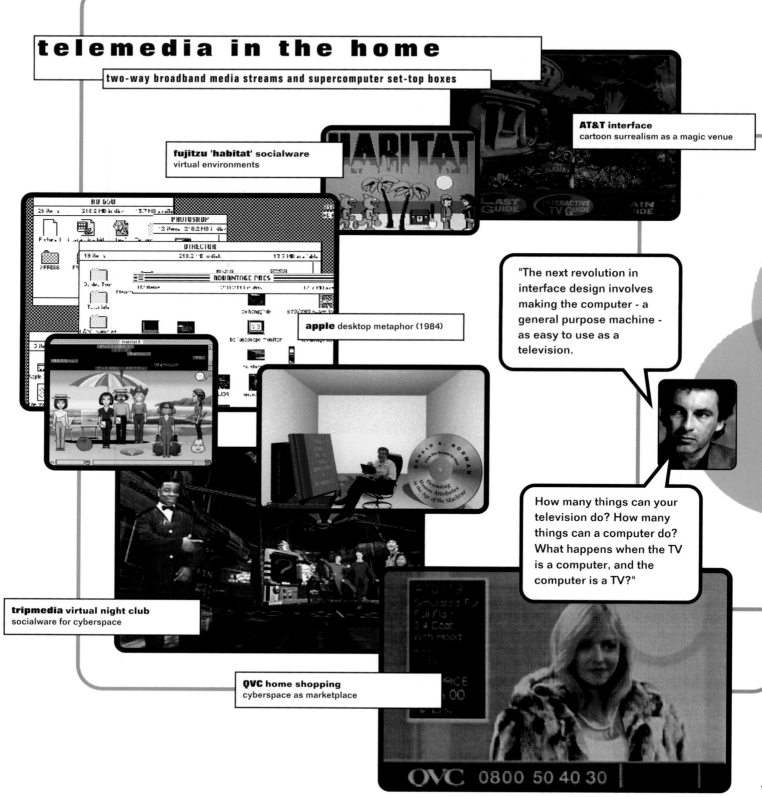

telemedia in the home

two-way broadband media streams and supercomputer set-top boxes

AT&T interface
cartoon surrealism as a magic venue

fujitzu 'habitat' socialware
virtual environments

apple desktop metaphor (1984)

"The next revolution in interface design involves making the computer - a general purpose machine - as easy to use as a television.

How many things can your television do? How many things can a computer do? What happens when the TV is a computer, and the computer is a TV?"

tripmedia virtual night club
socialware for cyberspace

QVC home shopping
cyberspace as marketplace

OVC 0800 50 40 30

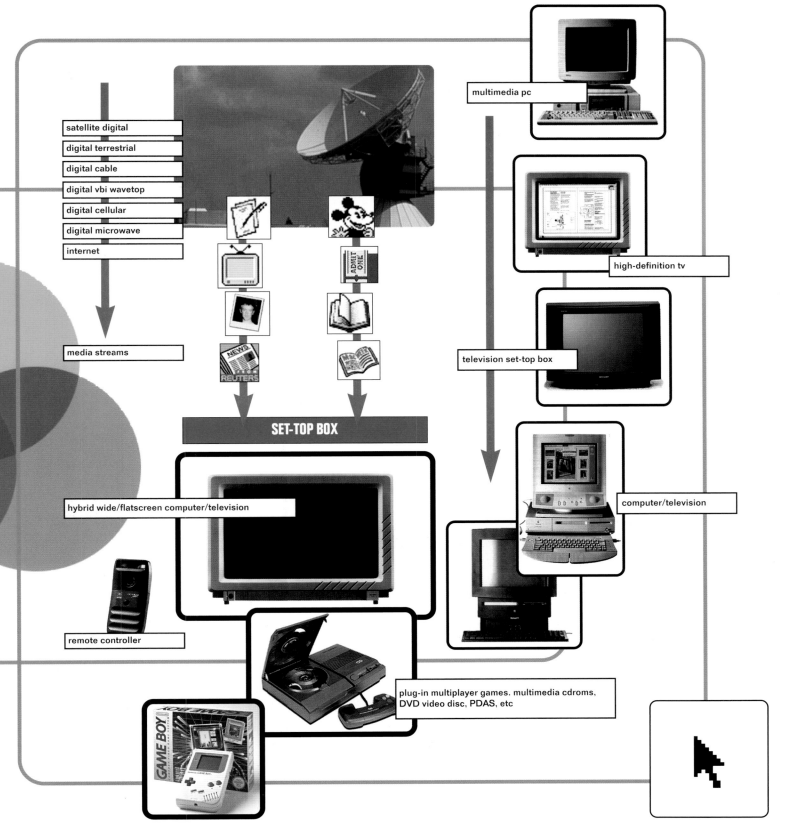

satellite digital

digital terrestrial

digital cable

digital vbi wavetop

digital cellular

digital microwave

internet

media streams

multimedia pc

high-definition tv

television set-top box

SET-TOP BOX

hybrid wide/flatscreen computer/television

computer/television

remote controller

plug-in multiplayer games. multimedia cdroms, DVD video disc, PDAS, etc

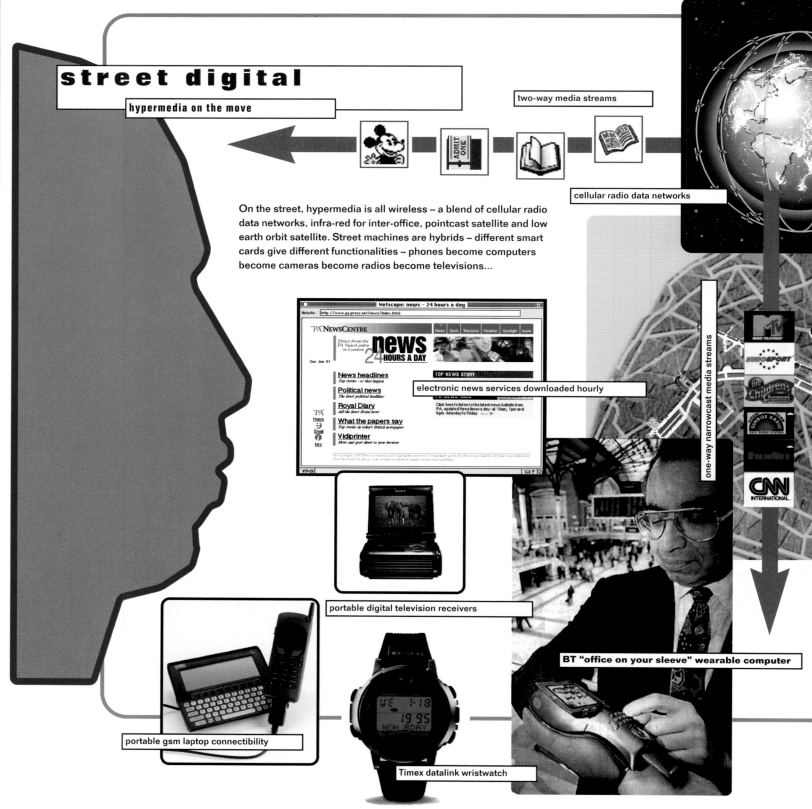

street digital

hypermedia on the move

two-way media streams

cellular radio data networks

On the street, hypermedia is all wireless – a blend of cellular radio data networks, infra-red for inter-office, pointcast satellite and low earth orbit satellite. Street machines are hybrids – different smart cards give different functionalities – phones become computers become cameras become radios become televisions...

electronic news services downloaded hourly

one-way narrowcast media streams

portable digital television receivers

portable gsm laptop connectibility

Timex datalink wristwatch

BT "office on your sleeve" wearable computer

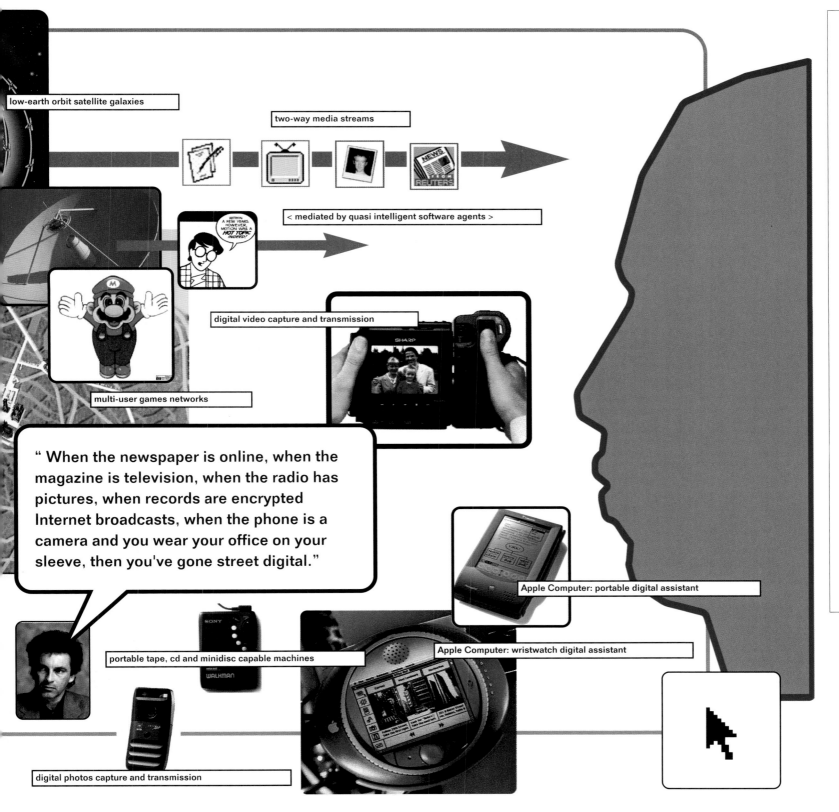

low-earth orbit satellite galaxies

two-way media streams

< mediated by quasi intelligent software agents >

digital video capture and transmission

multi-user games networks

" When the newspaper is online, when the magazine is television, when the radio has pictures, when records are encrypted Internet broadcasts, when the phone is a camera and you wear your office on your sleeve, then you've gone street digital."

Apple Computer: portable digital assistant

portable tape, cd and minidisc capable machines

Apple Computer: wristwatch digital assistant

digital photos capture and transmission

glossary

technical terms

Algorithm
A procedure for solving a particular problem. Devising an algorithm means formulating a method by which a solution to a problem can be found.

Alphanumeric
Describes systems that encompass both numerals and letters of the alphabet.

Analog
Information that can be recorded, stored, processed and communicated in a form similar to its source. For example, the grooves on a gramophone record are similar in form to the sound waves they reproduce.

Anti-aliasing
Technique used to alleviate the jagged appearance of graphics produced on low resolution devices such as computer monitors. Derived from techniques used in medieval tapestry, anti-aliasing involves the interpolation of a neutral colour between the edge of one colour plane and another.

Applets
Very compact computer programs, written in **Java**, designed to be downloaded by **Web browsers** to provide more dynamic and interactive Web pages.

Application
In computing, generally refers to **programs** that enable the user to perform a specific type of task such as writing, calculating or drawing.

ASCII
A standard scheme for encoding **alphanumeric** characters so that they can be stored in a computer. Each character input from the keyboard is represented by 7 **bits**.

Aspect Ratio
The width-to-height ratio of screen images or **pixels**.

Associative linking
The method, first proposed by Vannevar Bush, of connecting and organizing items in a **hypermedia** programme by association rather than by a formal classification system.

ATM (asynchronous transfer mode)
A fast packet-switching technology, capable of data transfer rates up to 2.4 gigabit/sec. ATM is likely to be one of the main foundations of the broadband global multimedia **network** that should grow from the **Internet** and **World Wide Web**.

Authoring
The process of constructing a **hypermedia** programme using a **software** package such as Macromedia Director or Apple's HyperCard.

Avatar
A virtual construct that represents an individual human user in a **VR** (virtual reality) environment, videogame or a networked multi-user domain. Avatars are controlled directly by their human owners and act as vehicles for interacting with other people (via their own avatars).

Bandwidth
Defines the capacity of a communications channel: the higher the bandwidth the greater the volume of information that can be transmitted within a given time. For example, a mid-range **modem** will deliver data at around 28.8 Kbits/sec (28.8 kilobits per second), while a broadband system will support several megabits per second (sufficient for video and hifi-audio).

BBS (bulletin board services)
The electronic equivalent of a notice or bulletin board, residing on a server (a computer attached to several modems). Anyone can connect from their own computer and **modem** to leave messages, engage in electronic conversations and conferences, and to download freeware or shareware.

Bit
The smallest unit (value 0 or 1) of computer data.

Bitmap
A computer graphics image, composed of **pixels**, that corresponds directly to data **bits** stored in memory.

Bitmap editors
More commonly called "paint" programs, bitmap editors enable the user to manipulate each individual **pixel** in a screen image.

Broadcast quality
Video of a standard acceptable to public broadcasting organizations.

Browse mode
Mode in which the user can survey or peruse all or part of the contents of a **hypermedia** programme.

Browser
A device that allows users to peruse the contents of a **hypermedia** programme, generally by providing some kind of overview (uch as a contents list) from which the user may select items of interest. See also **Web Browser**.

Button
An area or object, displayed on the screen, that reacts to some form of user input – such as the use of a pointer or the click of a mouse.

Byte
A set of **bits** considered as an individually addressable unit in computer memory. In personal computers a byte normally equals eight bits and can represents a single character such as a letter from the alphabet, a number from 0 to 9, or a punctuation mark.

Card
The basic unit in **hypermedia** systems that use the "cardfile" metaphor, such as Apple's HyperCard.

CD [compact disc]
The basic 120mm digital-optical disc that can be used to carry audio (CDDA) data, or data and **hypermedia** programmes (CD-ROM).

CD Extra
Audio **CDs** that when played on a computer can display a **hypermedia** programme.

CDi [compact disc interactive]
An early **multimedia** compact disc-based system, developed jointly by Philips and Sony.

CD Link
System developed by The Voyager Company to provide instant links between entries on a Web page and audio **CDs** in the user's CD-ROM drive.

CGI [common gateway interface]
Programs that administer interactions between Web users (clients) and the **HTML** and other Web page documents residing on a server. CGI programs can run programs on the server at the behest of the browser, and return the results to the **browser**. This could be information accessed from a **database** resident on the server, or the results of a simulation or calculation performed on the server or other networked computer. CGI scripts can be written to create Web pages "on the fly", in response to users, actions and interactions.

Client/server system
Describes the organization of a computer network whereby "clients" can access **software** or documents from a server, which holds the software or documents. The **World Wide Web** is based on a client/server model.

Compression
Refers to a number of techniques for reducing the amount of **data** required to store and transmit information.

Cursor
The symbol that represents the screen position of a pointing device, such as a mouse. The shape of a cursor often changes to indicate its function at any particular moment.

Cyberspace
Term coined by William Gibson to describe the interconnected web of **databases**, telecommun-ication links and computer networks that seem to constitute a new space for human communication and action.

Data
Information stored in **digital** form.

Database
A structured collection of **data**: information that has been organized in such a form that it can be stored, sorted, manipulated, and retrieved through a computer system.

Digital
Information represented by discrete units, usually binary numbers (0 and 1). The digitalizing of media elements, such as text, sound, image, animation and video, is the basis of **hypermedia**.

DNS [domain name system]
A "domain name" is given to each computer or network connected to the **Internet**, providing an **alphanumeric** address that is easier to remember than a numerical (or IP) address. This address used by the protocols that control **data** exchange over the Internet.

Download
The process of transferring **software** or other **digital** information from one computer to another over a **network**.

DVD [digital versatile [or video] disc]
A new standard for digital-optical discs. ADVD is the same diameter as a CD-ROM (120mm) but is double sided and stores data in two layers to give a capacity of up to 17 **gigabytes** per disc, capable of storing a feature length movie at **MPEG2** broadcast quality.

DVD-ROM
A version of the **DVD** format that can store a blend of **digital** video and mixed (CD-ROM) data. While DVD is primarily a linear medium, DVD-ROM provides more **interactive** programs.

DVI [digital video interactive]
A computer chip developed by Intel, specially designed for the **compression** and decompression of video images.

E-mail
Term describing messages sent over a computer **network**. E-mail has become one of the most popular uses of the **Internet**.

Extranet
A private computer **network** that uses **Internet** technology to link an organization with its suppliers, customers and other collaborators.

Feedback
In **hypermedia**, the process by which the **program** or system informs users of what it is doing so that they can take appropriate action.

Flat screen
A thin display screen using LCD (liquid crystal displays) or TFL (thin film transistor) or other display technologies that do not require a cathode ray tube.

Flowchart
A schematic diagram of a **hypermedia** programme.

Gigabyte
One thousand **megabytes**.

Groupware
Software designed to enable groups of people
to work together collaboratively.

GUI (graphical user interface)
A human-computer **interface** that uses screen graphics
to display **windows**, **icons** and **menus**, and uses a mouse
or similar device to select them. Typical examples of
GUIs are the Apple Macintosh and Microsoft
Windows.

Home page
The main or opening page on a Web site.

Hotlist
A collection of **URLs** grouped together for
quick reference.

HTML (Hypertext Mark-up Language)
The **scripting** language central to the **World Wide Web**,
based on the Standard Generalized Mark-up
Language (SGML). HTML uses embedded commands
within a plain text to specify layouts, font, point size
and other graphics-formatting information.

HTTP (hypertext transfer protocol)
The set of communication standards that together
enable different kinds of computer to communicate
with one another over the **World Wide Web**.

Hypermedia
A computer-based medium combining multiple media
(text, image, sound, animation and video) with high
levels of user **interaction** and the capability to link
items of information with other items within the
system.

Hypertext
Term originally coined by Ted Nelson to describe a
form of non-sequential writing. Now generally refers
to computer-based text that is linked in a variety of
linear and non-linear ways. The **World Wide Web** was
devised as a hypertext-based system.

Icon
A pictorial representation of an object, a computer
program, a feature or function within a **hypermedia**
programme or graphical computer **interface**.

Interaction
The process of control and feedback between user
and computer or **hypermedia** system.

Interactive
Describes any computer-based system in which the
user's input directly affects its behaviour and where
its resulting output is communicated to the user.

Interactive video
Now largely obsolete; a system that used a computer
to control the audio, stills and motion sequences
stored on a videodisc or tape.

Interface
An abbreviation for human/computer interface
– the hardware and software through which the user
interacts with a computer or **hypermedia** system.

Internet
The global **network** of computers and computer
networks that evolved from the US Department
of Defence's Advanced Research Projects Agency
network, an experimental packet-switching network
set up in 1972.

Intranet
A private internal **network** within an organization,
that uses **Internet** technology.

ISDN (integrated services digital network)
A **network** operated by telecommunications companies
that supports a higher bandwidth than
the ordinary public phone network. ISDN can
transfer data through two channels at typical rates
of 64 kbits/sec. (for single channel), 128 kbits/sec.
(for two channels) or up to 1.5 mbits/sec. for video
conferencing.

IT (information technology)
Describes the technologies that have developed
for handling information, particularly computer and
telecommunications technologies.

Java

An object-oriented programming language originated at Sun Microsystems in the early 1990s, Java is used to develop platform independent mini-**applications** (called **applets**) that run on a virtual Java computer (a software emulation) that can be installed on most computers. Many Web sites now contain downloadable applets, which may be anything from calculators to games.

Kilobyte

1,024 **bytes**.

Lingo

The **scripting** language used in Macromedia Director.

Megabyte

1,048,576 **bytes** or 1,024 **kilobytes**.

Menu

A range of options for the user, presented as a textual list of options in pull-down, pop-up or static form, or in pictorial form as a range of icons, pictures or labels.

Modem

A **digital**-to-**analog** device that links computers to the telephone network. A Modem enables digital **data** to be modulated so that it is compatible with the analog signals carried by the telephone system.

MPEG

A standard defined by the Motion Pictures Expert Group for the compression and decompression of motion video images.

Multimedia

Generic term for "multimedia computing" or "interactive multimedia": the use of multiple media within a computer system or **hypermedia** programme. Also used to describe artworks that combine several different media.

Narrowcasting

Term describing the precise targeting of content for a particular audience.

Navigation

The process of finding one's way around the contents of a **hypermedia** programme.

Network

System that links computers and other information/telecommunications technologies by cable, wireless, or a combination of both.

Operating System

A **program** that manages the resources of a computer, such as its input/output devices, memory and file retrieval. The operating system is loaded into the computer when it starts up, and supervises the running of other programs and **applications**.

Page

The basic unit of the **World Wide Web**. Each page has its own **URL**. There is no standard length for a page.

Pixel [picture element]

The smallest unit of a computer screen (usually a square or rectangle). The number of pixels per inch determines the resolution of a screen. The greater the number of pixels per inch, the higher the screen resolution.

Program

A set of statements and instructions designed to enable a computer to perform a specific task or series of tasks.

Programme

Describes a complete **hypermedia** product.

Programming

The process of preparing a set of instructions for a computer in order to make it perform a particular activity.

Pull technology

Refers to **client/server systems** where the client has to request information from a server.

Push technology

Refers to **client/server systems** where the server sends or pushes specified kinds of information to a client automatically.

QuickTime

A set of standards developed by Apple for dynamic (time-based) data handling, including image and audio **compression**/decompression. Computers running QuickTime software can play audio, animation and video without additional software or hardware.

QuickTime VR

A format and software developed by Apple. Quick Time VR enables developers to create "virtual" worlds either as panoramic movies that enable a user to look at and move around a 360-degree scene, or as objects that can be viewed from a variety of angles. These virtual worlds can be created by taking images from the real world, using photographic or digital cameras, or by using computer-generated images.

Random-access

A general term referring to non-sequential media, such as **hypermedia**, that do not have a physical beginning, middle or end.

Read-only

Describes a computer storage medium, which can only be read or copied from, and cannot be modified by the user. CD-ROM is a read-only medium.

Realtime

Describes computer processing that takes place apparently instantaneously.

Scripting

The process of programming using a scripting language, such as Lingo or HyperTalk. Scripting is a very high-level (nearly plain English) approach to programming and offers non-programmers a route to **authoring** without having to learn a programming language such as C or Pascal.

Simulation

The process of modelling and representing an activity, environment or system on a computer.

Socialware

Describes **software** and **hypermedia** environments that are designed to enable users to engage in social activities.

Software

The programming code or **data** components of a computer system. It is now broadly used to cover the content of media (such as music, film, animation and **hypermedia** programmes) as opposed to the physical medium that carries them.

glossary

glossary

Standards
Formal or informally agreed technical specifications allowing different equipment or **software** to work together. The **Internet** is essentially a set of standards enabling different **networks** and computers to communicate with one another.

Telecommunications
The transmission and reception of information from point to point, via wire, radio, microwave or satellite.

Unix
A multi-tasking, multi-user operating system developed in the early 1970s at AT&T's Bell Laboratories. Originally designed for mini computers supporting many terminals, it is now widely used as the operating system in many high-powered **workstations** and for servers in the **World Wide Web**.

URL (uniform resource locator)
The method of addressing all the resources (computers and files, Web sites etc.) that are available through the **World Wide Web**. Most URLs contain the service, host name and directory path, separated by either a dot (full point) or a forward slash. An example of a URL is: *http://www.amxdigital.com/uh2.html*, where the service is the World Wide Web, accessed through **HTTP** (hypertext transfer Protocol) at a computer (host) called amxdigital. The file to be retrieved is uh2.html.

VR (virtual reality)
Refers to simulations in which the user is immersed within a computer-generated environment VR usually involves **realtime** 3D animation, position tracking and stereo audio and video techniques.

VRML (Virtual Reality Modelling Language)
A set of specifications and standards for creating and viewing 3D **multimedia** and shared virtual worlds on the **World Wide Web**.

Web browser
A software **application**, such a Netscape Navigator or Microsoft's Internet Explorer, required to view information on the **World Wide Web**.

Window
Part of a hypermedia or graphical user **interface** that provides the user with a frame through which an **application**, file or part of the programme contents can be viewed.

Workstation
Describes very powerful, single-user, computers with very high-resolution graphics, mainly used for engineering and scientific applications.

World Wide Web
A sub-set of the **Internet**, the World Wide Web is a **hypermedia**-based system, that has had the most explosive growth in use of any new medium in history.

This is a list of some of the books that we have found helpful in preparing this book. It is in no way an exhaustive bibliography, but does suggest some of the most useful "associative links" for further reading.

Ambron, Sueann & Hooper, Kristina (eds)
Interactive Multimedia
Redmond, Wash., Microsoft Press 1988

Good introductory volume by two of the most knowledgeable doyens of interactivity, who are both still playing key roles in the development of the new media.

Aukstakalnis, Steve & Blatner, David
Silicon Mirage: The Art and Science of Virtual Reality
Berkeley, Peachpit Press 1992

This is one of the best VR books, well illustrated, with lucid explanatory diagrams and an encyclopedic coverage of current and future VR applications.

Benedikt, Michael (ed.)
Cyberspace: First Steps
Cambridge, Mass., MIT Press 1992

A collection of excellent (and deep) papers on the philosophical, design and technical aspects of cyberspace. Includes a brilliant and seminal paper by F. Randall Farmer and Chip Morningstar (then with LucasFilm Games) on the design and direction of the Habitat virtual community.

bibliography

Brand, Stewart
The Media Lab: Inventing the Future at MIT
New York, Viking Penguin 1987

Still one of the very best introductions to some of the key ideas and issues in hypermedia and the new digital media. Brand's easy style disguises his penetrating grasp of what is really important about the changes in media ecology and their wider effects. Essential reading.

Brand, Stewart
How Buildings Learn: What happens after they are built
New York, Viking Penguin 1994

Not a word about hypermedia, but this book about architecture is well worth reading by any hypermedia designer who is interested in designing systems that can change and evolve over time. Filled with insights and general principles about adaptive design.

Brunner, John
The Shockwave Rider
London, J.M. Dent 1975

Years before Gibson, Brunner mapped out much of the cyberpunk territory in his seminal scifi novels. See also *Stand on Zanzibar, Jagged Orbit* and *When Sheep Look Up.*

Bush, Vannevar
"As We May Think"
Atlantic Monthly, August 1945
Reprinted in *Macintosh Hypermedia Vol. 1,* by Michael Fraase Scott Foreman & Co., 1990. Available on-line at
http://www.isg.sfu.ca/~duchier/misc/vbush/

This was the essay that really sparked off the idea of hypermedia and networked information systems. Written three years before the invention of the transistor, it is still totally relevant today, with key insights on the use of information systems as tools to amplify thinking, communication and learning.

Bukatman, Scott
Terminal Identity
Durham and London, Duke University Press 1993

A rich collection of essays on the "virtual subject" in post-modern science fiction, by a film studies lecturer at New York University, that covers the complete span of science fiction media. A rich and fascinating examination of the contemporary zeitgeist, plus a great bibliography and filmography for those interested in the key developments in cyberspace culture.

Cotton, Bob & Oliver, Richard
The Cyberspace Lexicon
London, Phaidon Press 1994

A fully illustrated A to Z of terminology related to multimedia, hypermedia, cyberspace, telecommunications, videogames and all aspects of new media design and technology. Designed by Malcolm Garrett.

Cringley, Robert X
Accidental Empires
London, New York, Ringwood, Toronto & Auckland, Penguin Books 1996

An excellent, informative and irreverant history of personal computing and the people who created it.

Gates, Bill
The Road Ahead
New York, Viking 1995

Gates has played, and is still playing, a key role in the development of computer software. Written on the threshold of the new media revolution, *The Road Ahead* summarises Gates's thinking on many crucial areas of development, focusing on education and business.

Gelernter, David
Mirror Worlds
Oxford, Oxford University Press 1991

Gelernter is more of an inspired innovator and AI practitioner than a brilliant writer, but his ideas of realtime simulated virtual worlds are very important.

Gilder, George
Life After Television – The coming transformation of media and American life
New York, W.W. Norton 1992

Gilder is one of the foremost intellectuals and evangelists of the Internet, and this book analyses the effects that the telecomputer will have on business, education and entertainment in the next century. Very US-centric, but nevertheless a powerful argument for the new media.

Gibson, William
Neuromancer
London, Grafton 1986 (first published 1984)
Count Zero
London, Grafton 1987
Mona Lisa Overdrive
London, Grafton 1988
Burning Chrome
London, Grafton 1988

In the 1980s, these were the cult books to read, and together they defined the new genre of Cyberpunk. They are still essential and enjoyable reading. See also his later novels *Virtual Light* and *Idoru.*

Greenberger, Martin (ed)
On Multimedia
Santa Monica, The Voyager Company 1990
A series of transcribed conversations on the state of multimedia in the late 1980s. Key industrial players and designers consider the future of multimedia communications and publishing – many of the issues debated here are still relevant today.

Greiman, April
Hybrid Imagery
London, Architecture, Design and Technology Press 1990

Greiman is a world-class graphic designer, a student of the great Wolfgang Weingart and amongst the first to develop digital multimedia techniques. Hybrid imagery refers to the wide range of technical processes and media that Greiman incorporates in her work as a response to the increasing convergence of media in the digital domain.

Hardison, O.B.
Disappearing Through The Skylight: Culture and Technology in the Twentieth Century
New York, Viking 1989

Insights on the impact of quantum-level physics technologies (such as microprocessors) on culture. With chapters on many aspects of modern culture, from D'Arcy Thompson's morphologies, through concrete poetry and conceptual books to artificial reality and robotics, this book is a great catalytic tool for creative thinking.

Helsel, Sandra K. & Roth, Judith Paris (eds)
Virtual Reality: Theory, Practice and Promise
London, Meckler 1991

An early volume on virtual reality, mapping out theoretical issues, and including essays by Randal Walser, Brenda Laurel, Myron Kreuger, Scott Fisher and other VR and software pioneers.

Jones, J. Chrisopher
Essays in Design
Chichester, New York, Brisbane, Toronto & Singapore, John Wiley & Sons 1984

A fascinating set of thought-provoking essays by a leading thinker on design. Chris Jones is one of the few theorists to tackle the implications of what a shift from designing products to designing processes and systems means in practical terms for designers and others involved in the design process.

Kay, Alan C.
"Computers, Networks and Education"
Scientific American, Sept.1991
"Computer Software"
Scientific American, Vol. 257, No3, Sept.1984
"User Interface: A Personal View" in *The Art of Human-Computer Interface Design* edited by Brenda Laurel
Reading, Mass., Addison-Wesley 1990

To our knowledge, Alan Kay hasn't produced a book as yet, but try to dig out some of these articles – and anything else you can find that Kay has written. Kay invented the concept of the Dynabook, and he played a key role in the development of the graphical user interface, object-oriented programming and educational software. One of the most thoughtful figures in the computer scene, Kay continues to pose the kind of deep, probing questions that need to be considered if hypermedia is to reach its true potential.

Kurzweil, Raymond
The Age of Intelligent Machines
Reading, Mass., MIT 1990

An encyclopedic, fully illustrated, 565-page, large-format book on artificial intelligence by one of its leading practitioners (Kurzweil has done key work on text to speech reading machines). This book contains essays by AI and Philosophy luminaries such as Daniel Dennett, Sherry Turkle, Douglas Hofstader, Seymour Papert, Marvin Minsky, Harold Cohen, George Gilder and many others.

Laurel, Brenda (ed.)
The Art of Human-Computer Interface Design
Reading, Mass., Addison-Wesley 1990

This is essential reading for any design student involved in the new media. Includes essays by Ted Nelson, Alan Kay, Don Norman, Bruce Tognazzini, Nicholas Negroponte, Tim Leary, John Walker, Myron Kreuger, Laurel herself, and many other interface design and new media gurus.

Laurel, Brenda
Computers as Theatre
Menlo Park, Calif., Addison-Wesley 1991
"Interface Agents: Metaphors with Character" in *The Art of Human-Computer Interface Design* edited by Brenda Laurel
Reading, Mass., Addison-Wesley 1990
"On Dramatic Interaction" in *Verbum* 3/3
San Diego 1989

Laurel has written brilliantly on most aspects of software design. *Computers as Theatre* is her magnum opus, in which she develops a theory of interaction based on Aristotelian dramatic principles. Particularly useful for the criteria she gives for assessing different kinds of interactivity.

McLuhan, H. Marshall
Understanding Media
New York, New American Library 1964

We keep going back to McLuhan's *Understanding Media*, and still find new insights that seem to become fresher and more relevant as the years go by. The prescience of this great media philosopher is quite startling. The "global village", the idea of the "medium is the message", and the notion of "hot" and "cool" media all stemmed from McLuhan. His central concern here is with the way electronic communications technologies affect our sense ratios, extending our central nervous system in a global embrace.

McLuhan, H. Marshall & Powers, Bruce R.
The Global Village
New York & Oxford, Oxford University Press 1986

McLuhan's last book charts the cultural collision of individualistic visual space and holistic, communal, acoustic space, and explains his vision of how the two world views can be unified. This book provides fascinating updates of the seminal 1964 volume *Understanding Media*, including Powers's and McLuhan's insights into the Internet.

Negroponte, Nicholas
Being Digital
New York, Alfred A. Knopf 1995

Negroponte is head of MIT's Media Lab – an institution that has been in the forefront of developments in interactive media since the late 1970s. This is a collection of Negroponte's essays and insights on all things digital, largely culled from his columns *Wired* magazine.

Nelson, Ted
Computer Lib – Dream Machines
Redmond, Wash, Tempus Books/Microsoft Press 1987 (originally published 1974)

If you don't read any other book on hypermedia, read this one. Nelson invented the terms "hypertext" and "hypermedia", and in this book, he sums up all his wide-ranging and inventive thinking on what computer software should be. It is fully illustrated with Nelson's sketches, designed like a scrapbook and readable from both front and back. With this book Nelson really tried to convey the essence of hypermedia in printed form.

Palfreman, Jon & Swade, Doron
The Dream Machine: Exploring the Computer Age
London, BBC 1991

A comprehensive, beautifully produced and fully illustrated history of the computer, based on the popular BBC/ WGBH television series. If you need one introductory book that gives you all the background to the digital revolution and computers, this is it.

Papert, Seymour
Mindstorms: Children, Computers and Powerful Ideas
London, Harvester Press 1980

Papert's seminal book on children and computers describes the thinking behind his invention of Logo, the Turtle interface device, and his thoughts on computers and AI in education.

bibliography

Rheingold, Howard
Virtual Reality
London, Secker & Warburg 1991
The Virtual Community
London, Secker & Warburg 1994

Reporting right from the centre of cyberspace activities on the West Coast, Rheingold's books are brilliant and informed introductions to both VR and the socialware of multimedia networks.

Stephenson, Neal
Snow Crash
New York, Bantam Books 1992

One of the few post-Gibson cyberpunk authors worth checking out, Stephenson produces a credible West Coast vision of the hybrid real and virtual life we may lead in the near future of cyberspace communities and virtual real estate.

Sterling, Bruce
Islands in the Net
London, Arrow Books 1988

Alongside William Gibson, Bruce Sterling played a key role in defining cyberpunk, and has written some excellent novels, novellas and reportage. See also *Schismatrix*, the *Mirrorshades* cyberpunk anthology, and *The Hacker Crackdown*.

Stoll, Clifford
Silicon Snake Oil: Second Thoughts on the Information Highway
London, Macmillan 1995

One of a growing number of critics of life in cyberspace, the questions Stoll asks need to be seriously considered, even if like us you reject his conclusions.

Swadley, Richard (ed.)
On the Cutting Edge of Technology
Carmel, Sams Publishing 1993

Here is a good idea. In one quarto-size illustrated softback, you get a set of explanatory briefings on some key technologies, including motion capture, intelligent agents, morphing, 3D animation, VR, fractals, artificial life, nanotechnology and much more.

Tognazzini, Bruce
Tog on Interface
Menlo Park, Addison-Wesley 1992

Lots of insights on interface design by one of the key designers of the Mac OS interface. Awesome attention to the function of the Mac trash can icon, and wide ranging considerations of every aspect of human-computer interface design.

Turkle, Sherry
The Second Self: Computers and the Human Spirit
New York, Simon & Schuster 1984
Life on the Screen: Identity in the Age of the Internet
London, Weidenfeld and Nicolson 1996

Separated by over a decade, these two books chart the changes in our psychological attitudes towards the computer, computer games and networks. Key reading.

Vinge, Vernor
True Names and Other Dangers
New York, Baen Books 1987 – "True Names" first published in *Dell Binary Star* #5 1981

The main novella in this collection, "True Names" is an imaginative extrapolation into the near future of virtual-reality style networked MUDS (multi-user domains), and preceded Gibson's vision of cyberspace by 3 years. See also *Across Realtime* and *Fire upon the Deep*.

Winograd, Terry & Flores, Fernando
Understanding Computer and Cognition: A New Foundation for Design
Norwood, New Jersey, Ablex Publishing Corporation 1986

Not an easy read, but worth the effort. Winograd and Flores delve deep into a number of philosophical issues, not as an academic exercise, but in a very practical attempt to provide a firm foundation for the design of computer-based systems that are suited to human purposes.

Woolley, Benjamin
Virtual Worlds
London, Penguin Books 1992

This is a collection of Woolleys essays, articles and insights on the theory and practice of VR, with some useful and insightful discussions and discursions on artificial intelligence, hypertext, interface design, post-modern fiction and simulation, and much more.

Zuboff, Shoshana
In the Age of the Smart Machine: The Future of Work and Power
New York, Basic Books 1988

A key text for anyone who wants to understand the impact of information technology on the world of work. Zuboff charts the transition from a world of tangible objects to the more abstract digital domain in settings as varied as offices in an insurance company to pulp mills. Her ideas about "informating" rather than automating work should be required reading for all managers.

Software, hardware, book and image titles in *italic.*

7.3

index

index

acknowledgements

special thanks

7.4

Authors' acknowledgements

Very special thanks to Cara Mannion, whose focus, drive and support was crucial in getting this project together in time. Thanks, too, to Malcolm Garrett and everyone at AMXdigital whose hospitality, practical help and suggestions have been much appreciated. Thanks to Peter Anderson for the video shots in "Design and Production" The authors would also like to express their appreciation to the editorial team of Christine Davis, Paul Harron and Vivian Constantinopoulos, and to Jemima Rellie and Penny Webber, for their enthusiasm and commitment to this project. We would also like to thank all those from the hypermedia community who contributed pictures and information; work that has been used is individually credited in the photographic credits. (Every effort has been made to credit the correct copyright holders and we apologise to anyone whose copyright we may have unwittingly infringed.) Thanks, too, to all those who provided work we were not able to use due to pressures of space; we would have needed a much larger book to include everything worth showing. We would also like to acknowledge the contribution that Bob Condon, Gordon Davies, Gary Fairfull, Chris Jones, Karen Mahony, Jonathan Moberly, Clive Richards and Nick Routledge have made to our thinking by debating some of the ideas used in this book – even though they may not always agree with our conclusions. Finally, we would like to thank Andy Anderson, Debbie Cotton, Mimi Escudero, Benjamin Oliver and Colin Smith for all their help and support.

Bob Cotton (bc@amxdigital.com)
Richard Oliver (roliver@eudemony.demon.co.uk)
Malcolm Garrett (mx@amxdigital.com)

Photographic acknowledgements

The publishers wish to thank the following for their assistance in providing images and permissions. While every effort has been made to ensure accuracy, the publishers cannot accept liability for any errors or omissions.

Altavista 58, 71; Peter Anderson 96, 99, 102, 104; Amazon.com 134; AMXdigital 60, 61, 63, 67, 81, 83, 86, 87, 97, 98, 100, 101, 128, 129, 138, 139, 141, 153; David de Angelis 117; Apple Computer 29, 33, 58; Art of Memory 66, 156, 157, 159; Asif Choudhary 103; Bob Aufuldish & Eric Donelan 66, 75; BBC Resources 53; Berkeley Systems 80; BMW 142; Broderbund 60; Canal Plus 163; Cat Hill Productions 81, 165; Ian Cater 62, 148, 149; CD Media 65, 77, 126; Cisco Systems 52; CNN 62; CompuServe 58; Condé Nast 51; Sally Coe 119, 161; Bob Cotton & Malcolm Garrett 12, 13; Bob Cotton & Mathew Mayes 71, 86, 113; David Crow 26; CyberCash 141; Cyan/Broderbund 60; Joshua Dixler 116; DNC Project 131; Dorling Kindersley & Microsoft 83; Ecco Designs Inc. 118; Electronic Telegraph 122; Electronic Young Telegraph 51; Ellipsis 67; EMI Music Archives 18; Eudora 67; Fast Company 122; Feed 123; FitVision 144, 149; FontShop 72; Fox Interactive 79, 84, 151; Fuse 72; Peter Gabriel 27; Geocities 162; Sophie Greenfield & Giles Rollestone 26; Greenpeace 165; Maxine Gregson & Rory Hamilton 26, 119; William Gibson 39; Guerilla Girls 27; Hasbro 63, 112; Morton Helig 28; Hotbot 58, 71; Hotwired 123; i/0 360 74; id Software 61, 88; Inform 76, 77; Intro 65, 76, 158; IPC 127; Kodak 142 ; KPT 62; London Transport 18; Lowe-Howard-Spink/AMXdigital 145; Peter Lourenco & Sarah Brown 65, 67; MacMillan Interactive 67; MacPlay 91; Mahony Associates 159; Manga Entertainment 39;

Maris Multimedia 152; Mattel Media 63, 146, 147; Maxis 133; MetaDesign 74, 75, 160; Microsoft 37; Middlesex University 78, 118; Mini Co 60; MIT Media Lab 86; Modified 67, 82; Mosby Multimedia 67, 161; MSN 62, 66; NASA 52, 66, 155; Steve Nelson/Brilliant Media 80; Netscape 37; Nikon 143; No Frontiere 9, 48, 49, 60, 79, 120, 121; NSCA (University of Illinois) 37; Ogilvy & Mather/AMXdigital 136, 137; Mike Oldfield/WEA 15; Peet's Coffee & Tea 140; Penthouse Interactive 87; Perfecto Records 81; Peter Phillips 25; Pointcast 50, 123; Darren Poore 65; Project Guttenberg 157; Random House New Media 67; REM 75; The Residents 79; Saatchi 54; Sega 89; Shell 143; Silicon Graphics 88; Sony Design Center, Tokyo 132; Superscape 90; T-26/Carlos Segura 72; Telstar Electronic Studios 77, 148, 149; Tesco 138; Jake Tilson 27; The Spot 150; Tidycat 135; Tom Phillips 26; Trip Media 91; UCI 61; Virgin Records 114, 115; The Voyager Company 14, 24, 55, 64, 69, 79, 81, 82, 85, 89, 108, 109, 110, 111, 115, 124, 125, 130, 151, 154; Warner Music 63; Martin Williams Advertising 54; Working Knowledge Transfer 67; 2 Way Media Inc. 127.

understanding hypermedia 2.000